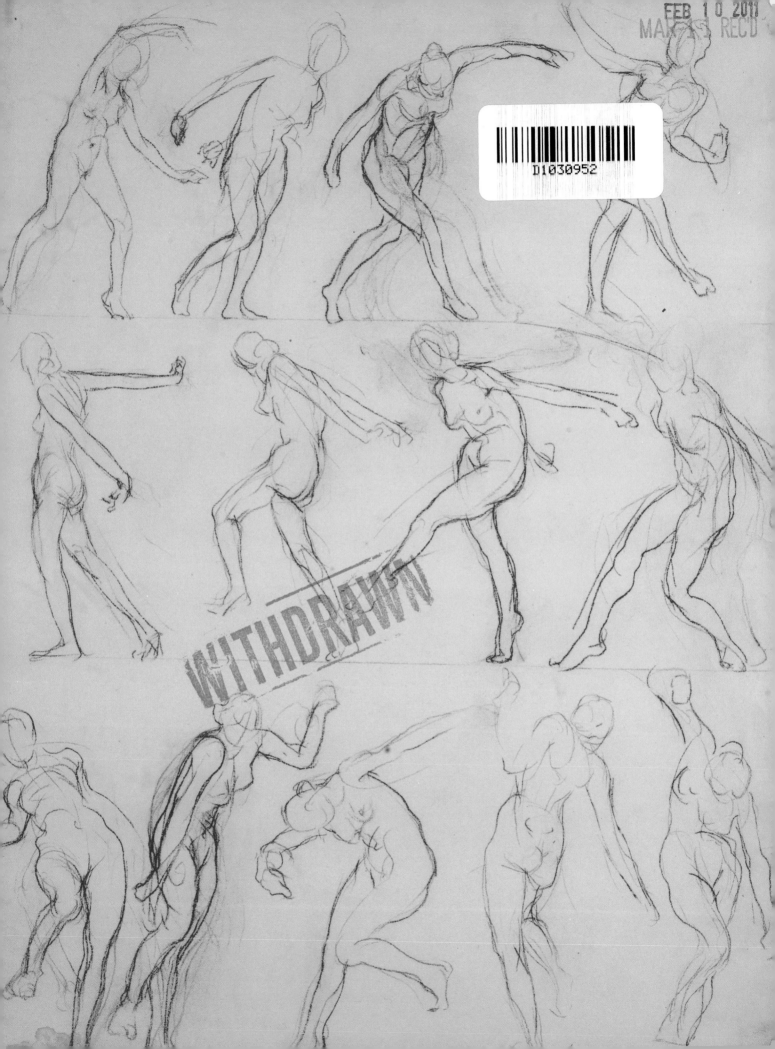

Classical Life
Drawing Studio

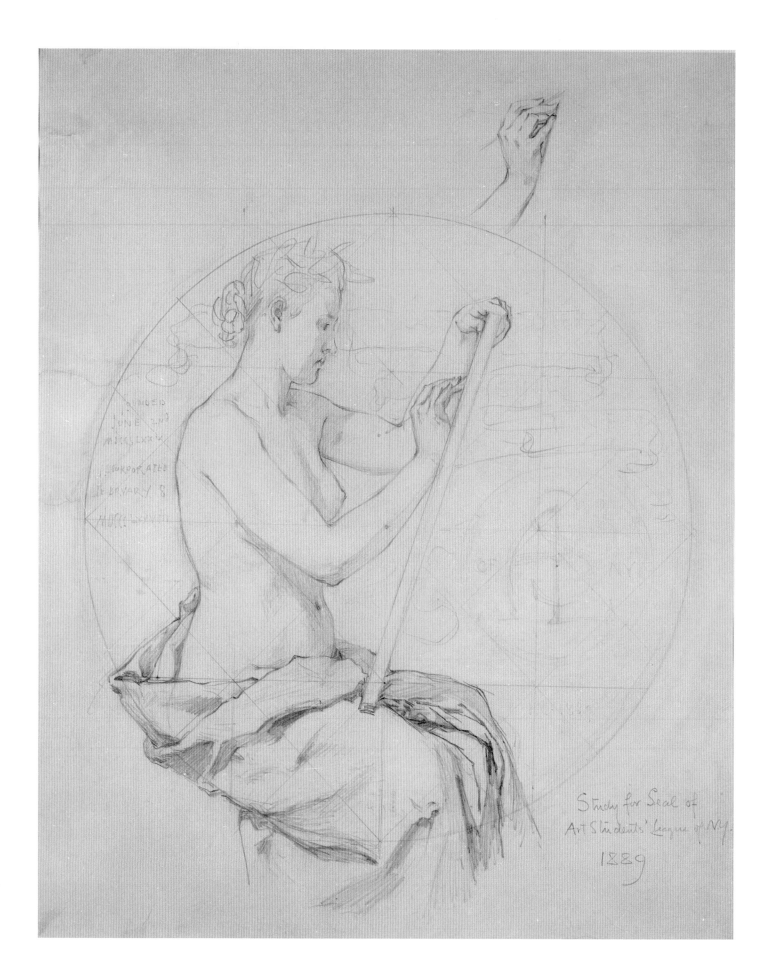

FOUNDED
JUNE 2ND
M.DCCCLXXV

INCORPORATED
FEBRUARY 8
M.DCCCLXXVII

Study for Seal of
Art Students' League of N.Y.

1889

Classical Life Drawing Studio

Lessons & Teachings in the Art of Figure Drawing

James Lancel McElhinney & the Instructors of
the Art Students League of New York

Foreword by Will Barnet

STERLING

New York / London
www.sterlingpublishing.com

STERLING and the distinctive Sterling logo are registered trademarks of
Sterling Publishing Co., Inc.

Library of Congress Cataloging-in-Publication Data

McElhinney, James Lancel, 1952-
 Classical life drawing studio / by James Lancel McElhinney and the instructors of the Art Students League of New
York ; foreword by Will Barnet.
 p. cm.
 Includes bibliographical references and index.
 ISBN 978-1-4027-6229-1 (hc-trade cloth : alk. paper) 1. Figurative drawing, American—Catalogs. 2. Human
figure in art—Catalogs. 3. Drawing—Private collections—New York (State)—New York—Catalogs. 4. Art Students
League (New York, N.Y.)—Art collections—Catalogs. 5. Drawing—Technique. I. Art Students League (New York,
N.Y.) II. Title.
 NC765.M385 2010
 743.4—dc22

 2009036852

Published by Sterling Publishing Co., Inc.
387 Park Avenue South, New York, NY 10016

Distributed in Canada by Sterling Publishing
c/o Canadian Manda Group, 165 Dufferin Street
Toronto, Ontario, Canada M6K 3H6
Distributed in the United Kingdom by GMC Distribution Services
Castle Place, 166 High Street, Lewes, East Sussex, England BN7 1XU
Distributed in Australia by Capricorn Link (Australia) Pty. Ltd.
P.O. Box 704, Windsor, NSW 2756, Australia

Author and general editor: James Lancel McElhinney
Book design and layout: Rachel Maloney

Printed in China
All rights reserved

Sterling ISBN 978-1-4027-6229-1

For information about custom editions, special sales, premium and
corporate purchases, please contact Sterling Special Sales
Department at 800-805-5489 or specialsales@sterlingpublishing.com.

Frontispiece: Kenyon Cox, *Study for the Seal of the Art Students League*, 1889, pencil on paper, 18½ x 15 inches.
Permanent collection, Art Students League of New York.

Contents

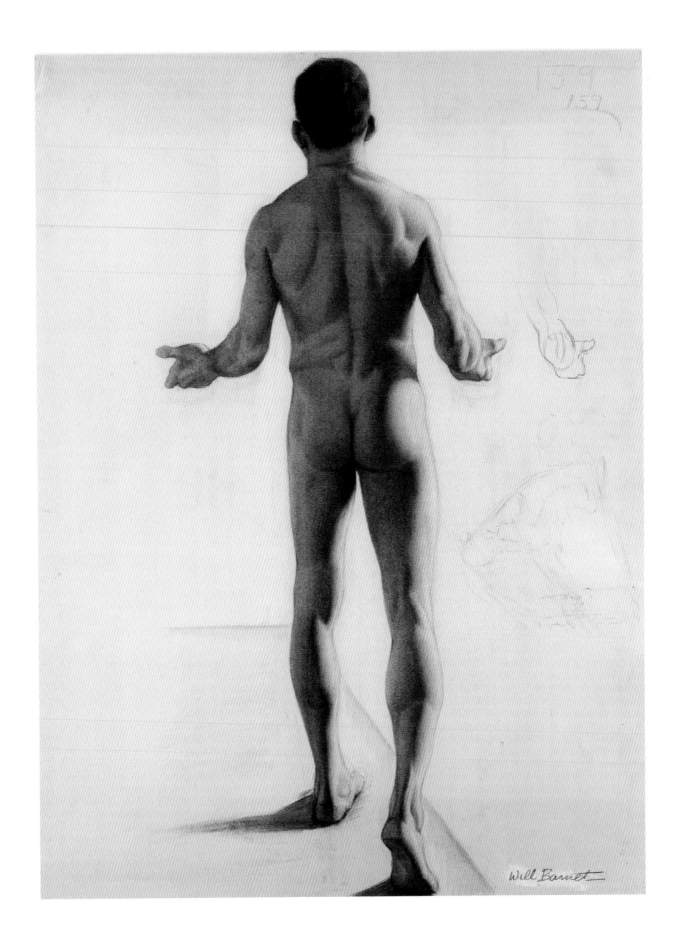

Foreword

A CHILD'S FIRST ATTEMPT TO PUT PENCIL TO PAPER usually results in random, unfocused, yet physically immediate stabs, lines, and scribbles. Soon the child develops a larger scope, beyond lines and scribbles, to forms that approach identification. Later, with increased vision and experience, the work becomes even more expansive and images become more readable. From ages five to seven (what I call the "Renaissance" period), they can do some very beautiful, colorful work full of action, spreading all over the page with an awakening awareness of composition. As the child grows older, he or she becomes dissatisfied and desires to draw in a more representational—rather than an imaginative—way. Finally, if the individual wishes to continue as an artist, he or she will go to an art school and learn to draw realistically.

In earlier centuries, schools were already set up to accept young students—schools with precise principles to be studied as to how to draw a figure that is anatomically correct and real. For generations, there existed what is now referred to as Classical academic training. I am probably one of the last living artists to receive such a strict training, and I am very aware of its advantages and pitfalls.

My formal training with Philip Hale at the Boston Museum School began with drawing from plaster casts. This also included the proper preparation and care of one's tools. Every morning, the charcoal in my box was beautifully sharpened and ready to go. When the required level of proficiency was achieved (and earned), you moved to the next step, figure drawing from live models. Most of my contemporaries in the class seemed more concerned with shading and modeling, and very often the observation of the whole figure was not realized. What bothered me a great deal was the intense interest in the technical rather than the physical dynamics of representation. This had a deep effect on my aesthetic foundation, and line (not shading, not shadows) became the lifeline to my work. Philip Hale also lectured on anatomy and one of his initial statements was his disagreement with Thomas Eakins, who had his students study cadavers. Hale's direction was more toward the lessons to be learned from Greek Classicism. The Greeks had done the hard work for us!

Because of this early academic training, I was dissatisfied by what I initially experienced when I arrived at the Art Students League on a four-year scholarship supported by Reginald Marsh. As was so often the case in Boston, I found that most of my fellow students were not able to comprehend the figure in its entirety. They became stalled in method. Later, when I became an instructor at the League, my passion was to give my students the experience of seeing the figure as a whole rather than in parts, having the parts actually relate to the fullness of the pose. I did not give

OPPOSITE PAGE
Will Barnet, *Lifestudy*, 1929, charcoal on paper, 25 x 19 inches. Collection of the Arkansas Art Center.

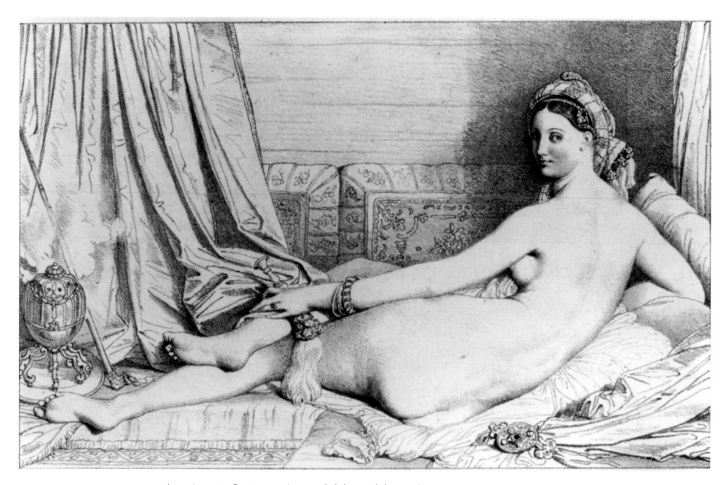

Jean-Auguste-Dominique Ingres, *Odalisque*, lithograph, ca. 1825.

them an academic training; I gave them a spatial training. The title of my course was "Putting the World Together." Structure became my most important lesson, demonstrating how line enhances structure—giving off energy and weight.

Academic training does not destroy creativity, but can reinforce it. In my teaching of the great classical masters such as Ingres, I taught my students that Ingres's use of the figure was abstractly conceived. Even Picasso realized this—Picasso having one of the severest Classical trainings of any modern master. Picasso took advantage of this training throughout his entire career. He knew the figure so well he could do anything with it! This puts to rest the hostility that Classical training met with in the twentieth century.

My teaching continued well into the 1980s and '90s, and today I still give critiques to advanced students almost ready for professional careers. Though the foundation of my approach to teaching remained constant in its values, each generation had its own concept of expression and its own reaction to what I hoped to instill. Even if they resisted the perfection of a Classical nude or an idealized landscape, they created something that reflected values. This was very satisfying to me and fulfilled my teaching career, completing the cycle that began with my Classical training nearly a century ago.

Is the necessity of an academic training still a valid argument? Today, in our media age, we are overwhelmed with imagery and influences. We leave so many exhibitions today with a sense of emptiness, a lack of substance of some kind. As all these new technological concepts and multimedia flashes take over, sometimes to a most satisfying effect, it is still difficult to find work that has any kind of the richness of experience that the past has given us. In all that, I feel that there is still no more satisfying or personal an experience for an artist than to simply put pencil to paper.

—Will Barnet
July 2009
New York City

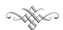

Preface

THE ART STUDENTS LEAGUE OF NEW YORK has been teaching studio art techniques and practices for over 135 years. It is an atelier school where no degrees are offered. There are no entrance requirements and class attendance is never taken. Classes are delivered seven days per week with schedules to fit any individual need. The tuition that is paid by the month is nominal by any standard. Students choose whom they wish to study with from among a faculty of leading professional artists. The instructors run their classes without curricular or administrative restrictions, and offer a broad array of aesthetic and philosophical points of view reflecting the evolving grammar and vocabulary of visual art in painting, drawing, printmaking,

and sculpture. Classes are offered on subjects ranging from classically based figure drawing, painting, and sculpture to nonobjective painting, assemblage, photo-etching, color lithography, and sculpture—from traditional methods like clay modeling, plaster, and bronze-casting to more contemporary approaches like welding and installation art. The League champions the individual by providing an environment in which each student can rise to their full potential depending on his or her drive, persistence, and perseverance. Educating artists in this way has resulted in an alumni list that encompasses some of the greatest names in American art, including Georgia O'Keeffe, Norman Rockwell, Frederick Remington, Jackson Pollock, Mark Rothko, Louise Nevelson, Alexander Calder, Louise Bourgeois, Will Barnet, James Rosenquist, Lee Bontecou, and Helen Frankenthaler, just to name a few. Our past faculty roster includes William Merritt Chase, Daniel Chester French, Augustus St. Gaudens, Childe Hassam, Reginald Marsh, Maxfield Parrish, Thomas Hart Benton, Gutzon Borglum, Jules Pascin, Hans Hofmann, Paul Manship, and Raphael Soyer.

From the founding of the League in 1875 until the early part of the twentieth century, the scope of aesthetic points of view was limited to the French and German Academic ideals of figure drawing and painting. Students were expected to master the naturalistic rendering of the nude figure, which was—and in some circles still is—considered an essential requirement for becoming a professional artist. While we continue to embrace the innovations of contemporary art, we also believe it is important to maintain and support the traditional underpinnings of art education that form the basis of Western visual culture. Rigorous training in figure drawing at the League is available to students who wish to be well prepared to work in more traditional modes. With a strong foundation in classical drawing, they will also be better prepared to delve into contemporary media and solve problems in design.

The drawings displayed in this book reveal how that tradition has been carried on through the years with similarities as well as vast differences between goals that instructors are getting their students to strive for in figure drawing today, as opposed to a hundred years ago. This book offers the reader a glimpse into both our past and our present, revealing why we are sure that maintaining high standards of drawing is essential to the future of art.

—Ira Goldberg
Executive Director
Art Students League of New York
May 29, 2008

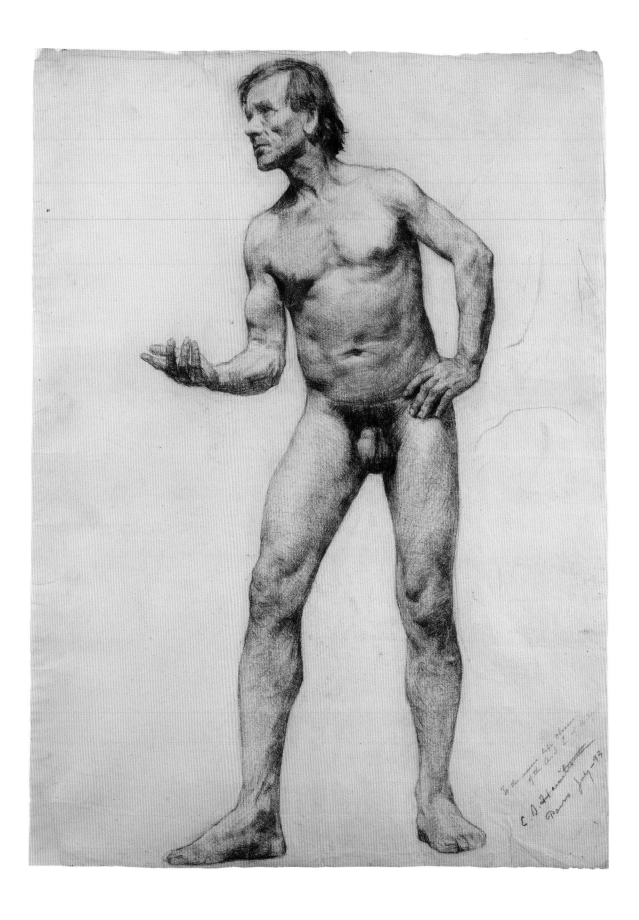

Academic Drawings in the League's Permanent Collection

THE AMBITIOUS STUDENTS WHO FOUNDED the Art Students League in 1875 made life-drawing instruction the very core of their new school. They knew well that drawing the nude was a central practice in European art academies, inspired by the great traditions of classical and Renaissance art, and that it was essential preparation for a career in painting, mural production, or literary illustration. It is no wonder, then, that outstanding life drawings were part of the foundation of the League's permanent collection.

At a time when New York City offered few opportunities to see original art, the League's constitution established an Art Committee to collect works of art and other materials that would be instructive to students.[1] Generous patrons donated books and reproductions to the school's library. Instructors gave their own drawings and paintings to the collection.[2] In 1882, League president William St. John Harper observed that the League had adequate financial resources to establish a reserve fund that would generate enough interest to purchase additions to the collection. He also announced a project to collect drawings by distinguished foreign artists. As art historian Ron Pisano noted, this international outlook distinguished the League and its collection from the older National Academy of Design, where candidates for membership were required to present a self-portrait to the Academy's collection. Once elected to membership, the Academician was asked to donate an example of his work.[3]

While no such contributions were *required* of League artists, an 1882 bylaw proposed waiving fees for League students while they traveled abroad; in return, they were asked to send back "exile drawings" of the nude that had earned the approval of their European instructors. A fine example of such a work is E. D. Harnits's drawing of a standing male nude, at left, which he inscribed "To the men's life drawing classes of the A.S.L. of N.Y . . . Paris, July '93." Setting high standards, these drawings entered the permanent collection. In his report on the League's first ten years, president Frank Waller acknowledged gifts to the League, including thirteen etchings by Whistler; four life drawings given by Walter Shirlaw; one life drawing (an "exile contribution") by Cy Turner; and two life drawings and two life studies in oil, done by Kenyon Cox.[4]

The League's academic drawings also served as an important record of student achievement, a source of pride for an institution that aimed at being a "national" school. Any life or antique drawing that earned its creator a League scholarship or

significant award entered the permanent collection. The word "scholarship" or the stamp "Property of the Art Students League of New York" is often found on such drawings. Archival photographs indicate that such outstanding works were often framed and mounted on the League's studio walls for inspiration. In the decades ahead, student work by such artists as Georgia O'Keeffe and Norman Rockwell were acquired in this manner. By the 1920s, the League offered cash rather than scholarships to acquire students' outstanding works, which is still the case today. Over time, instructors' paintings, sculptures, prints, and drawings were also purchased for the collection, forming a register of changing styles and interests among American artists of the twentieth century.

Unfortunately, documentation of the early collection is incomplete. Board of Control minutes for June 8, 1890 record that the "Art Committee" was responsible for management of monthly exhibitions, arrangements of work submitted for prizes and scholarships, collection of educational materials, and "the care and preservation of the League's permanent collection."[5] Early presidents' reports acknowledging gifts, notations on the actual drawings themselves, and Board of Control minutes fill in some of the blanks. In addition, the school's annual course catalogs offer information on purchases of student works. The thoroughness of these records varies from decade to decade and was particularly complete during the 1920s and 1930s. It was not until the 1990s that League members actually catalogued and photographed the entire collection, and there was no formal curator until 1998. Before then, oversight was done on a voluntary basis by instructors, librarians, and members, reflecting the collective, self-reliant spirit that has characterized the League from its founding. It is a tribute to their dedication that the collection survived as well as it did.

Of particular note in this regard are the life drawings themselves. While some were kept in flat files, many more were maintained in simple artist portfolios and must have been shared informally with students by instructors who passed them on from generation to generation. In 1999, a remarkable trove of these portfolios was discovered, packed floor to ceiling in a long-forgotten closet. Locked up for fifty years, according to the League's maintenance head, it was filled with hundreds of antique and life drawings and prints from the 1890s to the 1940s. As an art historian, it was my great pleasure to go through these portfolios, to research their provenance, and to enter them into the collection. Many of these are reproduced for the first time in this volume.

As museums and galleries proliferated in New York, the collection's use as a teaching resource became less important. Instead, it has grown as an important documentation of the school's history and significant chapters in American art. This is particularly true of the nude studies, an enduring aspect of the League's curriculum. By 1951, artists could study life drawing with traditionalists Reginald Marsh or Kenneth Hayes Miller, modernists Will Barnet or Vaclav Vytlacil, or twenty-one others. Drawings in the collection reflect this impressive diversity, from a baroque, animated nude by a George Bridgman student to a cubist figure drawn by George McNeil in Hans

Hofmann's class. The early life drawings, however, speak most eloquently of the high aims and serious purpose among the students who founded the League, determined to establish its connections to the great traditions in art.

—Pamela N. Koob
Curator of the Permanent Collection
Art Students League of New York

1. Archives of American Art, Smithsonian Institution, reel NY59-20. For contemporary accounts of students' access to original art in the 1880s, see Lawrence Campbell, "Foreword" *The Art Students League of New York 1875–1975* (New York: The Art Students League of New York, 1975), p. 20.

2. *Daily Graphic*, October 27, 1877, p. 816.

3. "A Collection in the Making," *The Art Students League: Selections from the Permanent Collection* (Hamilton, N.Y.: The Gallery Association of New York State, 1987), p. 105. For information on the National Academy of Design collection, see Lois Marie Fink and Joshua C. Taylor, *Academy: The Academic Tradition in American Art* (Washington, D.C.: National Collection of Fine Arts, Smithsonian Institution Press, 1975).

4. "First Report of the Art Students League of New York," Archives of American Art, Smithsonian Institution, reel NY59-20, frames 46–47.

5. Minutes of the Board of Control, June 8, 1900, Archives, The Art Students League of New York.

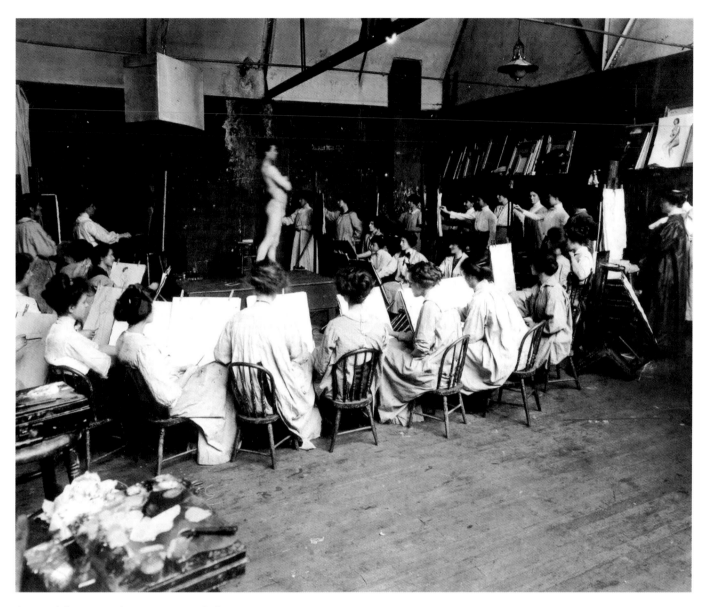

A turn-of-the-twentieth-century women's drawing
class at the Art Students League of New York.

Academic Drawing: A Living Tradition

IN 1791, THE SCOTTISH MINIATURIST Archibald Robertson opened the Columbian Academy of Art in lower Manhattan. Among his first students were the daughters of wealthy New Yorker Robert Livingston, Robertson's backer. For more than three decades, Robertson and his brother Alexander devoted themselves to teaching. The title page of Archibald's 1802 drawing manual *Elements of the Graphic Arts* includes a panoply of brushes, maulstick, and palette with the phrase *Non lingua pinxit Appelles* (No other language is equal to the paintings of Apelles). Art historian Megan Fort states in her doctoral dissertation on the Robertson brothers that this logo was used in their advertising and on academy signage. By alluding to Apelles (ca. 352–308 BCE), reputedly the favorite painter of Alexander the Great, Archibald Robertson proclaims himself heir to an artistic legacy rooted in Antiquity. Twenty-first-century readers might wrongly assume that looking to the distant past is a mark of conservatism. Neoclassicism was the visual expression of revolution and modernity. Comparing voluptuous, decadent European monarchies with the ordered and rational ideals of Athenian democracy or the Roman republic bestowed authority on radicals seeking political reform and gave them legitimacy based on ancient pedigrees. Eighteenth-century revolutionaries in America and Europe were bent not on destroying social order but on restoring it.

This Elgin marble statue from the Parthenon's east pediment depicts a reclining Dionysus.

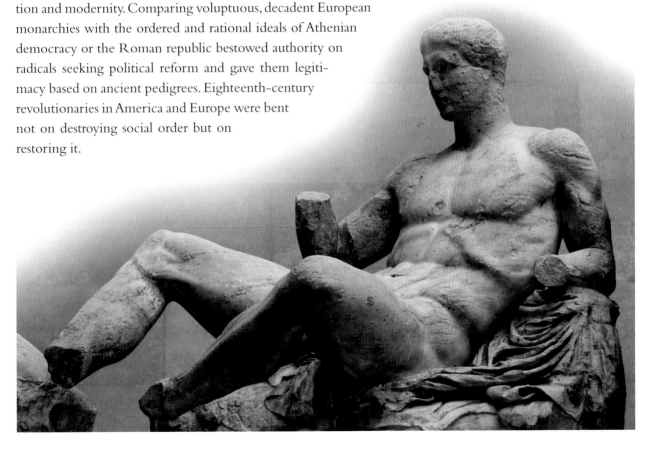

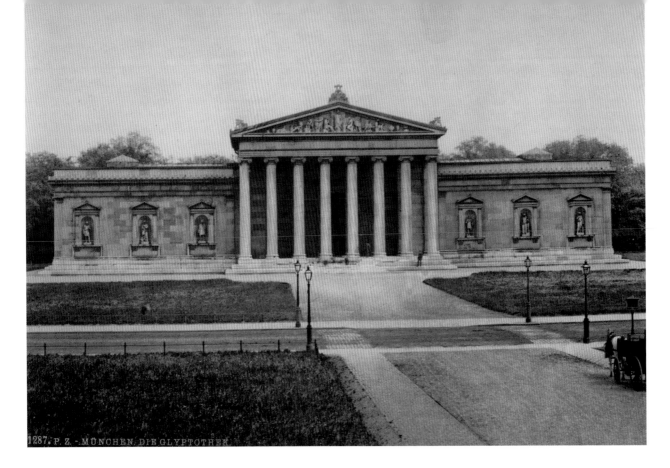

Façade of the Glyptothek (1816-30) at Königsplatz in Munich. A pastiche of Classical architecture, it was commissioned by the future King Ludwig I to house his collection of ancient statuary, from which plaster casts were created for the Akademie der Bildenden Künste München, a new art academy founded by Ludwig's father, King Maximilian I, in 1808. More than five hundred American artists during the nineteenth century, including future Art Students League instructors such as William Merritt Chase and Frank Duveneck, trained at the old Munich academy and visited the Glyptothek. The academy is now newly renovated, and the Glyptothek is open to the public.

Neoclassicism became the official style of change and progress. The Elgin marbles were removed from the Parthenon to London for safekeeping, where they remain. Napoleon withdrew from Egypt with massive loot, including the Rosetta stone—a codebook to ancient languages—and an obelisk that was installed in the Place de la Concorde, marking the spot where the guillotine had stood during the Terror. Shrewd monarchs like the Wittelsbach kings of Bavaria dispatched buyers to Greece in search of ancient statuary. They bought plaster casts of ancient and Renaissance sculpture to fill the halls of the Glyptothek and the Akademie für Bildenden Künste München (Academy of Fine Arts, Munich); rebuilding Munich with marble temples and wide boulevards proclaimed their modernity. Many American artists trained in Munich during the nineteenth century. Some like William Merritt Chase were influential at the Art Students League of New York during its first years of operation. The League motto *Nulla dies sine linea (*Never a day without a line*)*, attributed to Apelles, claims an ancient lineage and enduring legacy upon which the instructors and students at the Art Students League of New York today continue to build.

Academies to 1790

According to legend, the first fine-art academy was founded by Apelles. Its curriculum has been forgotten; his treatise on painting has never been located. The best known example of his work survives as a copy in a first-century BCE floor mosaic in the collection of the Museo Archeologico Nazionale in Naples, reputed to be the copy of a painting depicting the victory of his patron Alexander the Great over the Persian emperor Darius at either Issus in 333 BCE or Gaugamela in 331 BCE. What little is known today about artistic practice in Antiquity comes from writers like Pliny or Plutarch and from the study of surviving artworks. Throughout history, artistic training follows three dominant pedagogical models: individual instruction via apprenticeship, academic training, and self-instruction. Individual instruction from a father or an uncle was practiced—as it is often still done today—within hereditary trades. Successful tradesmen belonging to a guild might bring paying students into the workshop as apprentices. Consortia of individuals practicing within a particular trade, guilds set standards for training, mastery, and future admission into the guild by new talent. Art was a skilled trade in which painters were granted no higher status than builders, carpenters, weavers, or dyers. During the Renaissance, architecture, painting, and sculpture were elevated to a higher status. Accordingly, European artists were expected to become and behave as men of learning, letters, and science. Leonardo da Vinci is perhaps the best and most famous example of a so-called Renaissance man: he was a painter, sculptor, architect, engineer, and scientist. Late in life, Piero della Francesca abandoned painting for mathematics and the study of perspective. Painter Albrecht Dürer revolutionized fine-art printmaking and publishing. Widespread distribution of his images and extensive personal travel throughout Europe made Dürer one of the first international art-world superstars. Michelangelo began as a sculptor and then worked as a painter and an architect before returning to sculpture. He also wrote poetry and invested in real estate. Giorgio Vasari wrote and published the first known compendium of artist biographies. It remains in print to this day. Limitations of guild-system training led, in the sixteenth century, to the formation of academies where students could blend the study of art with outside pursuits and refinements, and not be confined to workshops run by tyrannical masters. The course of study offered at Leonardo's academy in Milan is unknown, but we can surmise that it promoted a balanced study of theory and technique. Founded in 1563, Vasari's Accademia del Disegno (Drawing Academy) in Florence marked the transformation of artists in the Renaissance from tradesmen into men of learning. In 1593, Federico Zuccaro established the Accademia di San Luca (Academy of Saint Luke) in Rome, where students followed a more structured regime of perspective, life drawing, and anatomy. The Carracci brothers are credited by some with inventing the life drawing class at their Accademia degli Incamminati (Academy of the Progressives) in Bologna. The atmosphere in these academies must have been electric. Students and artists engaged in animated discussions ranging from pigments to poetry. New academies were organized. Drawing manuals were

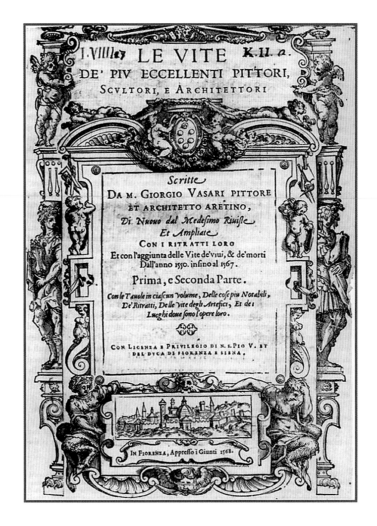

The title page of the 1568 edition of Vasari's *Le Vite*, which chronicled the "Lives of the Most Excellent Italian Painters, Sculptors, and Architects, from Cimabue to Our Times."

published. Albrecht Dürer published a painting manual that included figure drawing in 1525. Andreas Vesalius's influential treatise on anatomy, *De humani corporis fabrica libri septem* (On the Fabric of the Human Body in Seven Books [How the Figure is Made]) was published in 1543. Veneto painter Palma Giovane described methods for drawing human figures in *Regole per imparar a disegnar i corpi humani* (Rules for Learning to Draw the Human Body), published in 1636.

Following instructional models developed in Italy, the new Académie Royale de Peinture et de Sculpture opened its doors in Paris in 1648 under the patronage of Louis XIV. The new French academy in its earliest days fell under the despotism of taste that later became synonymous with the term "academic." Unlike students in the Italian academies on which it was based, students at the new French academy who were competing for prizes and exhibitions succeeded only by working in styles favored by the king. The presumed monopoly that the French Academy briefly enjoyed was challenged by the emergence of new academies in 1738 in Copenhagen, 1750 in Venice, 1757 in St. Petersburg, 1768 in London, 1772 in Vienna, and 1785 in Mexico City. While all these academies were founded under royal patronage, what that implied varied greatly from one realm to another. By 1780, the Royal Academy

of Arts in London was financially independent of King George III. Colonial settlements in the Americas by the eighteenth century had developed into quasi-European communities at once similar to and unlike their mother countries. Growing numbers of students from Latin America in European academies, together with increased demand for criollo talent contributed to the establishment of academies in Mexico City and Cartagena. Globalism is a twenty-first-century buzzword, but in the eighteenth century it was already a fact of life. Porcelain and lacquer-ware from China, paper and silk from Japan, tea from India, silver from Mexico, beaver hats fashioned from pelts trapped in the wild hinterlands of Siberia and the Rocky Mountains, prints and paintings from Europe—all were consumed and collected by planters, shipping magnates, and real-estate tycoons on both sides of the Atlantic, members of the new merchant elite who themselves became role models for ambitious members of a growing middle class. Before art academies were established in the New World, the only local public access to great works of art was limited to public spaces such as churches and civic buildings. In British North America, the best paintings and engravings hung in private homes, out of public view.

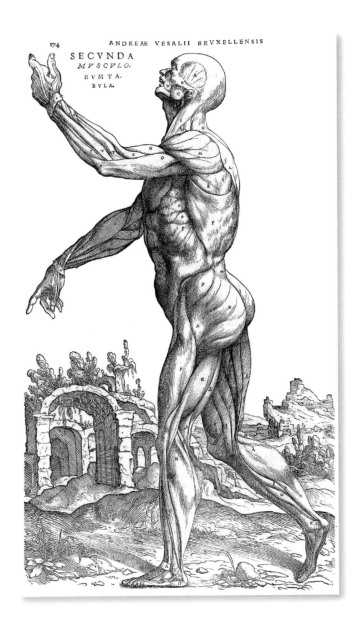

Colonial America functioned more as an engine of empire than a haven for culture. Before Britain was divided from its thirteen Atlantic colonies, finished goods were seldom produced for export by colonials. Architecture, furniture, and utilitarian decorative arts by American artisans and craftsmen were created solely for local consumption. Domestic finery and works of art suitable for the American ruling class dwellings were imported from Europe, through Great Britain and its allies. Until the creation of the United States, most inhabitants considered themselves to be British. The first president of the United States born a U.S. citizen was Martin Van Buren, who was not elected until 1836, sixty years after the Declaration of Independence. Living in a new republic led its inhabitants to embrace new identities. Subjects became citizens. A confederacy of former colonies identified itself as a *nation*—a term with tribal implications, as much as *country* denotes a territorial possession. Perhaps because the American Revolution

An écorché depicting a nude flayed to reveal muscle groups, illustrated in *De humani corporis fabrica libri septem*, a definitive compendium on anatomy by Belgian-born physician Andreas Vesalius, published in 1543.

Pennsylvania native Benjamin West (1738-1820) was president of the Royal Academy of Arts in London when this print of an (exclusively male) life drawing class at the academy school was produced in 1808—the same year the Munich academy was founded.

was led by educated elites—and not by righteous armed mobs—the political experiment has endured. It also assured a more stable patron base for homegrown artists, the establishment of which had been underway for almost a century.

Decades before the American Revolution, British painter John Smibert's attempt to found an academy in Bermuda resulted in a detour to Boston, where he opened a "colour shop" in the 1730s, selling art supplies and engravings of European masterpieces. He displayed his own pictures—many of them copies of famous works of art—and received commissions from local patrons. Young John Singleton Copley surely had access to Smibert, who was a close friend of his stepfather Peter Pelham. The precocious teenaged Copley created an anatomy book for his own use, drawn from materials owned by Pelham, Smibert, and perhaps others. Facing limited prospects like many other American artists of his generation, in 1774 Copley moved to London to pursue his career, where Pennsylvania native Benjamin West befriended him. West later became the president of the Royal Academy in London (1792–1805 and 1806–20), which at the time was the only school offering formal fine-arts training in the English-speaking world.

Individual artists sometimes gave instruction in their own ateliers, after the manner of guild apprenticeships. Mexico City's Academia de San Carlos (Academy of Saint Charles) was founded at almost the same time as the Royal Academy in London. Differences in language and centuries of lingering mistrust would discourage Protestant American colonials from taking their training in Catholic Mexico. The appearance of these two institutions and others at nearly the same time is not accidental. Signaling

an increased demand for trained artists—and a growing number of amateurs seeking instruction in drawing—the new academies mark the emergence of a nouveau riche middle class aspiring to cultural patronage and desirous of ensconcing themselves within environments aptly decorated and appointed as befit their newfound prosperity. Patrons in the new republic of the United States were no different.

New York Academies 1791–1875

Advertising instruction in drawing for both sexes, Archibald Robertson opened the Columbian Academy of Art on William Street in 1791. Ambitious painter, scientist, and museum director Charles Willson Peale opened Philadelphia's Columbianum in 1794, but failed to realize his dreams for consolidating an art academy and a museum under one roof. It was a prescient idea in light of the future successful establishment of new art schools across the nation linking schools to museums. The Corcoran School of Art in Washington, the Milwaukee Institute of Art and Design, the School of the Art Institute of Chicago, the University of the Arts in Philadelphia, the Boston Museum School, and others can trace their origins in some way to Peale's vision. After working at the Columbian Academy with his brother Archibald, first on William Street and later on Liberty Street in lower Manhattan, Alexander Robertson opened his own Academy of Drawing and Painting in New York in 1802.

In 1801, the founding of the New York Academy of the Fine Arts marked a shift away from artist-run academies. Presided over by Robert Livingston's brother Edward, the governing body of the New York Academy included no artists. In 1802, Philadelphia community leaders revived Peale's initiative by underwriting the formation of the Pennsylvania Academy of the Fine Arts—which is still a going concern. A new academy opened the same year at West Point to train promising young men in engineering and military science. Its curriculum specified two hours of drawing instruction per day for second- and third-year cadets. Six years later, the New York Academy of the Fine Arts was chartered by the state of New York as the American Academy of the Fine Arts (not to be confused with later institutions bearing the same name). Under the direction of Colonel John Trumbull from 1817 to 1825 it became the premier venue for artistic training in New York City.

America's lack of major public art collections hindered instruction. The first major public exhibition of antique plaster casts in New York opened in 1803 and remained on view through 1804 on Greenwich Street at the so-called Pantheon—a large building (now demolished) used for circus and theatrical performances. The collection was shipped to New York by Robert Livingston, while serving as U.S. Ambassador to France, to promote refinement and elevate popular taste by the exposure of public audiences to great works of art. A few years later, the Pennsylvania Academy acquired its own collection of casts. A hunger for masterpieces required American artists and students to study abroad. American academies offered the same

skills as European schools, taught by professionals, but American cities lacked important public collections where students could study great works of art in person.

Kingston, New York, native John Vanderlyn painted the first great American nude. A former student of Jacques-Louis David, Vanderlyn's frankly immodest 1809–14 *Ariadne Asleep on the Island of Naxos* (collection of the Pennsylvania Academy of the Fine Arts) thrilled audiences as much as its eroticism scandalized them. In 1819, Trumbull's American Academy exhibited European masterworks collected by the colorful and notorious Madam Jumel (the future Mrs. Aaron Burr). When her debut as a patroness of the arts failed to impress New Amsterdam elites, she sold the lot. Art has always been an instrument of social mobility as much as it is a medium for personal delectation. Elevating public taste as a means to enhance community and national status is in line with republican values, but has roots in the conduct of Roman emperors and Renaissance princes. Devotion to the cause of art by wealthy patrons was—and is—regarded as a demonstration of noblesse oblige evincing lofty comportment and refinement of sensibility, with or without coronets.

By the 1820s, mechanized transportation defied tides and weathers, crowding harbors and rivers with steamboats laden with passengers bound for Boston, London, and Albany. Painters dragged their supplies on sylvan rambles in far-flung destinations. Unthinkable ten years earlier, the landscape painting revolution they helped to launch coalesced around Thomas Cole and Asher B. Durand. Improvements in personal mobility also transformed art education. Students knew what they could expect from American artistic training. With few exceptions—like William Sidney Mount, who declined offers for him to study abroad—most American artists resigned themselves to the necessity of study in Europe. Mobility raised the bar for American academies, demanding they be more competitive.

When students were refused access to the antique studio at the American Academy of the Fine Arts, they arose in protest. Bristling under Colonel Trumbull's authoritarian control of resources and curriculum, disgruntled students broke

A wood engraving from a sketch by W. S. L. Jewett, published in *Harper's Weekly*, illustrates a crowded reception at the National Academy of Design annual exhibition in New York, May 1868.

away to organize their own school which became in the following year the National Academy of Design. Under the leadership of the "American Leonardo," Samuel F. B. Morse, the NAD followed the model set by European academies by also dedicating a venue for the public exhibition of work by the nation's artists. Trumbull's academy was replaced by the artist-run NAD. Reigning supreme in New York for half a century, uneven and indifferent management has been blamed for leading the NAD throughout its long history from one financial crisis to another. On several occasions the academy school was forced to cancel classes for lengthy periods of time. In the spring of 1875, the school announced that it would close until December, effectively canceling classes until the beginning of the following year. Students at the NAD were barred from using the NAD library. They complained of unfair treatment and sought parity with students in Munich and Paris, who had access to academy libraries that in some cases allowed books to circulate. Learning that classes in which they were enrolled would not meet as scheduled provoked students at the NAD to organize a cooperative art school with advice and guidance from their professor, Lemuel Wilmarth. Academy member and prolific diarist Jervis McEntee noted these developments with contempt. The feeling was mutual.

Meeting in Wilmarth's studio on June 2, 1875, the assembled students and artists drew up a document detailing its mission to attain "higher development in Art studies; the encouragement of a spirit of unselfishness among its members; the imparting of valuable information pertaining to Art as acquired by any of the members . . . the accumulation of works and books of Art . . . mutual help in study, and sympathy and practical assistance . . . in time of sickness and trouble . . . form and sustain classes for the study of the nude and draped model, of composition, perspective, etc." Conditions for membership required "Ladies and Gentlemen who intend making Art a profession" to be elected. The Art Students League's school first roosted in a walkup "cockloft" located at the corner of Sixteenth Street and Fifth Avenue, in a building occupied by piano rooms and other businesses (the current main campus building on West 57th Street dates from 1892). The Art Students League shared its cramped top floor quarters with a photographer named Jeremiah Gurney. The League was founded at a moment when increased demand for art instruction coincided with a flurry of cultural activity. New American museums and art schools were being organized, many in concert with one another. The Boston Museum of Fine Arts and its school were founded in 1870. The Metropolitan Museum of Art was founded in 1870 and opened its doors in 1872; it was followed by the Philadelphia Museum of Art in 1876; the Art Institute of Chicago in 1879; the Corcoran Museum in Washington, D.C. in 1890; and Pittsburgh's Carnegie Museum in 1896. In some way all are indebted to the model for partnering museums and schools as envisioned by C. W. Peale in the late eighteenth century.

Within twelve months of the League's founding, the Centennial Exposition opened in Philadelphia. George Custer was killed in battle along the Bozeman Trail in Montana. In 1876, New York City had thirteen separate life-drawing venues:

schools and clubs running sessions with live models. Artists and students flocked to the League. Lemuel Wilmarth returned to his post at the NAD in 1877, and Munich-trained Walter Shirlaw took over his classes. League president Frank Waller and other instructors who had trained in Paris differed with artists like Indiana native William Merritt Chase, who had trained in Munich. Chase began teaching at the League in 1879. Kenyon Cox, Thomas Eakins, and John Sartain, who had trained at the methodical and dogmatic Académie Julien in Paris, clashed with Munich Academy alumni Chase, Shirlaw, and John Henry Twachtman, who favored a more spontaneous, direct approach to painting and drawing. Lively debate promoted a tolerant environment that welcomed diverse instructional philosophies. In time, French methods prevailed, but without displacing a pedagogical pluralism that shapes the League today. Relaxing admission requirements by 1903 led to an open-door policy promoting a unique inclusive environment for teaching and learning. The tumult of Modernism and the influx of European refugees and artists during the 1930s and '40s had a significant impact on the League. In the postwar heyday of Abstract painting, the League embraced change—but life drawing and anatomy remained the bedrock of its studio instruction. Second- and third-generation instructors like George Bridgman, John Sloan, Stuart Davis, Frank DuMond, Leon Kroll, Reginald Marsh, Thomas Hart Benton, and Robert Beverly Hale embodied this tradition. *Their* former students include Frank Mason, Harvey Dinnerstein, and Will Barnet, who trained subsequent generations to teach in ways that revere the past, value modernity, and look to the future.

Theory

More ink has been spilled defining Classicism than perhaps any other artistic genre. Developed by ancient sculptors Phidias, Myron, and Polycleitus; painters Parrhasius, Xeuxis, and Apelles; along with architects and decorative artists, Classical formalism arose in the Hellenic world as much more than a style, and nothing less than the visual expression of natural order via systems of proportion and canons of beauty. The best surviving ruins are located in places like Siracusa, Taormina, and Paestum, former outposts of *Magna Graecia* (Greater Greece) that fell with the rest of the Mediterranean under Roman rule. Rome appropriated the visual codes of Hellenistic Classicism, adapting them to a kind of Italic naturalism in portraiture and decorating monumental buildings. Classical antiquity achieved advances in science, mathematics, and rational thought that were expressed by the painting, sculpture, and architecture of the time as beauty revealed by order. A popular and wrongheaded take on Classical principles is that they are either static formulas regulating how one should depict the body, decorate a vase, and build a temple; or a recipe book of proportions based on counting heads or comparing the length of a nose to the big toe in ways that cool passion, impede inspiration, and stifle personal expression. Classical principles propose

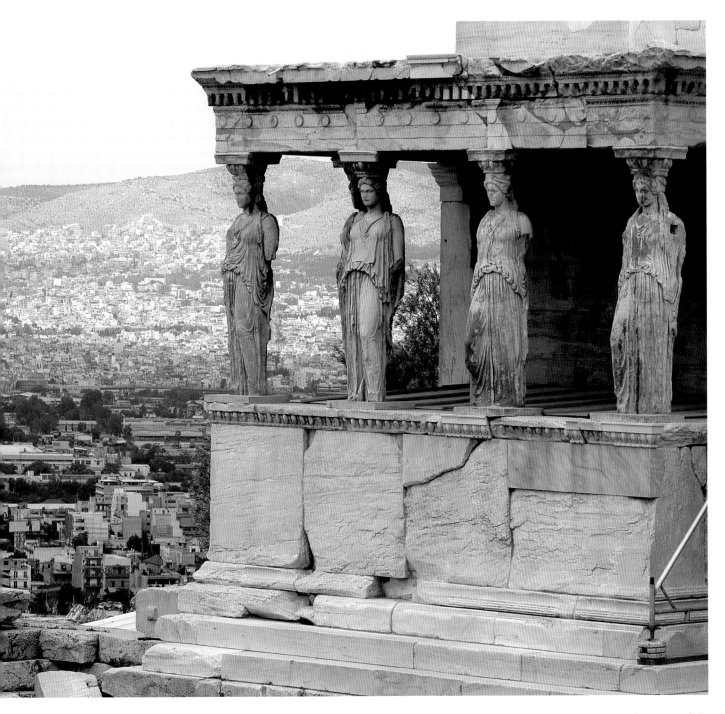

The Porch of the Caryatids—or Maidens—gracefully adorns the Erechtheum temple (ca. 421–405 BCE), located atop the Acropolis, a rocky promontory rising above Athens. Together with the Parthenon and other public buildings on the summit, it marks the birthplace of ancient Classicism.

a visual language that intersects with similar languages of poetic form, history, music, drama and dance, science, mathematics, and the art of war, measuring how the world is expressed as a balance between nature and ideas. How these ideas entered into art education and developed into a living tradition informing the way drawing is taught at the Art Students League of New York today requires a brief overview of historic teaching methods.

Lesson Plans

Most art instructors in New York during the first decades of the nineteenth century were forced to rely on engravings and the occasional painted copy to provide their students with worthy images suitable for study. Almost everything a student learned about the history of art came from reading, book engravings, and loose sheet engravings. Painted copies and plaster casts filled in the gaps. As homegrown artists became more skillful, productive, and successful, the supply of originals increased. No museums existed as we know them today. Private collections were closed to the public, and the art student who could study Old Master paintings usually possessed lofty social connections. The Robertsons' teaching was based not solely on observation, but on idealized templates of form and beauty. The role of art was not to record what the eye beheld, but to improve it. Various systems of points, lines, and triangles were used in mapping objects across the page. One such method involved locating two points most distant from one another within the pose—such as the top of the model's head and the bottom of the foot, and then plotting other angles between subsequent parts of the body—elbows, shoulders, knees, and so forth—until an armature of triangles had been constructed, upon which contours delineating the shape of the body could be accurately drawn. Formulas were taught showing how to draw a foot or hand from any angle so that even in observational drawing the hand was directed by these frameworks as much as by actual visual data; laws of proportion were memorized and practiced by students copying lessons that the teacher had prepared for them, or from other plates created for their use.

John Gadsby Chapman outlines similar methods in his *American Drawing-Book*, published in 1847. His chapter on drawing the human figure follows others in describing how one should draw the head, hands, and feet—features tackled reluctantly by beginners today. Chapman's logical progression of exercises prepares the student for drawing the whole figure by having them first master its parts.

Chapman's title page promises that "Anyone who can learn to write can learn to draw." At this level, drawing and handwriting were approached and understood in the same way—a language of points, lines, shapes, and patterns that could be organized to describe anything in graphic terms. Rembrandt Peale used many of the same methods in creating the first high school drawing curriculum at Philadelphia Central High School in 1834. Heads, hands, feet, and figures could be constructed quickly and

60. Many have been deterred from learning to draw, by the formidable array of studies that have been unnecessarily placed before them; these should never be in advance, but always, as far as possible, progressive with a certain degree of capacity both of eye and hand. The judgment and power of execution being thus matured together, their growth is healthful and gives certain assurance of success. Let the pupil, therefore, try his hand in drawing the above profiles or any others more suited to his taste, to which he may have access. Let him practically apply the principles laid down, and if he does not succeed in producing a fair copy, he may rely upon it he has gone too fast, and before proceeding farther should retrace the ground he has passed over. A more finished example in drawing the profile, and on a larger scale, may be now attempted.

A page from John Gadsby Chapman's 1847 *American Drawing-Book* assures readers that "Many have been deterred from learning to draw, by the formidable array of studies that have been unnecessarily placed before them." The title page of the popular book proclaims that "Anyone who can learn to write can learn to draw."

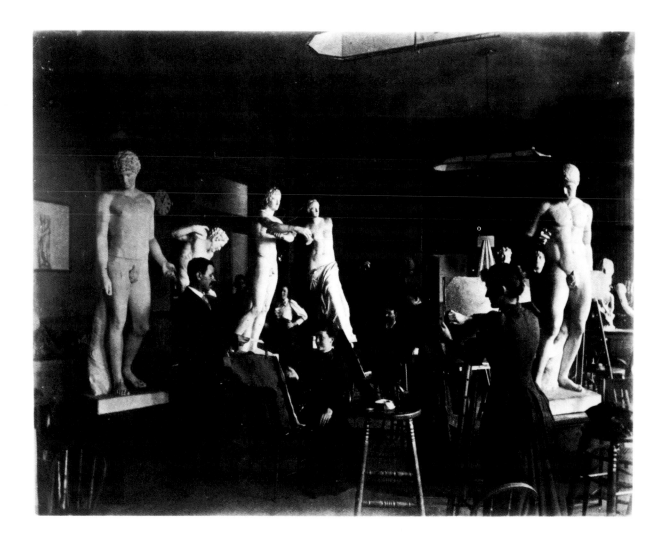

Female students
drawing cast-plaster
reproductions of
Classical statuary
in Frank DuMond's
"antique" class at the Art
Students League of New
York, ca. 1892–93. At this
time, some European
art academies were still
closed to women, while
artistic training had been
available to ladies in New
York City for more than a
century.

simply by dividing equilateral triangles in various different ways. Specificity apart from the ideal pattern required a lot of measuring. Students who mastered the rudiments of drawing might be allowed to copy Old Master compositions from engravings—a process from which most students gained an understanding of pictorial composition. Most courses in drawing were progressive. Simple problems were followed by more complex exercises, expecting that each student would improve sufficiently by mastering one step to achieve the one following.

Copying engravings might be succeeded by the greater challenge of drawing antique casts, which, as replicas of great works of art, put students in the presence of genius. Drawing the casts is not merely a way of perfecting one's powers of scrutiny or skill at manipulating charcoal and stump on paper. Meditating on the spirit of the piece—its genius—and finding it in one's drawing is how Classical drawing becomes expressive.

When a student had progressed sufficiently in the rudiments of copying and cast drawing, the instructor might allow a student to join a life class. Rules were strict and space was limited. Newcomers had to fit in where they could find a space.

Life classes were not organized at the NAD school on a regular basis until 1837, and several times during the years to follow they were suspended due to short funds. Male models were the norm, not so much out of propriety but because the Classical canon deemed the male nude superior in beauty to the female. As in Europe, only men were admitted into the life studio. Women were first admitted to the Academy in 1831, but were not allowed into the life classes until 1893—one year after the Chicago Columbian Exposition. The appearance of women in art schools coincides roughly with that of female models in life classes. Male models answered public advertisements, whereas hiring female models required more discretion.

In *Academy: The Academic Tradition in American Art* (1975), Lois Marie Fink cites an 1849 letter from artist Thomas le Clair to Asher B. Durand describing one of his models as a woman "of the loose order . . . but I judge from the condition in which I find her figure that she trained herself specially [*sic*] for this purpose."

Fink quotes Durand as saying that women in the academy school "doubtless eventuate no small advantage to the cause of Art. For if the potent influences of mothers has directed the impulse of the statesman and the Hero, what may not result in its exercise in our more genial cause." While Durand clearly did not regard women as future professionals, the four women who entered the NAD school that year were professionals, just two years before the Seneca Falls Convention launched the Women's Movement in America. Durand may have had one thing in mind, but the ladies had plans of their own. Regardless, life classes were segregated by gender for many years to come, and in the European academies women were excluded until the twentieth century.

Courtesies and customs that endure to this day include setting models in poses and marking their position, timing the duration of poses and breaks, providing models with comfort and privacy, and enforcing rules governing who may enter and leave the life studio when models are posing. Breaking the final pose, models at most studios still receive a round of applause.

Drawing instructors in traditional atelier environments followed their own curriculum—as they do today at the League. Most of the historic student drawings that survive are drawings of plaster casts and so-called *Académie* drawings—sustained works produced during long poses. The object of these drawings was to locate the figure on the page with precision, and then to describe it in detail. Novices would be undone by focusing on minutiae, while advanced students who had absorbed their progressive lessons could gather their observations into a cohesive synthesis of line and tonality expressing volume, the effect of light and shadow, and movement. Looking at these drawings today after more than sixty years of expressive mark-making, we might easily mistake them for finished products. Done on cheap student-grade paper and newsprint, they were exercises, not masterpieces. Instructors with conflicting methodologies favoring either the point or the stump found common ground in these tasks, a way to measure improvement and assay achievement.

Like the Renaissance, the nineteenth century was a moment when art and

science intersected. An 1859 article published in John Durand's periodical *The Crayon* admonished landscape painters to familiarize themselves with geology in the same way that figure painters were expected to know anatomy. Painters and engravers accompanied scientific and survey expeditions to the far West, Polar zones, and the South Seas. Ignited by the writings of Alexander von Humboldt, Hudson River School painter Frederic Edwin Church embarked on multiple painting expeditions to the Andes, Jamaica, the Middle East, and the Arctic Circle. The Drawing Academy at West Point flourished under the leadership of Professor Robert W. Weir, a member of the National Academy of Design. The 1883 property list compiled after Weir's retirement in 1876 reveals a wealth of instructional materials accumulated over forty years of Weir's teaching. Paintings, prints, books, and plaster casts comprise precisely what one might expect to find in any well-supplied art school. Robert Weir's son John Ferguson Weir was appointed the director of the new Yale School of Art in 1869 and remained in the position for more than forty years. His brother Julian Alden Weir taught at the Art Students League.

Post-Enlightenment art education encouraged the study of anatomy not only through the study of books, prints, and ecorché statues but also by performing dissections. Cadavers had been peeled and mined in the name of science as early as the fourteenth century. Leonardo, Michelangelo, and other Renaissance masters dismantled corpses to unravel the mysteries of human bioengineering. Later books on anatomy and proportion by Andreas Vesalius, Albrecht Dürer, and Palma Giovane spared artists a trip to the morgue, but by the late eighteenth century advances in science had led to medical teaching practices that made it possible for artists to study the body in similar ways. In 1803, Napoleon reopened French academies closed during the Revolution. New statutes mandated anatomy classes equipped with the "best anatomical statues, various large tables, mainly osteological and myological, some ancient statues and many fragments formed on the natural flayed body." The professor in charge was also responsible for yearly finding a dozen fresh "well shaped cadavers so they can be profitably drawn by the students." Napoleon's military adventures provided a fresh supply of corpses. Pennsylvania Academy instructor Thomas Eakins kept cadavers on site for his anatomy lessons, making casts of some to preserve his dissections. Performing meticulous investigations of perspective, Eakins measured space like a topographer.

Gilded Age patrons bored with the seriousness of Classical art and the kind of American realism that blended art with science cast their support behind the Bohemian aestheticism espoused by Whistler, Chase, Louis Comfort Tiffany, John La Farge, and Augustus Saint-Gaudens. Oriental exoticism, Impressionism, the Arts and Crafts Movement, Art Nouveau, the Vienna Secession, and ultimately the Bauhaus redefined fine art in a way that elevated the applied arts and created an instructional matrix that was adopted after 1945 by accredited art schools in the United States and many others around the world. Preceding these changes, the Classical drawing lessons detailed in this book represent a tradition of instruction that lives on in the teaching and creative

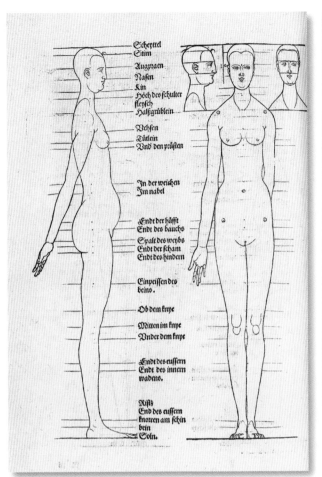

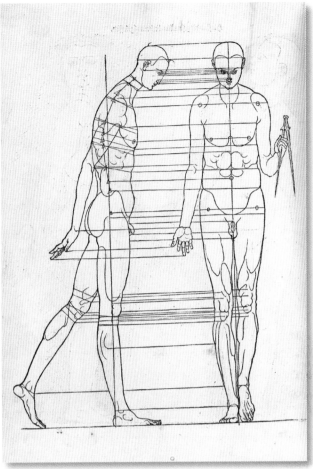

work of those instructors working at the Art Students League of New York who have contributed to this book.

These artists represent a living tradition and a culture of instruction that has developed at the Art Students League of New York since it began—professional artists teaching their own methods and philosophy in an atelier setting to whoever wants to learn. The only admissions requirement is that students are willing to be taught and possess the nerve to pick up a pencil, a brush, or a handful of clay and try to shape it into something. All of the instructors featured in this book approach their teaching in different ways. This book is about what they share with one another and with their students.

—James Lancel McElhinney

Diagrams by Albrecht Dürer illustrating the canonical measurements and proportions used to draw the human figure, from his *Vier Bücher von menschlicher Proportion* (Four Books on Human Proportion), 1528.

The American Fine
Arts Society Building
(architects Hardenbergh,
Hunting, and Jacobsen),
located at 215 West 57th
Street in New York City,
seen here ca. 1940, has
been the home of the
Art Students League of
New York since 1892. It is
now designated a historic
landmark.

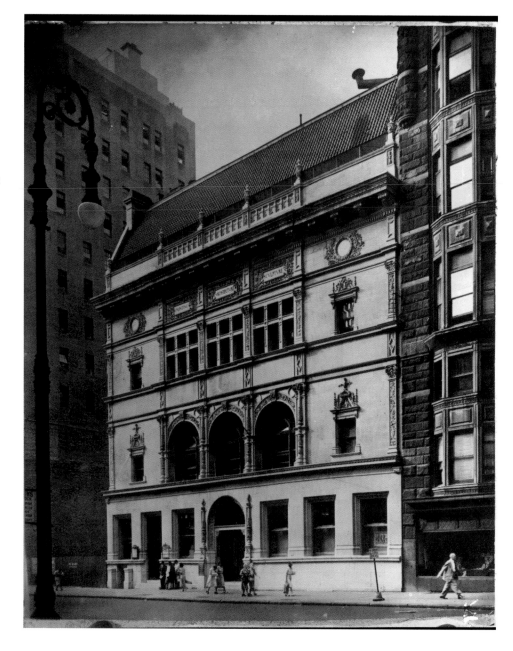

Contributors

Sherry Camhy's large-scale drawings owe a debt to Classicism in the formal presentation of carefully rendered nudes in austere environments. Her painstaking depictions of the human body defy notions of ideal beauty in ways that speak to contemporary issues of gender and identity. The intense corporal specificity of her drawings challenges fashion-plate paradigms of beauty. Portraying wrinkles, tummy rolls, and body hair might be mistaken for impartiality if Camhy did not regard these blemishes as marks of beauty.

Harvey Dinnerstein is an influential painter whose long and distinguished career has included an enduring association with the League. His nudes, portraits, and ambitious narratives of urban life steadfastly resisted Modernist trends for most of Dinnerstein's career. Standing by a figurative aesthetic for many years has inspired several generations of young painters to follow his example.

Ellen Eagle works primarily in pastel, which, strictly speaking, is a painting medium. Drawing is not a technique but a language that informs visual creativity in a wide range of media and modalities. Eagle's closely observed essays on light and form are firmly rooted in Classical drawing, from which her skills are derived. Her subjects are more human than ideal. Shifting her paradigm of beauty with an adoring gaze, Eagle improves her sitters while Camhy regards them with an unflinching eye.

A League instructor for many years, **Jack Faragasso** comes from a slightly different trajectory—studying with Frank O'Reilly and then working as an illustrator, Faragasso identifies himself with a lineage of teaching that he traces back to the founding of the French Academy in 1648. Many of Faragasso's drawings celebrate a popular ideal of feminine beauty. His pursuit of an ideal links him to academic drawing.

Leonid Gervits began his training in Odessa and later studied at the Repin Institute in Leningrad (present-day St. Petersburg), where he followed the compulsory regime of strict academic training. The city gave him access to important public collections where he could study masterworks by Rubens, Rembrandt, and others in person. Soviet art academies made it difficult for artists who sought outlets for free expression, but gave students a firm grounding in basic skills—benefits evidenced in the work of the new Leipzig painters like Neo Rauch, and others engaged in contemporary issues and personal expression via traditional methods. Gervits's rigorous Classical training is evident in his masterful drawings. Drawing in dark and light chalks on colored papers became popular in the early Renaissance as a rehearsal for underpainting by German and Northern Italian painters.

Dan Gheno's studies of nudes are more closely related to Venetian and Baroque drawing in painterly ambition than to nineteenth-century Academic artists like Jean-Léon Gérôme or William-Adolphe Bouguereau. His paintings are similarly physical in blending line with brushwork. They may not seem Classical in style, but they are

nevertheless informed by a profound awareness of academic training and his mastery of life drawing skills.

Michael Grimaldi is among a group of younger painters favoring a return to atelier instruction. Embracing modes of representational drawing and painting long associated with the Pennsylvania Academy of the Fine Arts, his reclining nudes reveal a Classical desire to locate beauty within the elements of form. Fluid volumes and elegant contours trace transitions of light and volume from hip to leg, suggesting a landscape. Reminiscent of Edwin Dickinson, Grimaldi's manipulation of light and shadow is expressive and descriptive—a quality that links him with other Philadelphia painters such as Nelson Shanks, Sidney Goodman, Wade Schuman, and the late Ben Kamihira.

Gregg Kreutz studied with David Leffel at the Art Students League, where he has taught for twenty-five years. His portrait drawings and nudes are carefully observed investigations of light, shadow, and movement.

Like Gervits, **Leonid Lerman** studied first in Odessa. Subsequent training and museum visits in Leningrad launched Lerman on an entirely different trajectory. His early work reveals a mastery of skills and methods one might expect from academic training. The more recent drawings are inventive, humorous, and personal. In one, a beanbag *putto* hovers above a landscape reminiscent of Claude Lorrain like a Macy's Thanksgiving Day parade balloon of eroded antique statuary, or the marshmallow monster from *Ghostbusters*. Alluding to tradition without imitating it, Lerman is developing his own eccentric brand of Classicism.

Frank Mason's powerful, almost improvisational sketches are filled with Baroque energy and a kind of fresh, raw enthusiasm for historic drawing methods. The venerable Mason, who has taught at the League for well over half a century, embodies its living tradition. Some among the legion of his former students proudly refer to themselves as "Masonites." Mason's drawings and those of his students were made by people who find as much delight in looking at drawings as in making them.

James Lancel McElhinney started teaching at the League in 2005. He studied at Tyler with John Moore and Richard Callner, and at Yale with Bernard Chaet, William Bailey, and Philip Grausman. Stressing composition and drawing from observation in his teaching, McElhinney favors a linear approach to drawing, constructing volumes from the inside out built on geometric structures embedded within the form.

Frank Porcu now bears the torch that was carried for many years by Robert Beverly Hale and afterwards by the late Deane Keller. Notable for giant demo drawings and his inventive use of hoagie submarine sandwiches and other unlikely props to illustrate anatomical structures, Porcu's anatomy lectures play to sellout crowds. His own drawings possess a geometric insistence, firmly rooted in his knowledge of human anatomy.

Eminent portraitist and figure painter **Nelson Shanks** has worked with many notable sitters, from H.R.H. Queen Elizabeth II to Bill Clinton and the late Luciano

Pavarotti. Academically trained in Italy, Shanks also studied at the Art Students League of New York, the National Academy School of Fine Arts, and the Kansas City Art Institute, where he studied with Wilbur Niewald. Shanks frequently draws directly on the canvas with a brush—without making preliminary drawings in pencil, chalk, or charcoal—using methods that connect him to Chase and the Munich faction in the League's early days.

Sharon Sprung dropped out of Cornell University and returned to New York to continue her training at the Art Students League. Her work blends aspects of the Classical tradition with a photographic precision that informs her paintings of women. Set against open fields of color, Sprung's stark nudes relate to imagery found in Roman wall paintings and early Northern and Italian Renaissance painters like Masaccio, Piero della Francesca, Rogier van der Weyden, and Lucas Cranach the Elder. Like Shanks, she seldom makes preparatory drawings. Her drawings reproduced in this book reveal a sense of elegance and restraint also found in her paintings.

Costa Vavagiakis studied at Queens College and at the National Academy. Close observation of nude male and female models guides his drawings. Employing classic academic methods similar to those followed by Camhy, Eagle, and Sprung, Costa places each of his subjects in austere settings, lighting them from one side, and works on a somewhat less monumental and confrontational scale than Camhy. His subdued palette bows to form, whereas Sprung uses color to isolate shape and intensify a sense of abstraction. Vavagiakis insists on a high finish in his drawings while unflinchingly noting the minutest details of form and flesh.

Gallery of Classical Drawings from the Collection of the Art Students League of New York

Detail, Anonymous,
Antique drawing, 1892,
charcoal and graphite on
paper, 24½ x 18 inches.

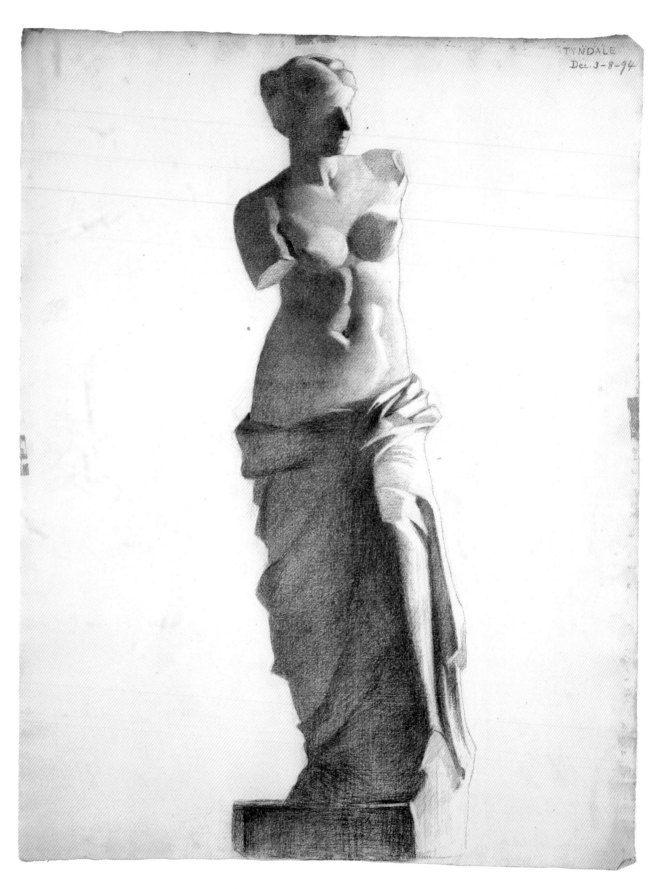

TYNDALE
Dec. 3-8-94

Mary Tynedale, Antique drawing, 1894, charcoal on
paper, 24½ x 19 inches. Student of J. Carroll Beckwit

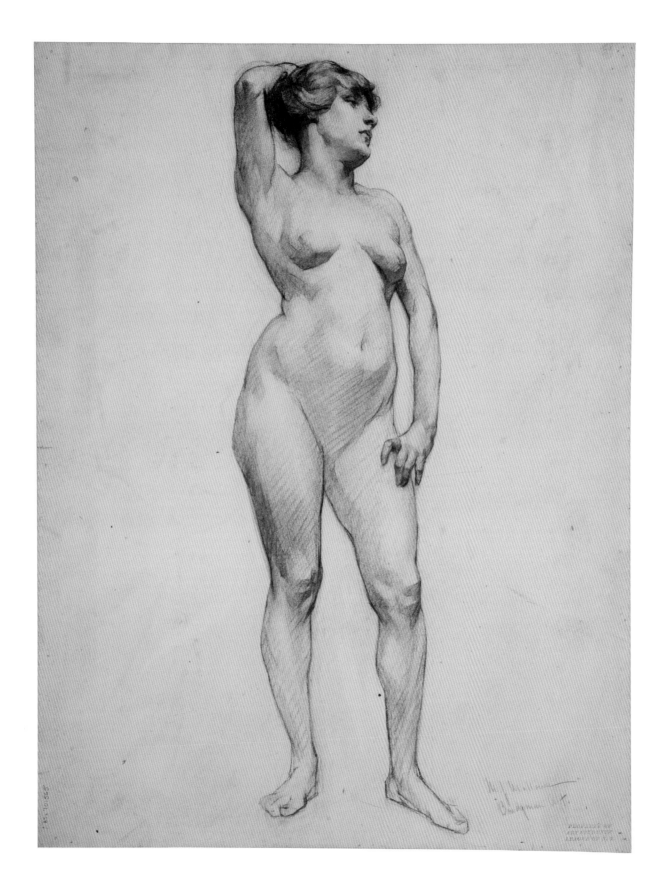

Ethel Turnbull, Academic drawing, ca. 1898,
charcoal on paper, 24½ x 18½ inches. Student of
George Bridgman.

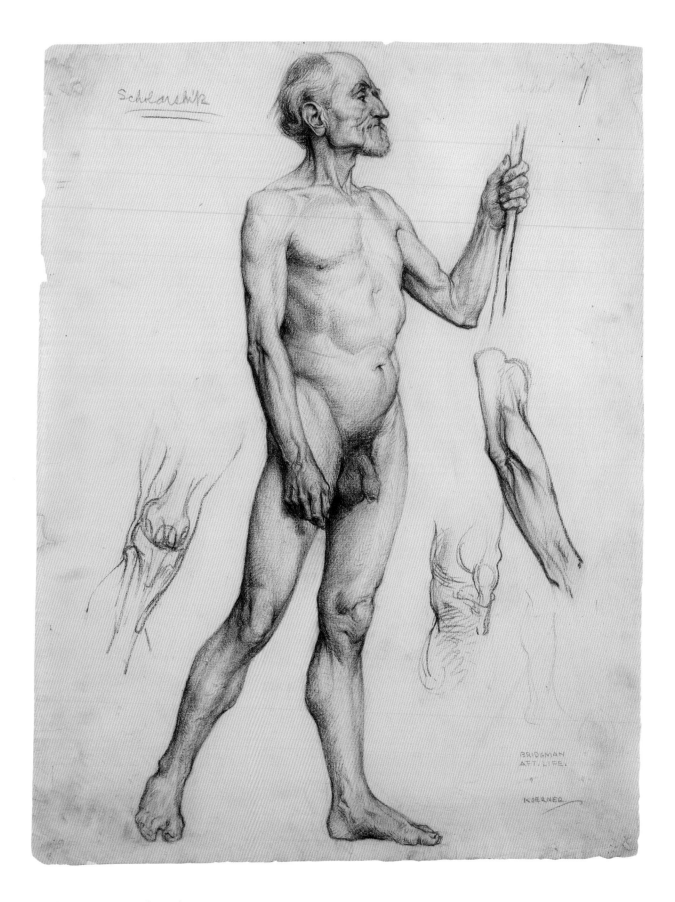

W. H. D. Koerner Jr., Academic drawing, ca. 1905–6,
charcoal on paper. Student of George Bridgman.

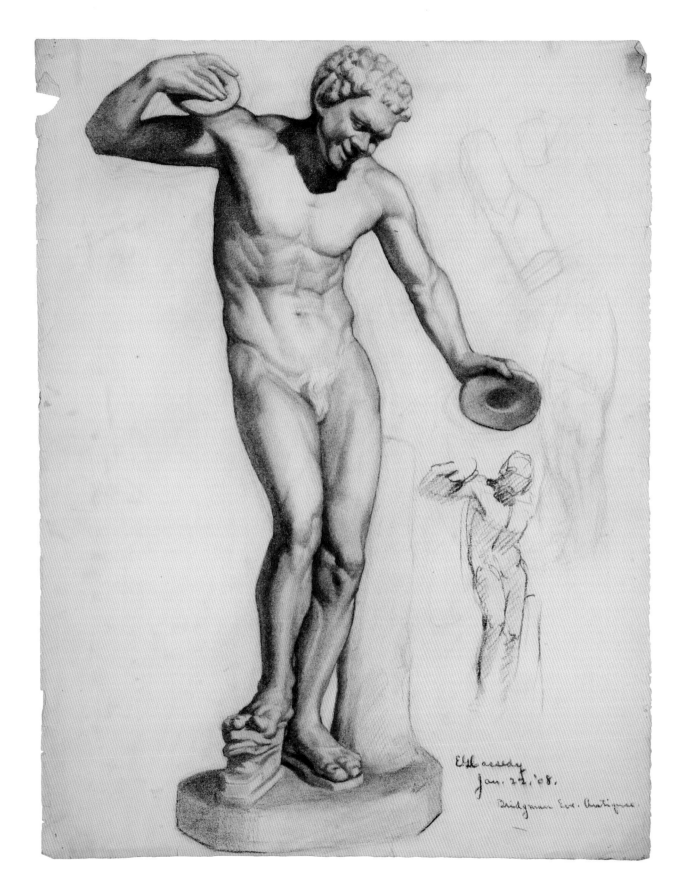

E. G. Cassidy, Antique drawing, 1908, charcoal on
paper, 24 x 19 inches. Student of George Bridgman.

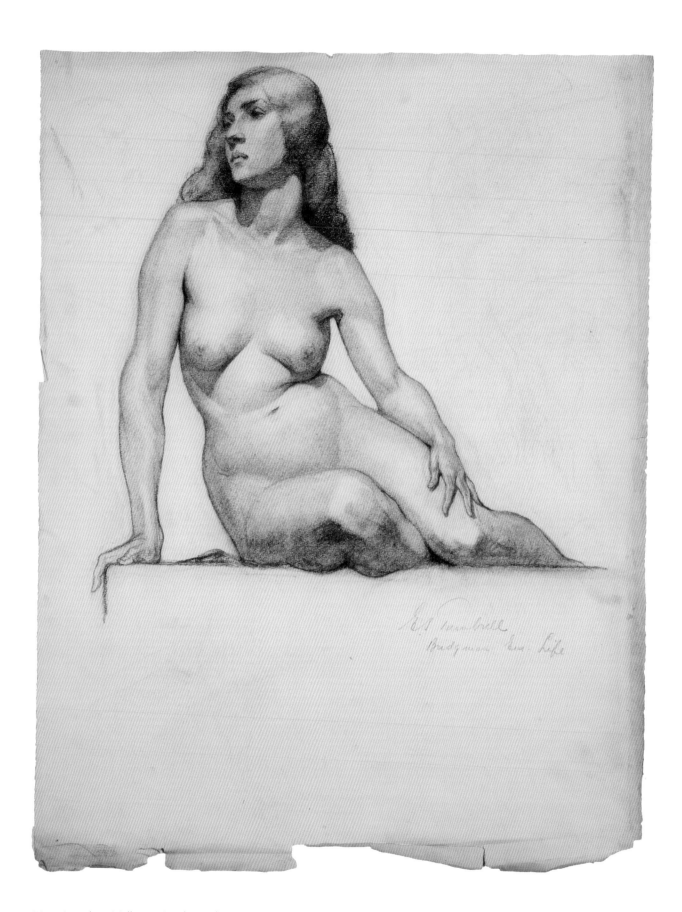

Mary Josephine Mallonee, Academic drawing,
ca. 1912, charcoal on paper, 24½ x 18½ inches.
Student of George Bridgman.

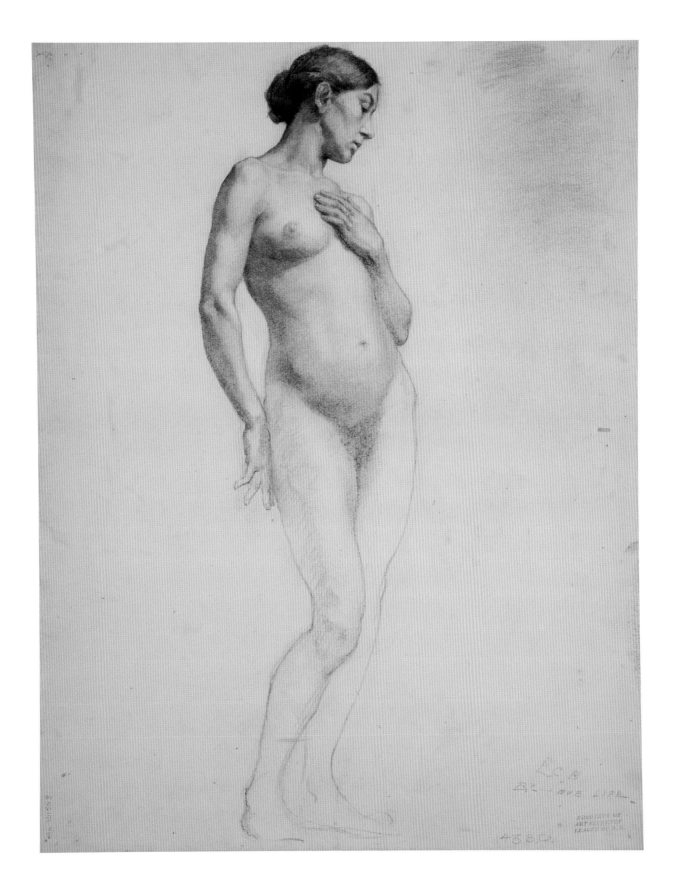

Louis C. Bange, Academic drawing, ca. 1914,
charcoal on paper, 25 x 19 inches. Student of
George Bridgman.

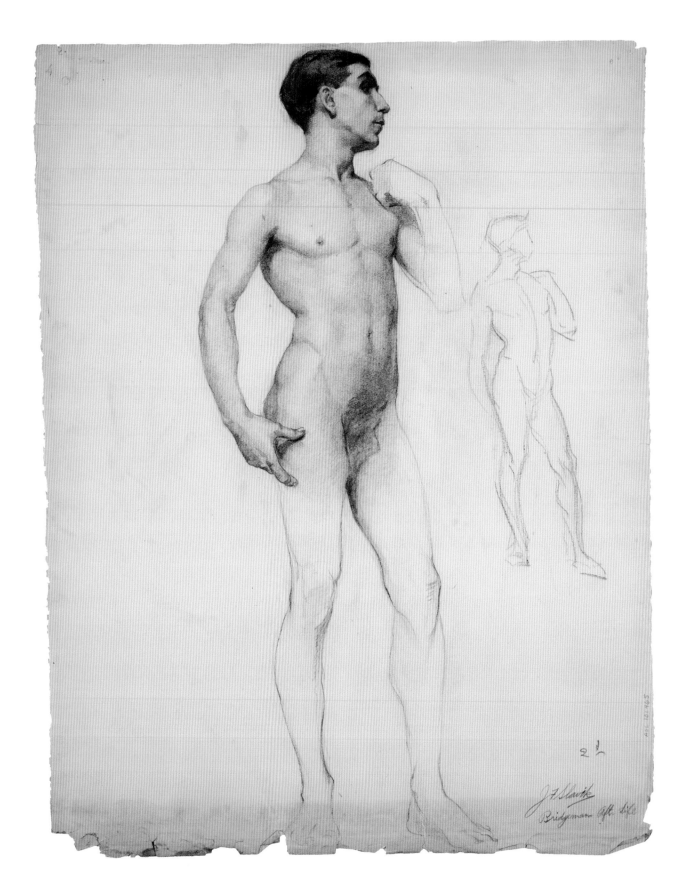

J. F. Slavik, Acadmic drawing, 1914, charcoal on paper,
25 x 18¾ inches. Student of George Bridgman.

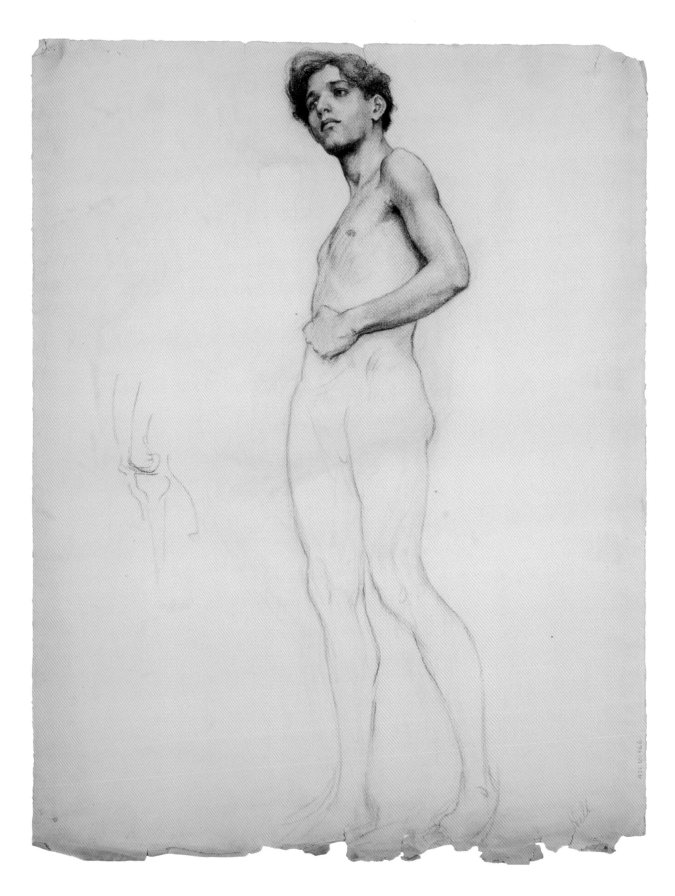

Katharine Hall, Academic drawing, 1914–15,
charcoal on paper, 24½ x 18¾ inches.
Student of George Bridgman.

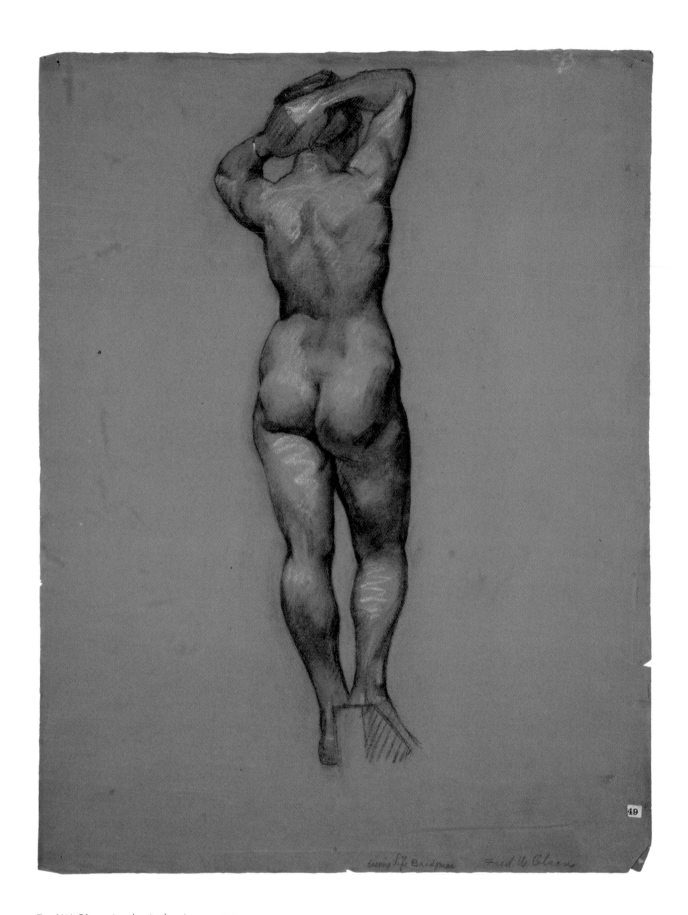

Fred W. Olson, Academic drawing, ca. 1917,
charcoal on gray paper, 25 x 18¾ inches.
Student of George Bridgman.

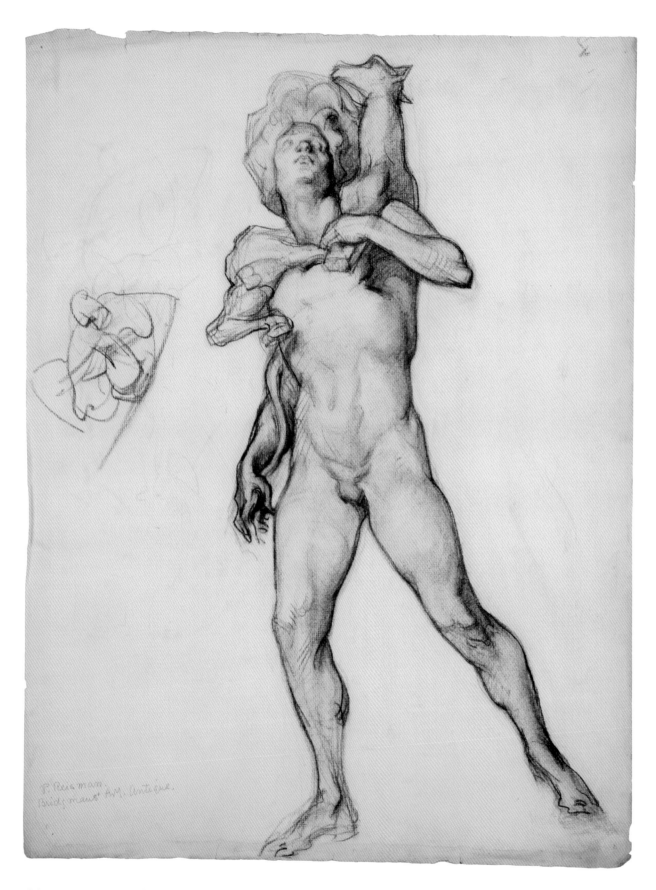

Philip Reisman, Antique drawing, 1922, charcoal on
paper, 25 x 18 inches. Student of George Bridgman.

Frances M. Vreeland,
Figure studies, 1932,
charcoal on paper,
19¾ x 8¼ inches.
Student of George
Bridgman.

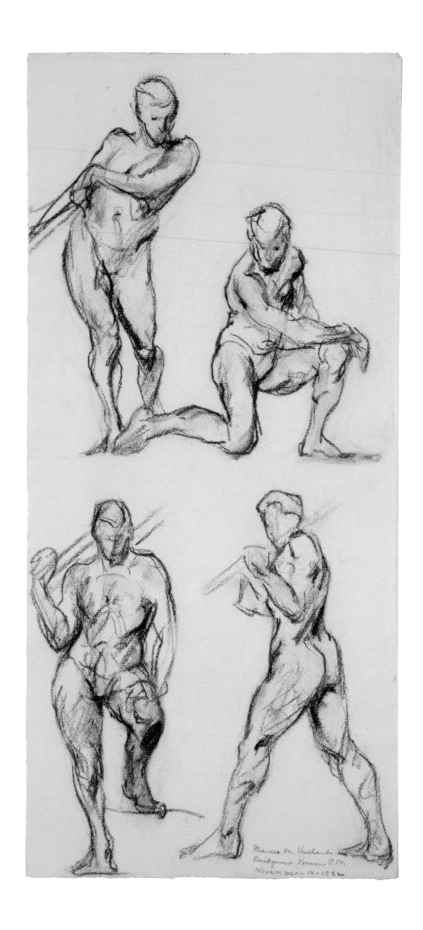

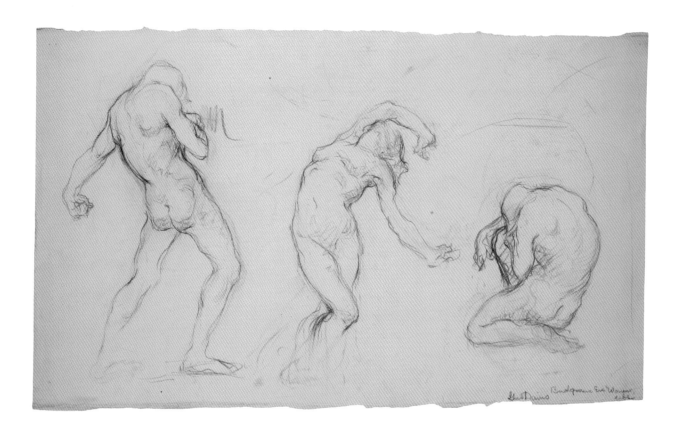

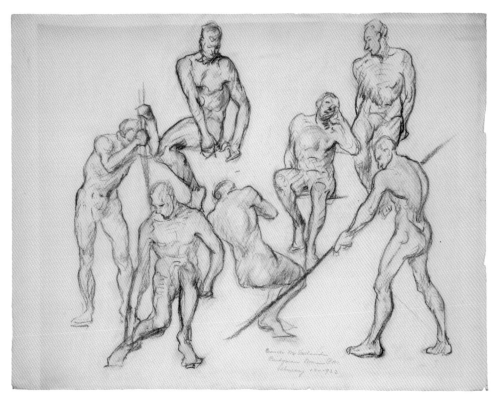

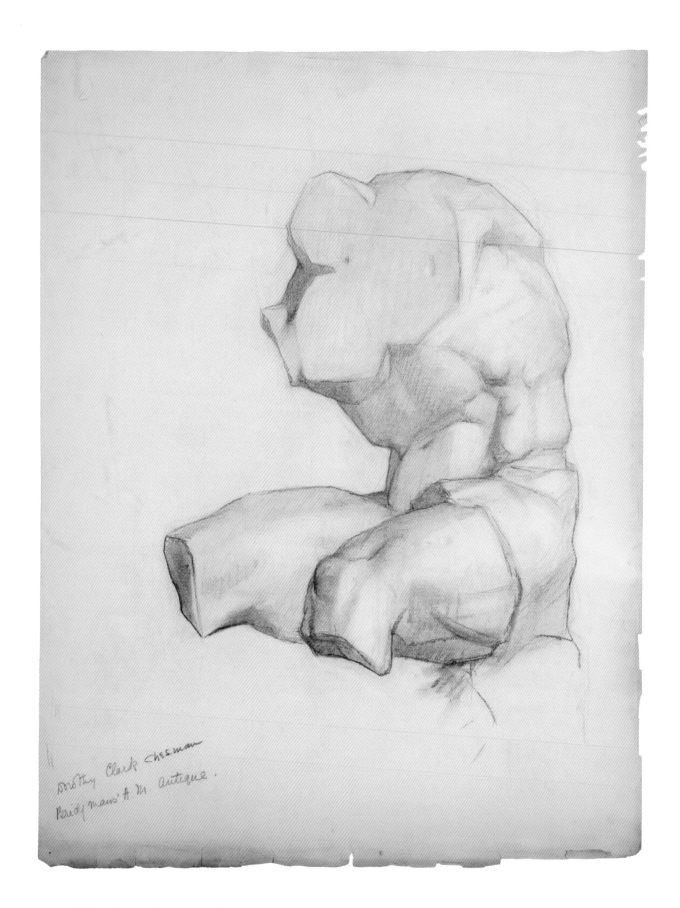

Dorothy Clark Chesman, Antique drawing, 1925,
charcoal on paper, 25 x 19 inches. Student of
George Bridgman.

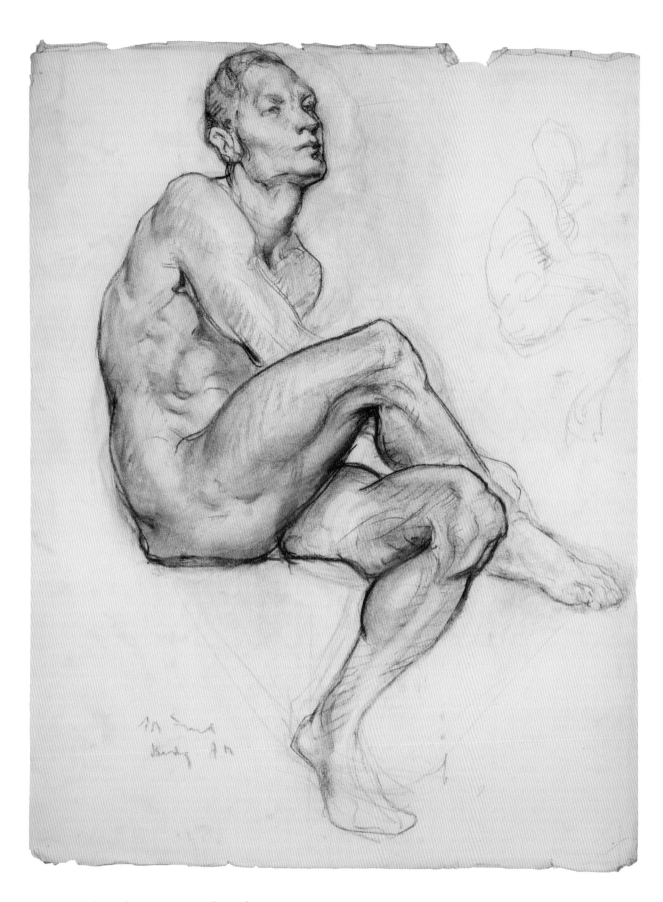

M. Frank, Academic drawing, ca. 1934, charcoal on
paper, 25 x 19 inches. Student of George Bridgman.

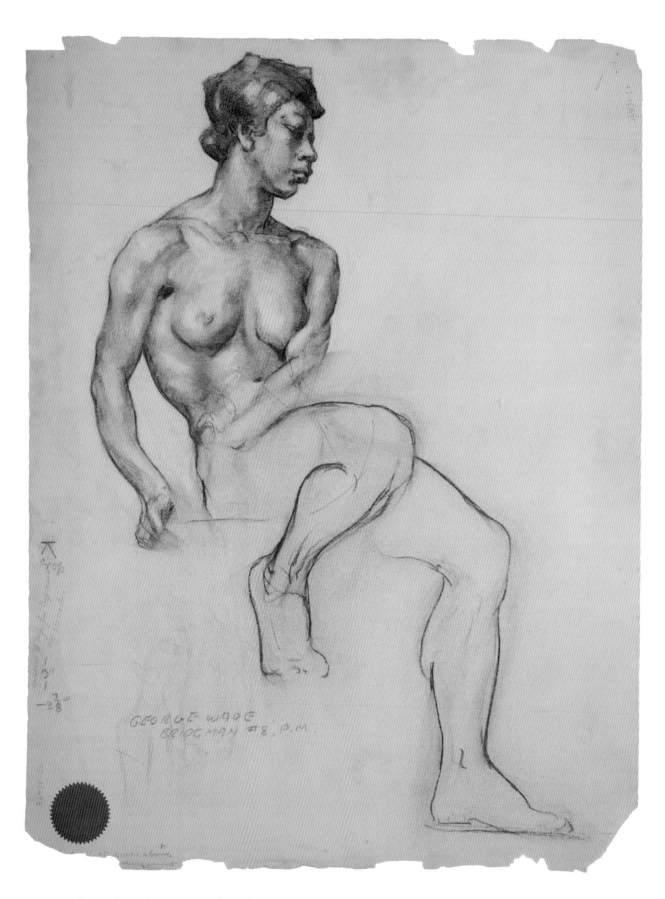

George Wade, Academic drawing, 1935, charcoal on
paper, 25 x 18¾ inches. Student of George Bridgman.

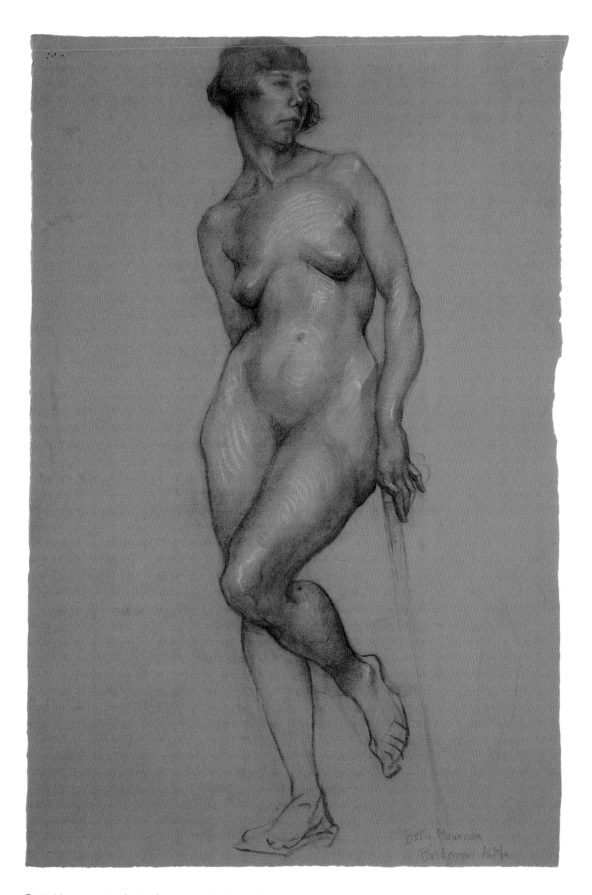

Betty Newman, Academic drawing, n.d., charcoal on gray
paper, 19 x 12½ inches. Student of George Bridgman.

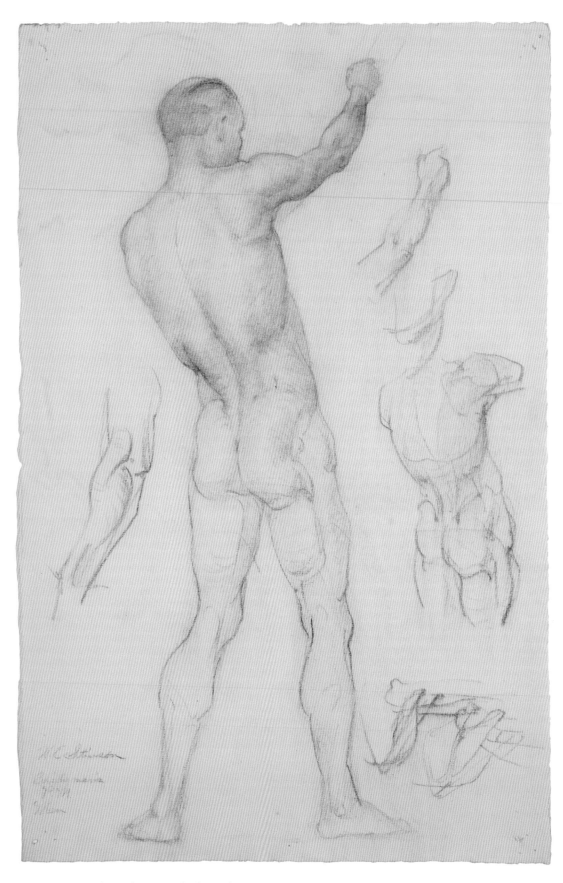

Anonymous, Academic drawing, n.d., charcoal on
paper, 19 x 12½ inches. Student of George Bridgman.

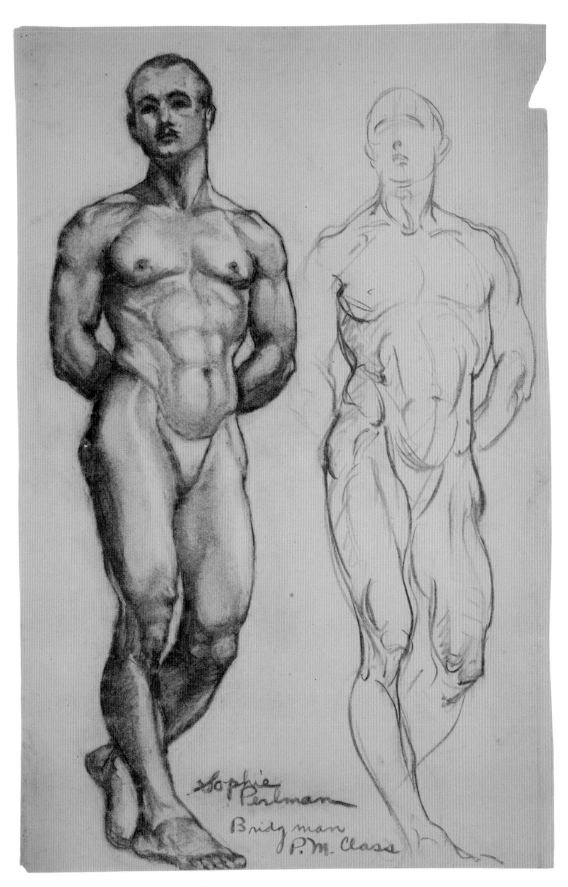

Sophie Perlman, Academic drawing, n.d., charcoal on
paper, 19 x 12 inches. Student of George Bridgman.

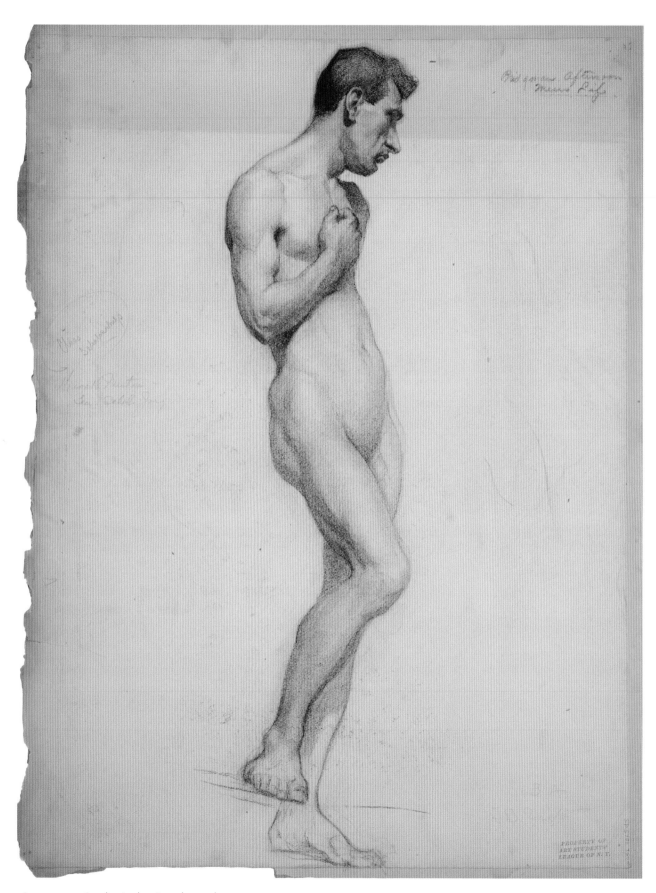

Anonymous, Academic drawing, charcoal on paper,
24½ x 18½ inches. Student of George Bridgman.

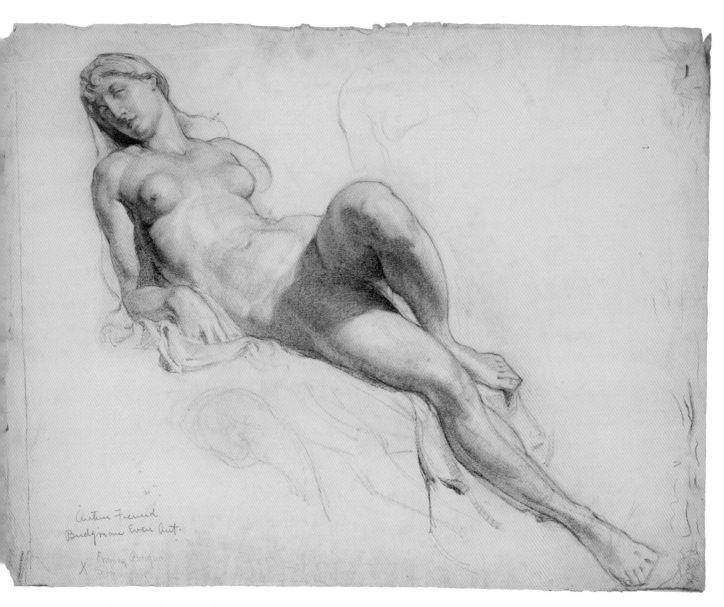

Arthur Freund, Antique drawing, charcoal on paper,
18½ x 24¾ inches. Student of George Bridgman.

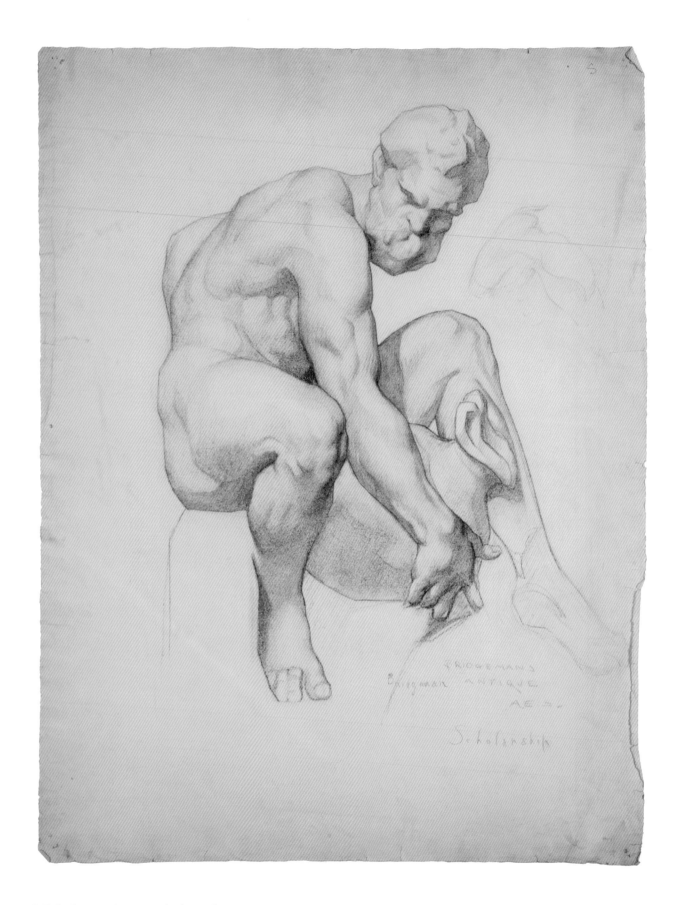

A. E. S., Antique drawing, n.d., charcoal on paper,
24½ x 18½ inches. Student of George Bridgman.

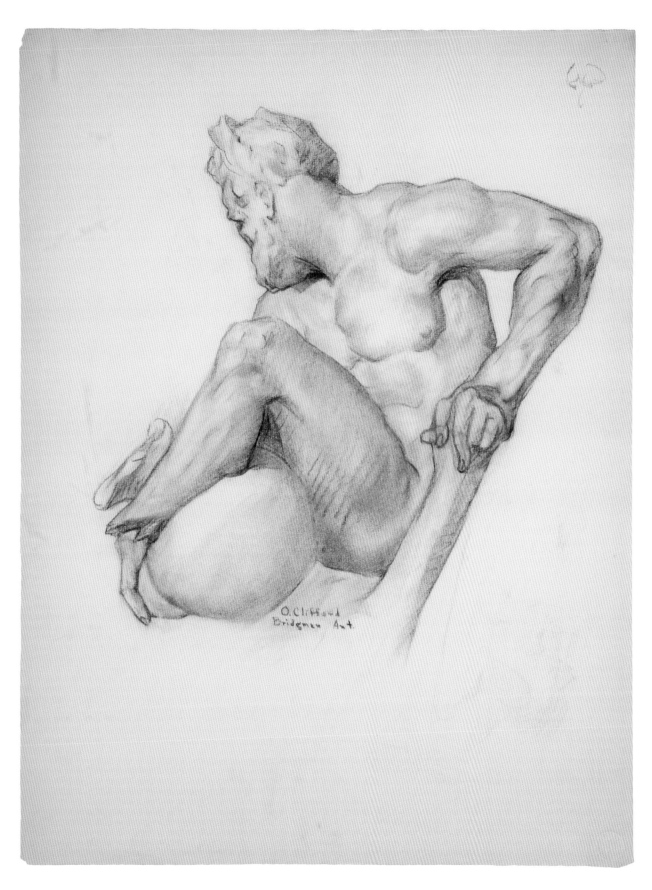

O. Clifford, Antique drawing, n.d., charcoal on
paper, 25 x 19 inches. Student of George Bridgman.

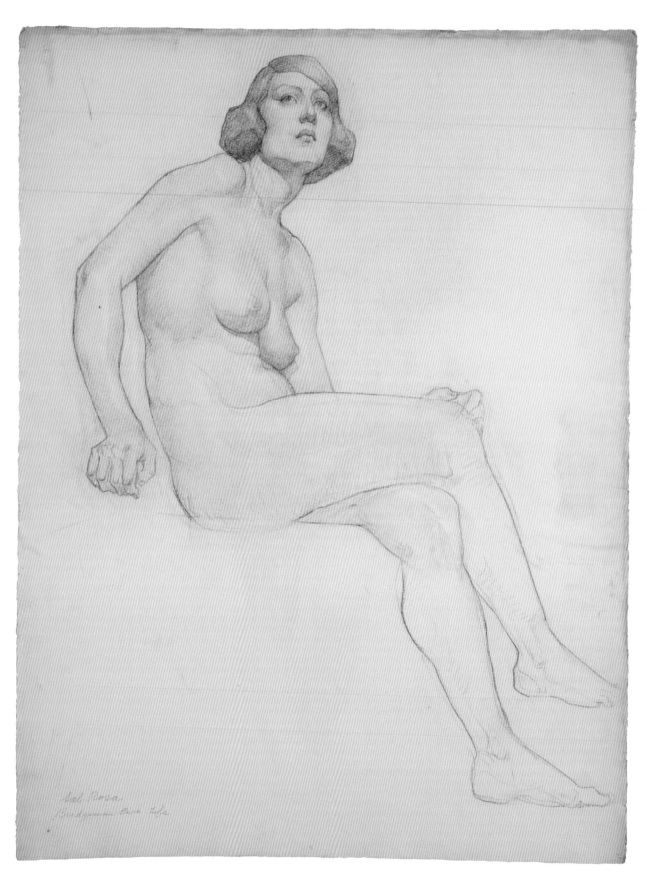

Sal Rosa, Acadmic drawing, n.d., charcoal on paper,
25 x 19 inches. Student of George Bridgman.

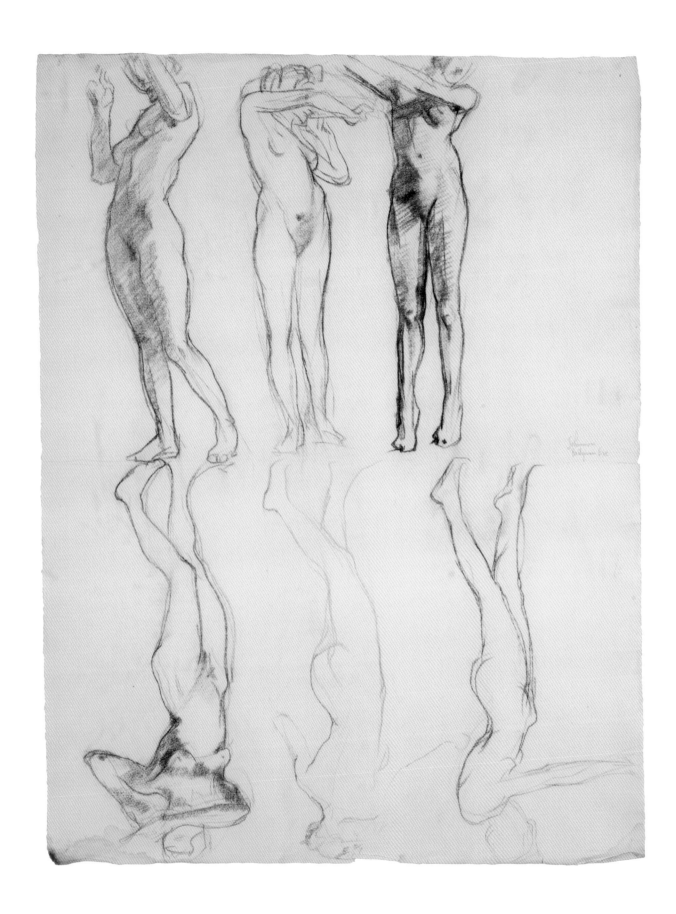

Johnson, Academic drawings, n.d., charcoal on paper,
24½ x 18½ inches. Student of George Bridgman.

Lola Scott, Academic drawings, n.d., charcoal and white chalk on gray paper, 12 x 19 inches. Student of George Bridgman.

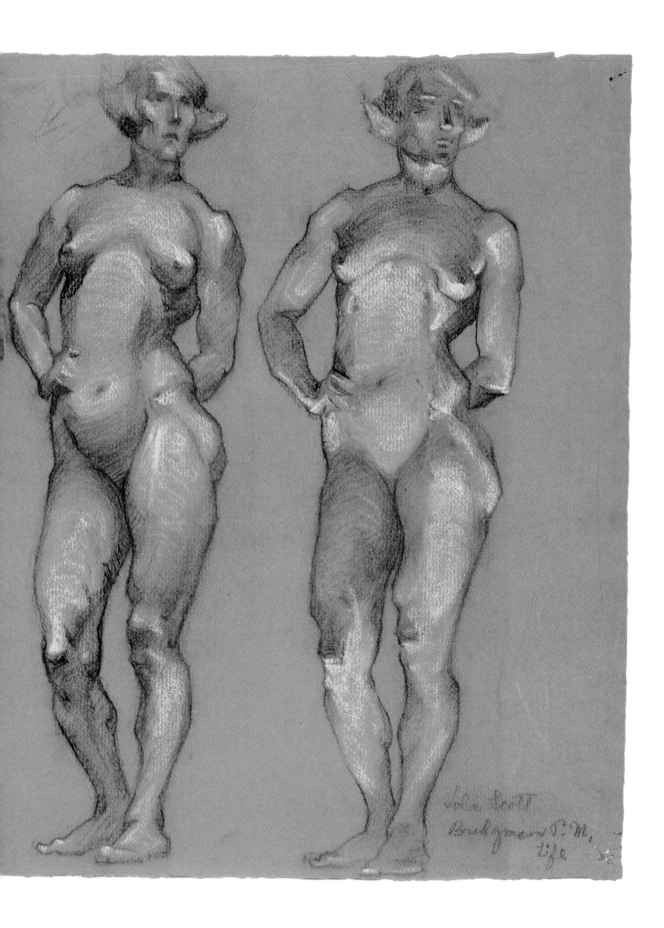

John Scott
Bridgman P.M.
life

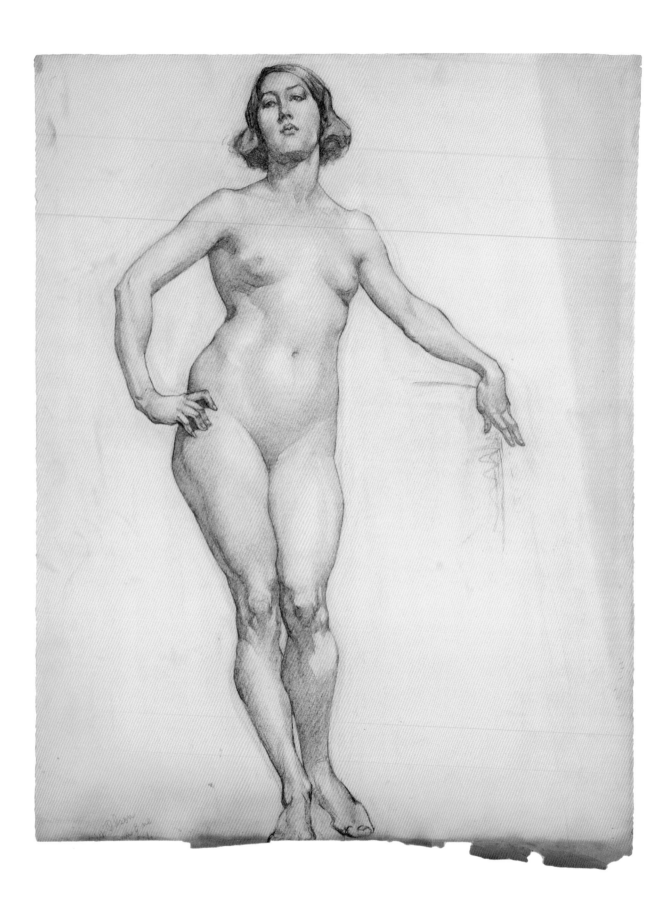

Fred W. Olson, Acadmic drawing, n.d., charcoal on
paper, 25 x 18 inches. Student of George Bridgman.

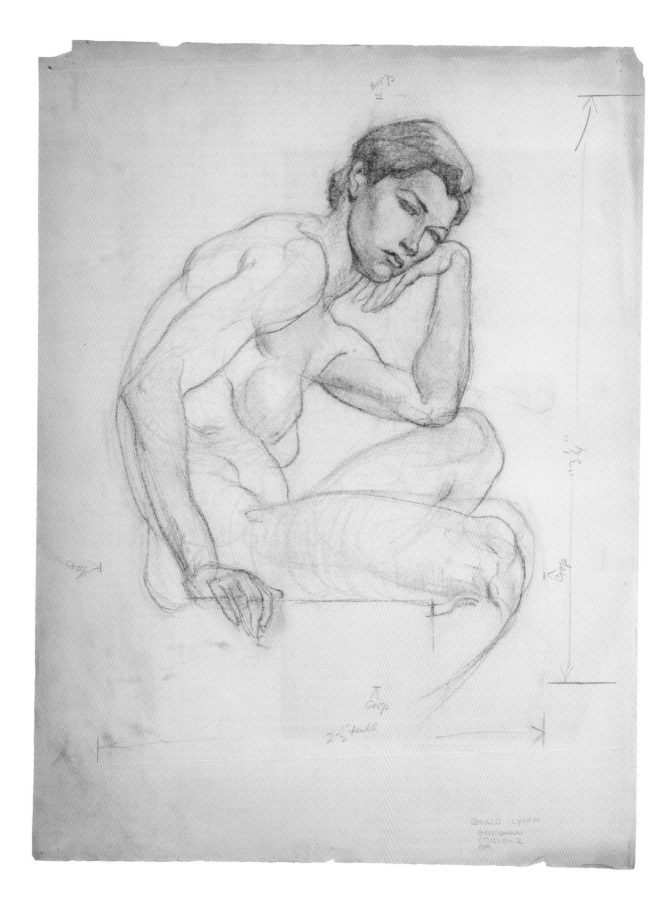

Donald Lynch, Academic drawing, ca. 1932, charcoal on
paper, 24½ x 18½ inches. Student of George Bridgman.

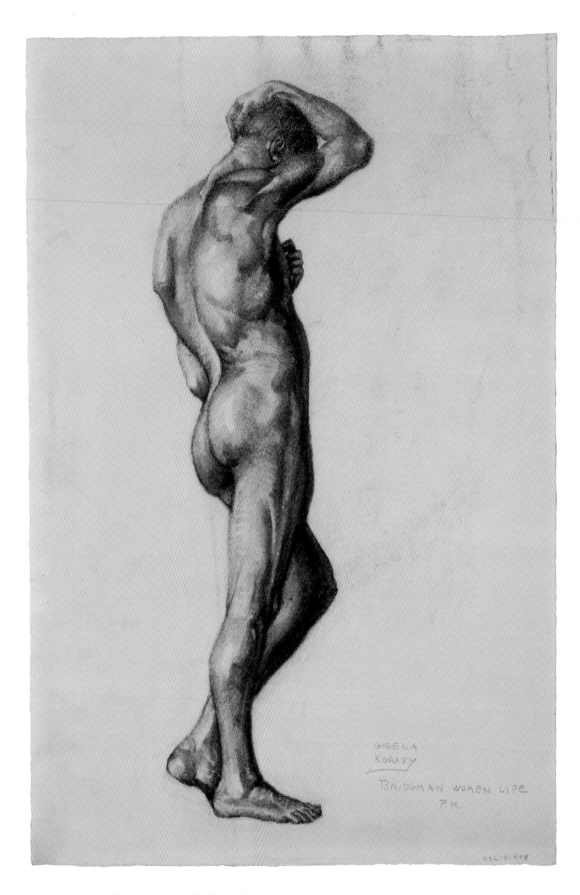

Gisela Korady, Academic drawing, n.d., charcoal on
paper, 19 x 12¼ inches. Student of George Bridgman.

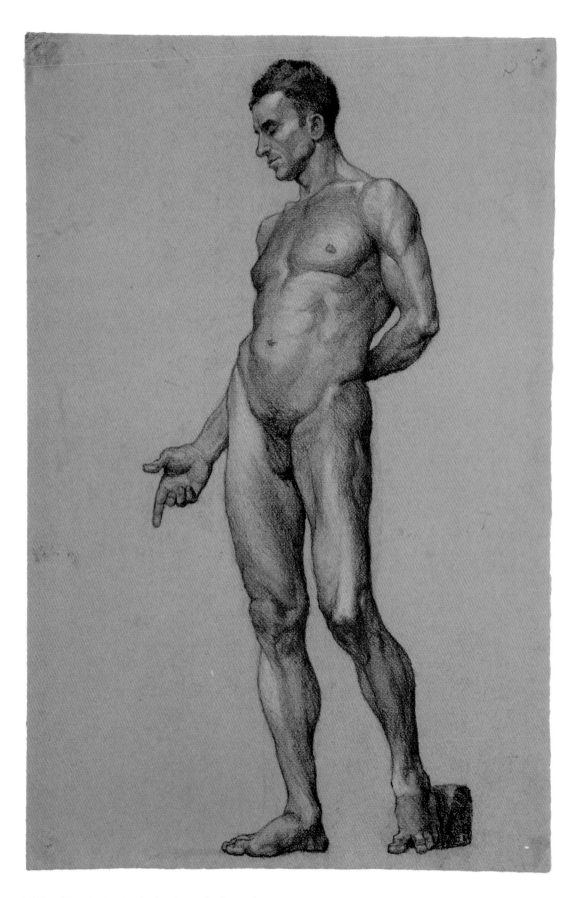

William Rinswig, Academic drawing, n.d., charcoal
and white chalk on gray paper, 19 x 12½ inches.
Student of George Bridgman.

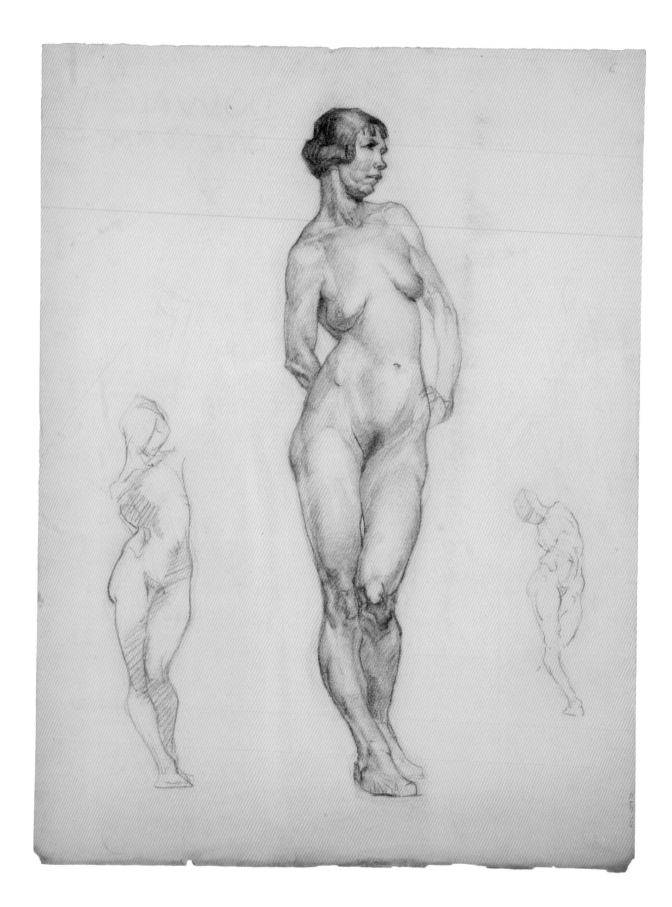

Downer, Academic drawing, n.d., charcoal on paper,
28 x 18 inches. Student of George Bridgman.

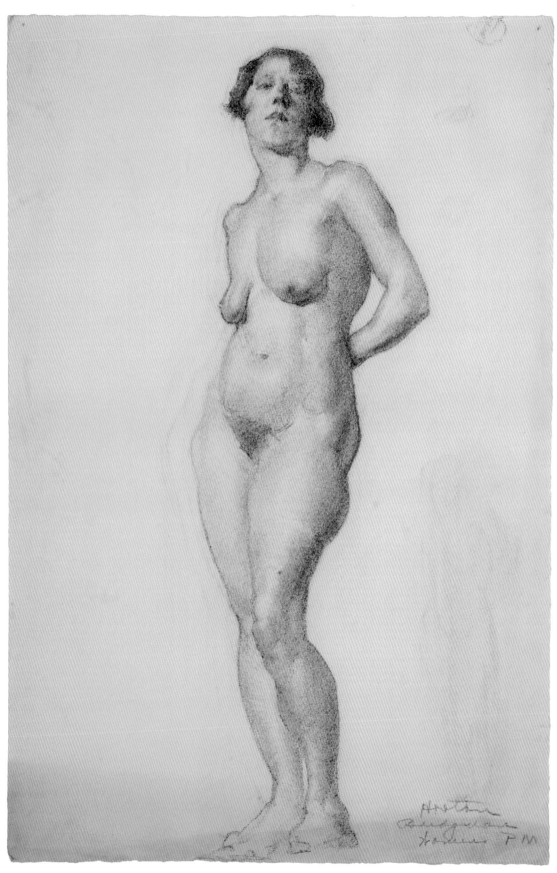

Anonymous, Academic drawing, n.d., charcoal on
paper, 18½ x 12¼ inches. Student of George Bridgman.

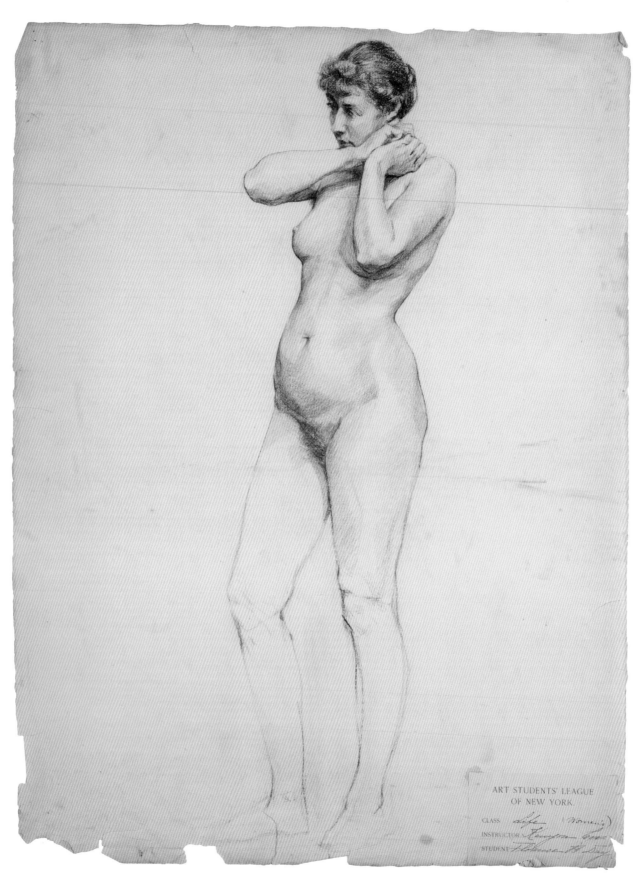

ART STUDENTS' LEAGUE
OF NEW YORK.

CLASS *Life* (Women's)
INSTRUCTOR *Kenyon Cox*
STUDENT *Florence B. Day*

Florence B. Day, Academic drawing, ca. 1890–93, charcoal
on paper, 24½ x 18½ inches. Student of Kenyon Cox.

Hulda Parton, Antique drawing, 1904, charcoal on
paper, 27 x 11 inches. Student of Kenyon Cox.

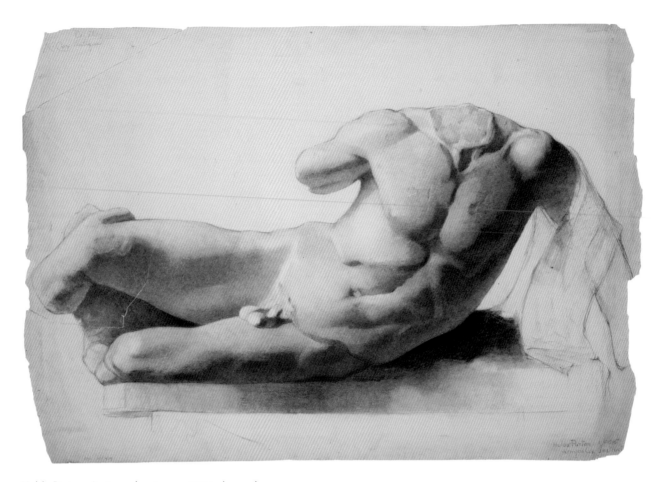

Hulda Parton, Antique drawing, ca. 1904, charcoal
on paper, 20 x 29 inches. Student of Kenyon Cox.

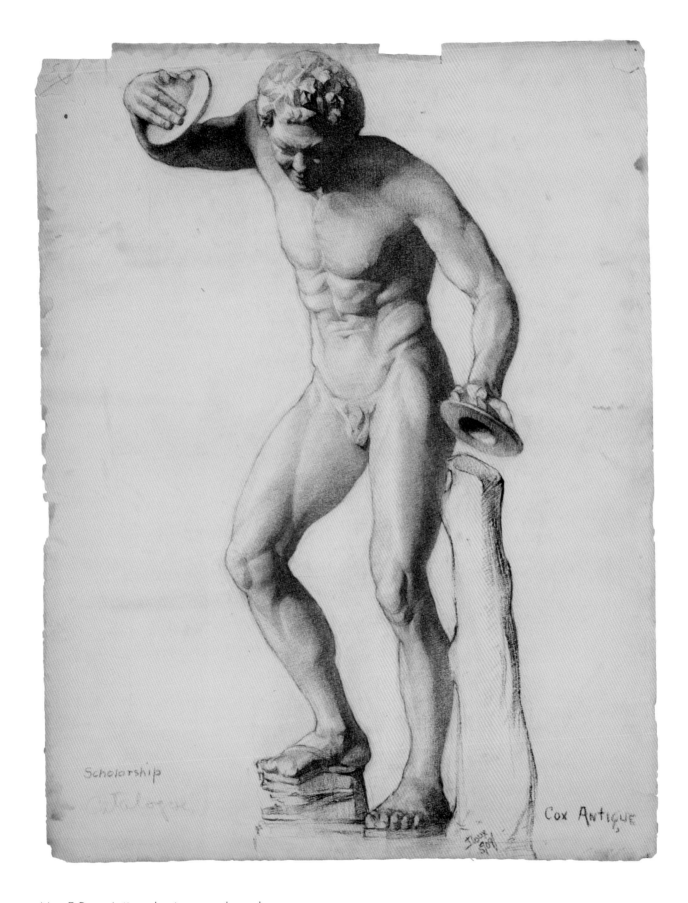

Mary F. Doux, Antique drawing, 1909, charcoal on
paper, 24½ x 18½ inches. Student of Kenyon Cox.

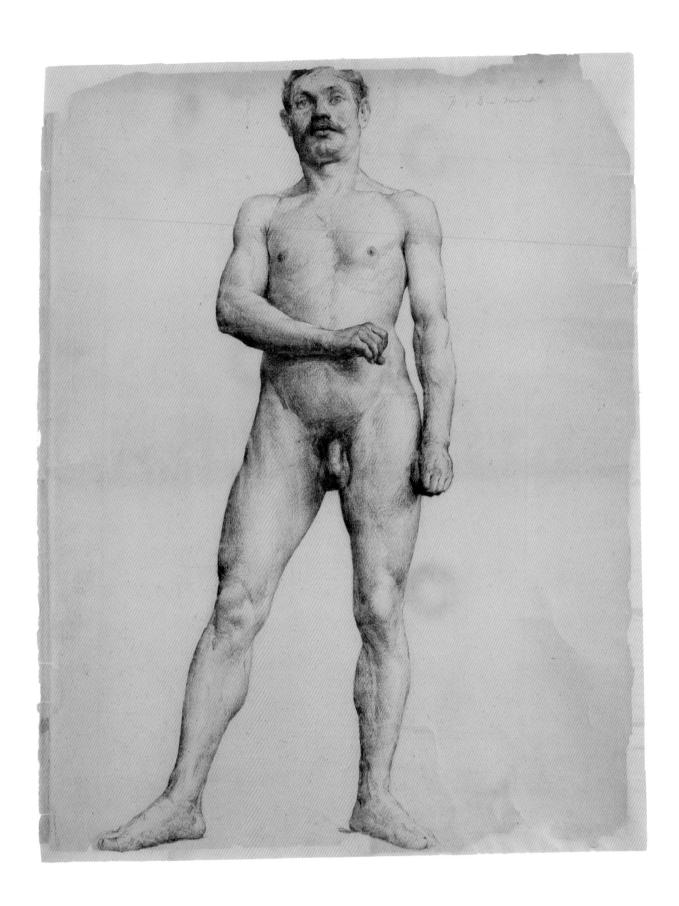

Frank Vincent DuMond, Academic drawing,
ca. 1886, charcoal and graphite on paper.
Student of William Sartain.

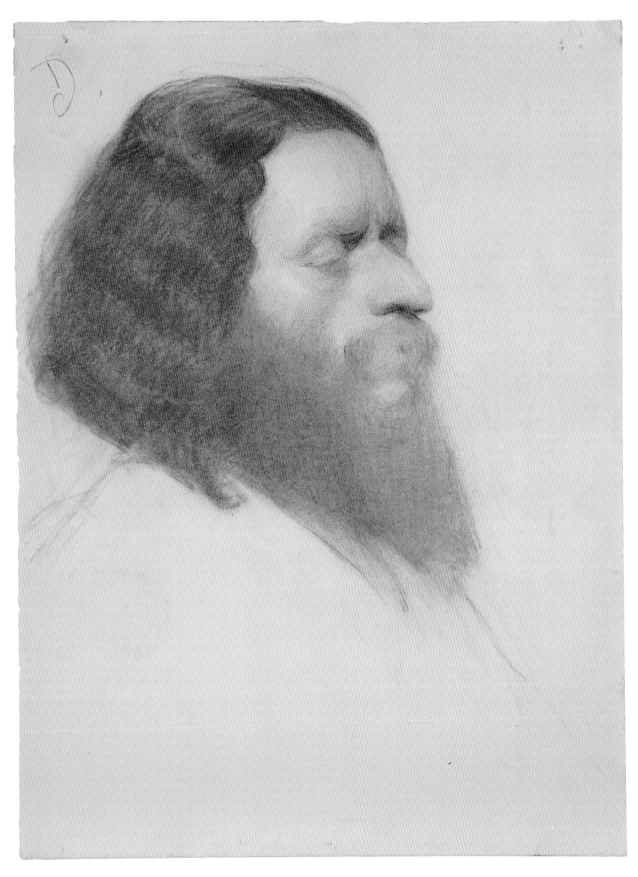

Anonymous, Male head, n.d, red chalk on paper,
16 x 12 inches. Student of Frank Vincent DuMond.

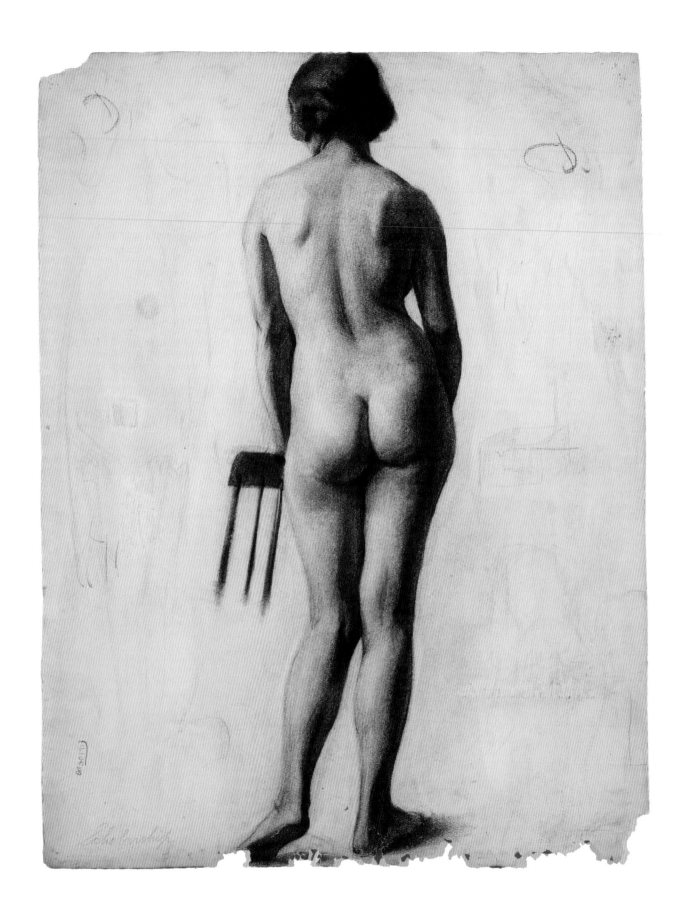

Arthur H. Roos, Academic drawing, 1913,
charcoal on paper, 24½ x 18½ inches.
Student of Frank Vincent DuMond.

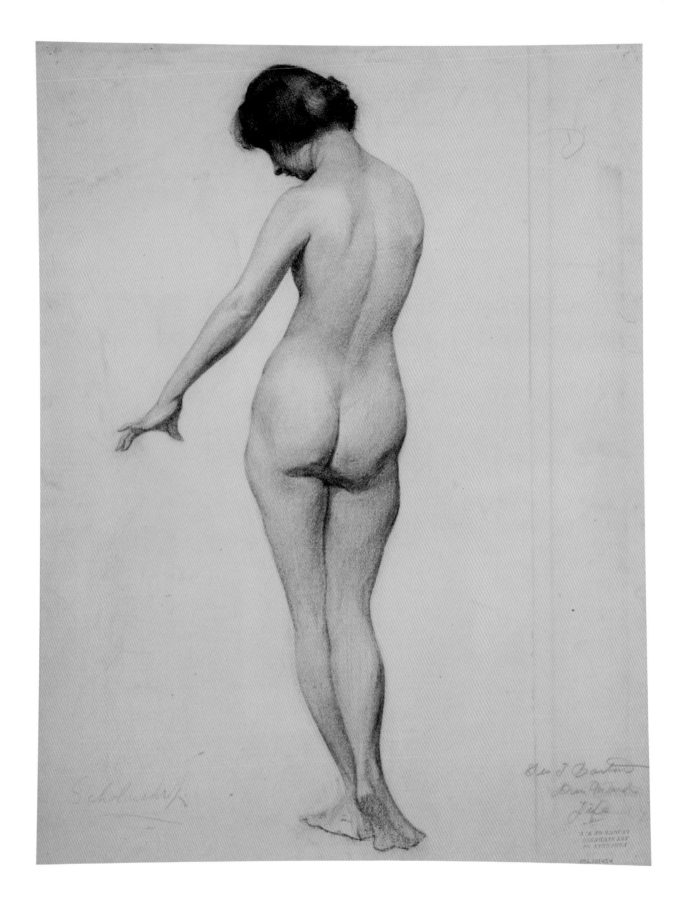

George J. Barton, Academic drawing, ca. 1915,
charcoal on paper, 24¹/₂ x 18³/₄ inches.
Student of Frank Vincent DuMond.

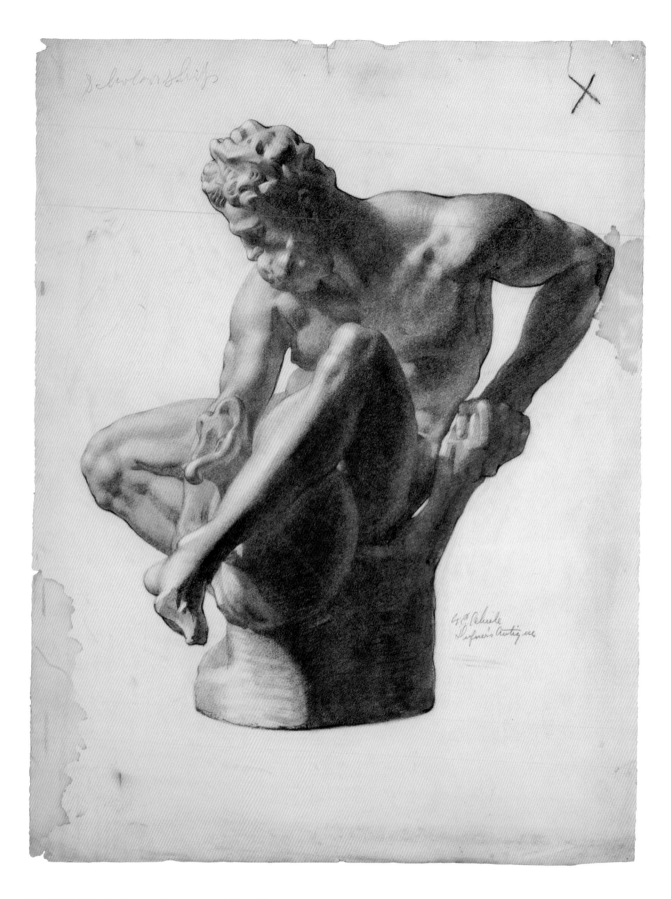

Franklin E. Schiele, Antique drawing, 1910, charcoal on
paper, 24½ x 18½ inches. Student of Edward Dufner.

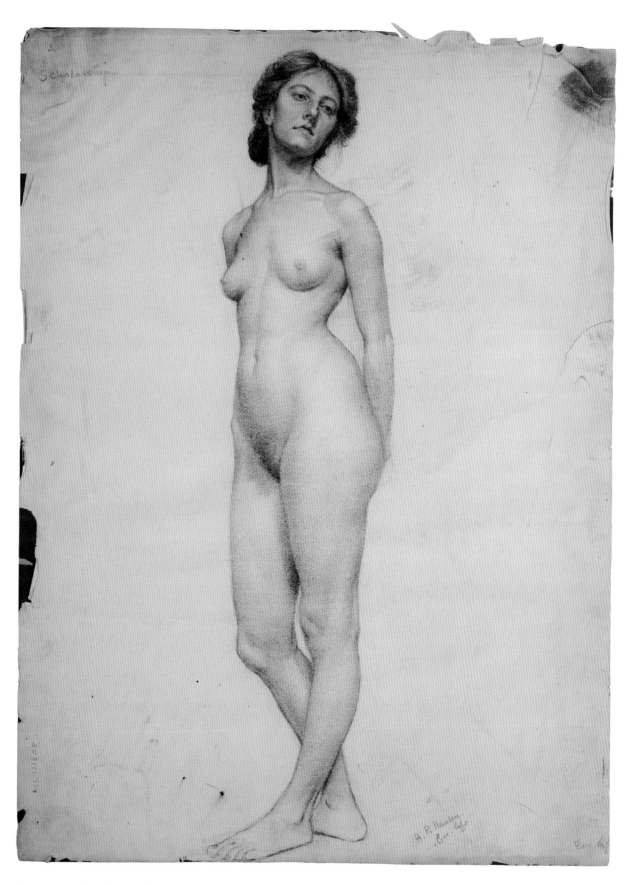

Anonymous, Academic drawing, ca. 1912–18,
charcoal on paper, 24¼ x 17¾ inches.
Student of Hans Peter Hansen.

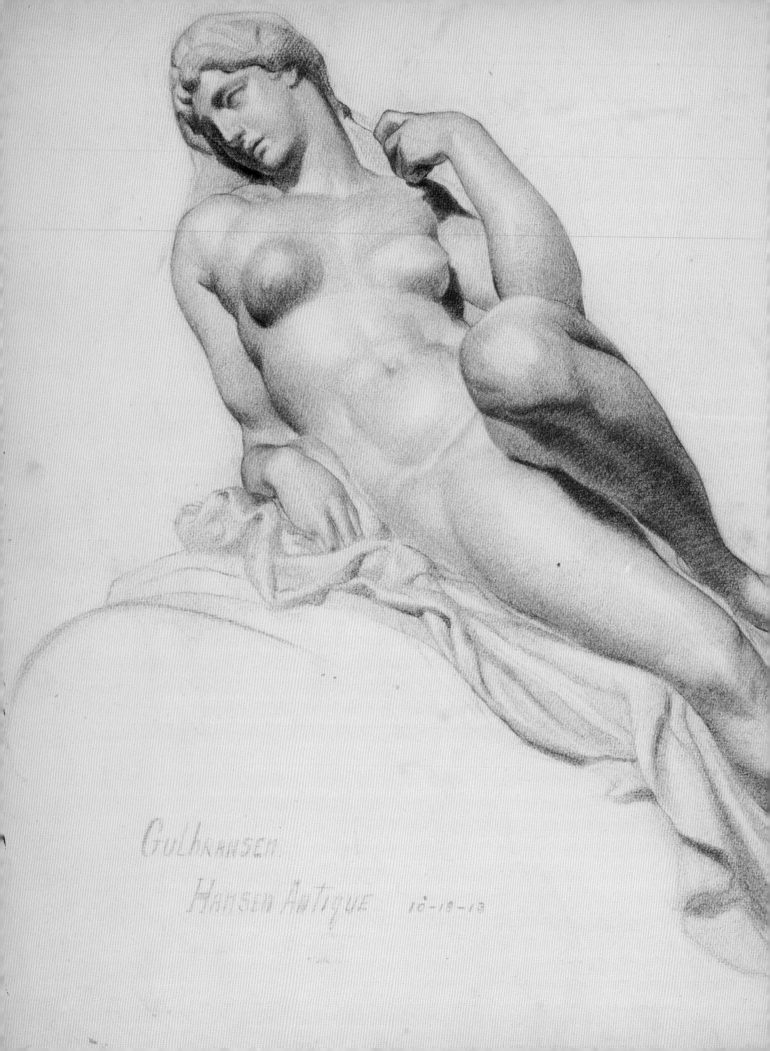

Gulbransen.
Hansen Antique 10-18-13

Segur Gulbransen,
Antique drawing, 1913,
charcoal and graphite on
paper, 17 x 23½ inches.
Student of Hans Peter
Hansen.

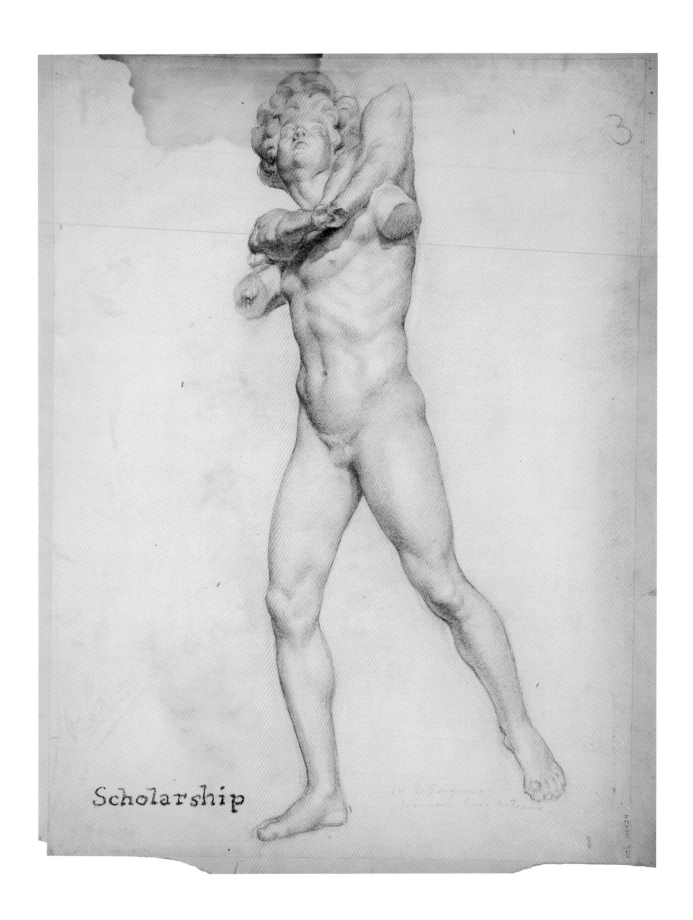

Scholarship

M. J. Ferguson, Antique drawing, ca. 1912–18,
charcoal on paper, 28 x 22 inches. Student of
Hans Peter Hansen.

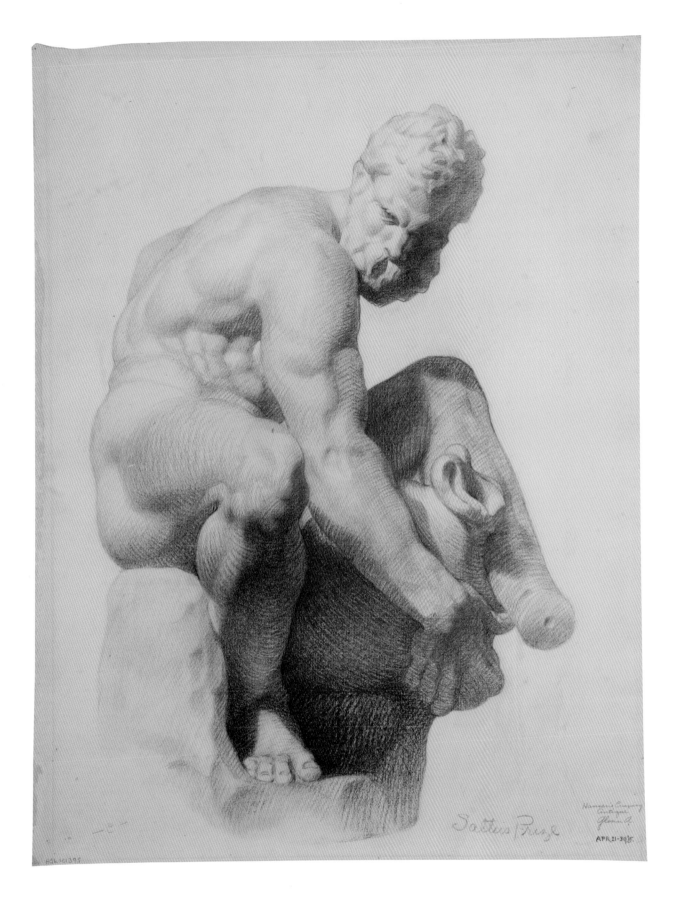

Glenn A., Antique drawing, 1915, graphite on paper,
24½ x 19 inches. Student of Hans Peter Hansen.
Awarded the Saltus Prize.

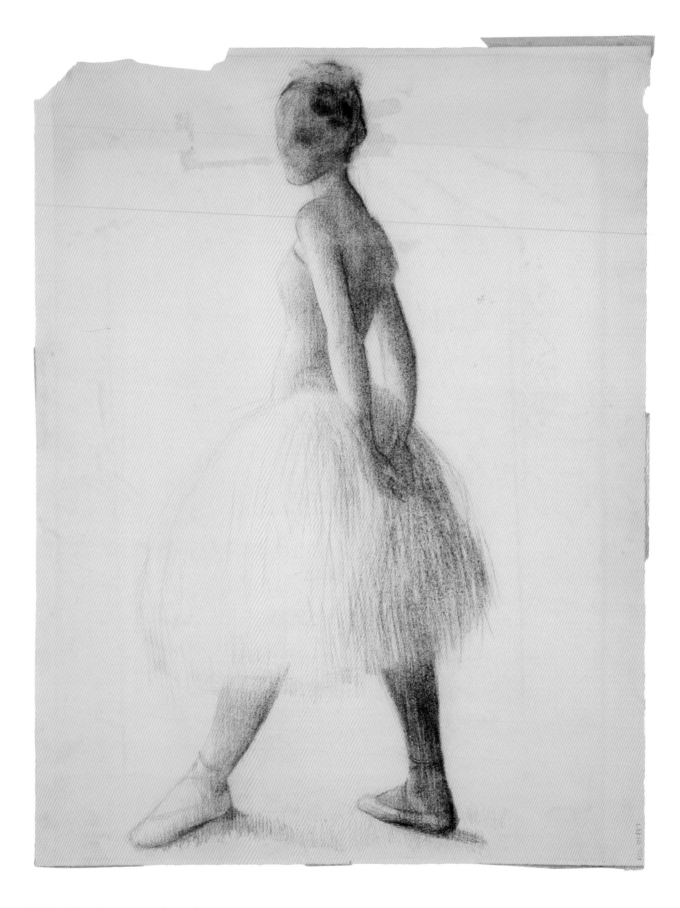

Charles Rigg, *Dancer*, 1947, charcoal on paper.
Student of Bernard Lamotte.

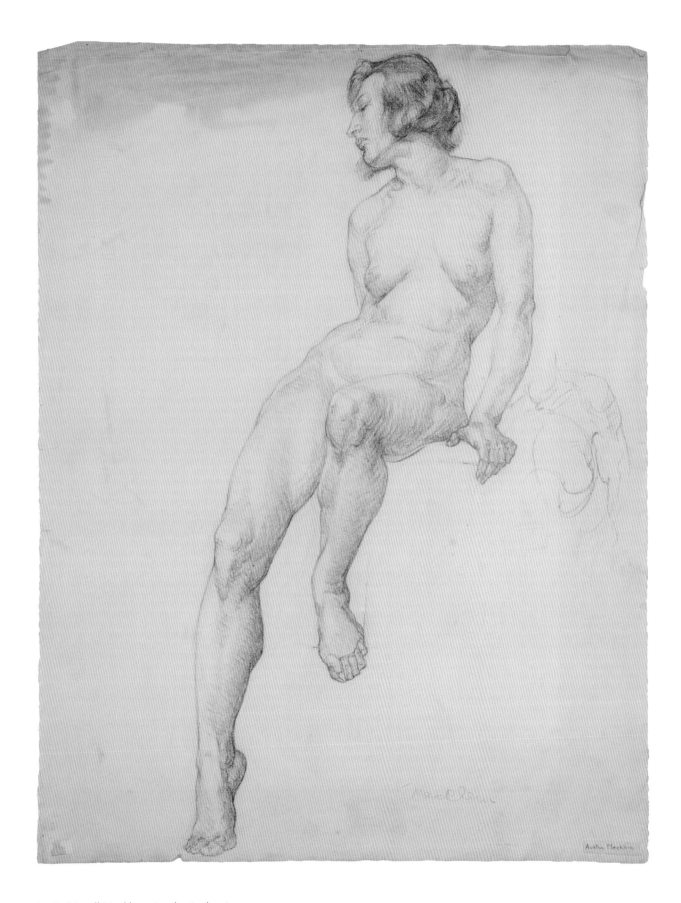

Austin Merrill Mecklem, Academic drawing,
ca. 1925, graphite on paper, 25 x 18 inches.
Student of Kenneth Hayes Miller.

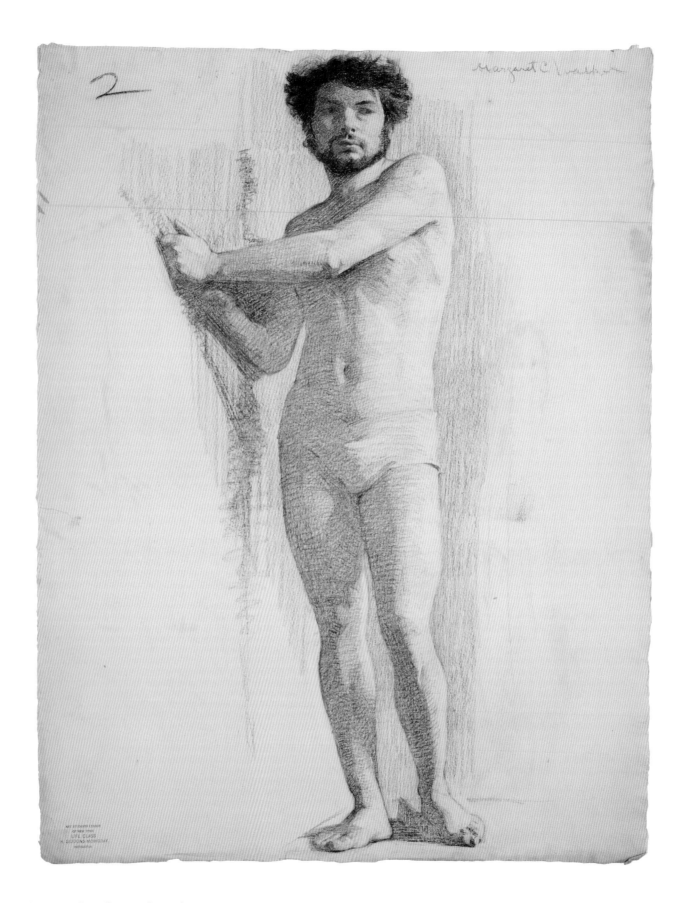

Margaret C. Walker, Academic drawing, 1901,
charcoal on paper, 24 x 18½ inches. Student of
H. Siddons Mowbray.

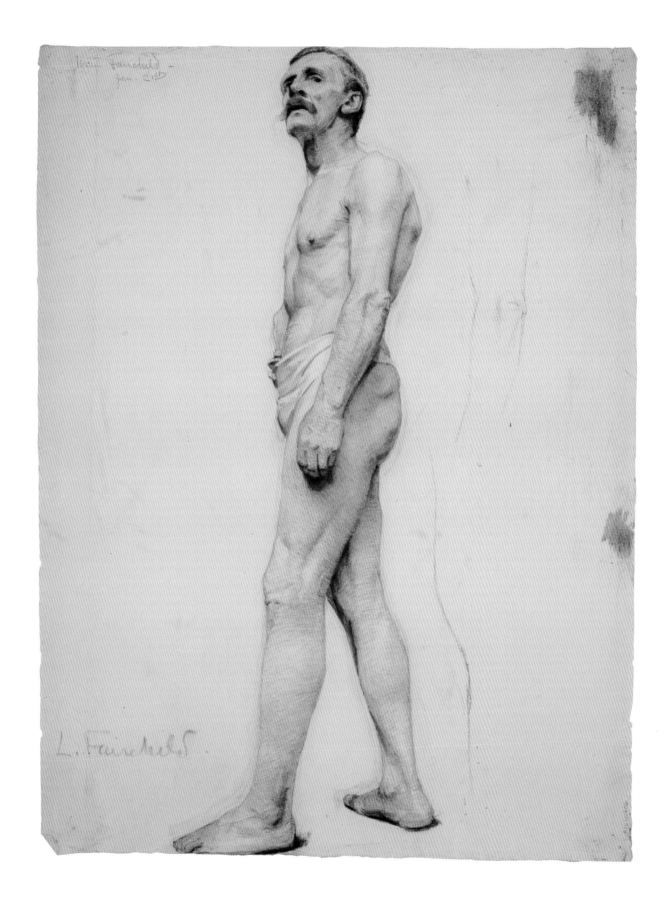

Lucia Fairchild, Academic drawing, ca. 1889,
charcoal on paper, 25 x 18½ inches. Student of
H. Siddons Mowbray.

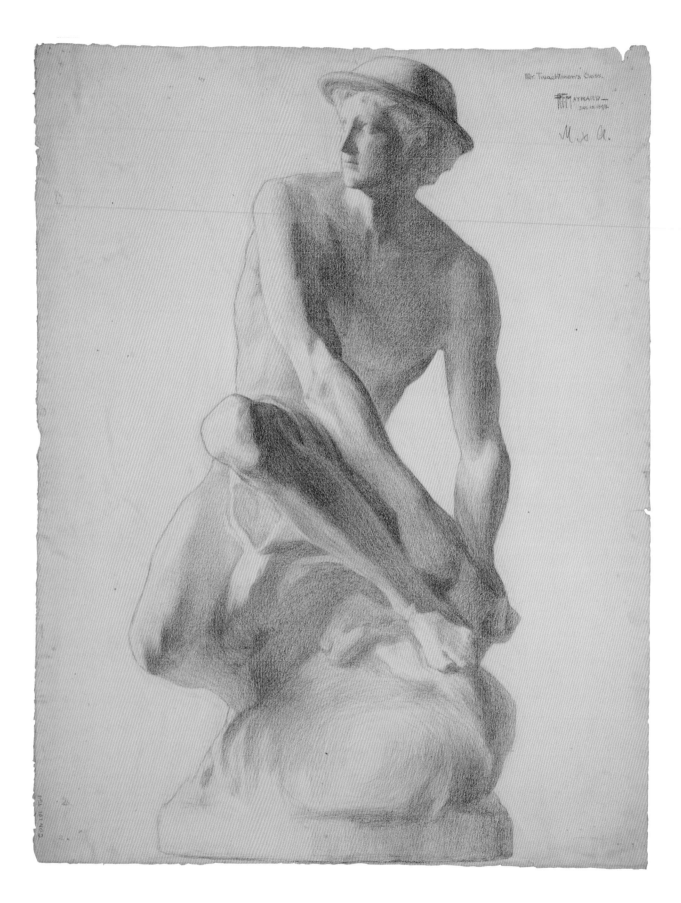

R. F. Maynard, Antique drawing, 1898, graphite and
charcoal on paper, 24½ x 19¼ inches. Student of
John Henry Twachtman.

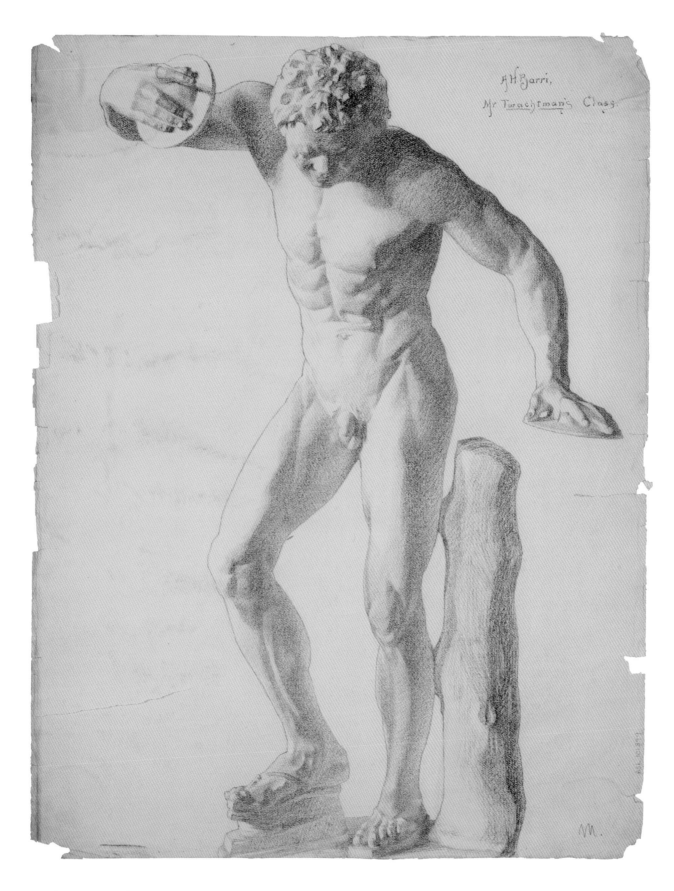

A. H. Barri, Antique drawing, c. 1898, charcoal and
graphite on paper, 25 x 19½ inches. Student of
John Henry Twachtman.

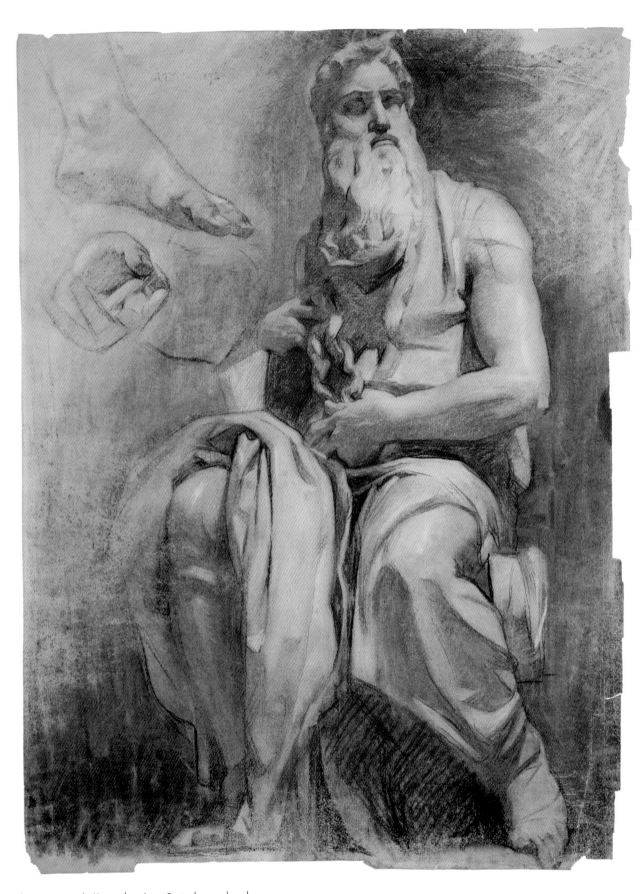

Anonymous, Antique drawing, 1892, charcoal and
graphite on paper, 24½ x 18 inches.

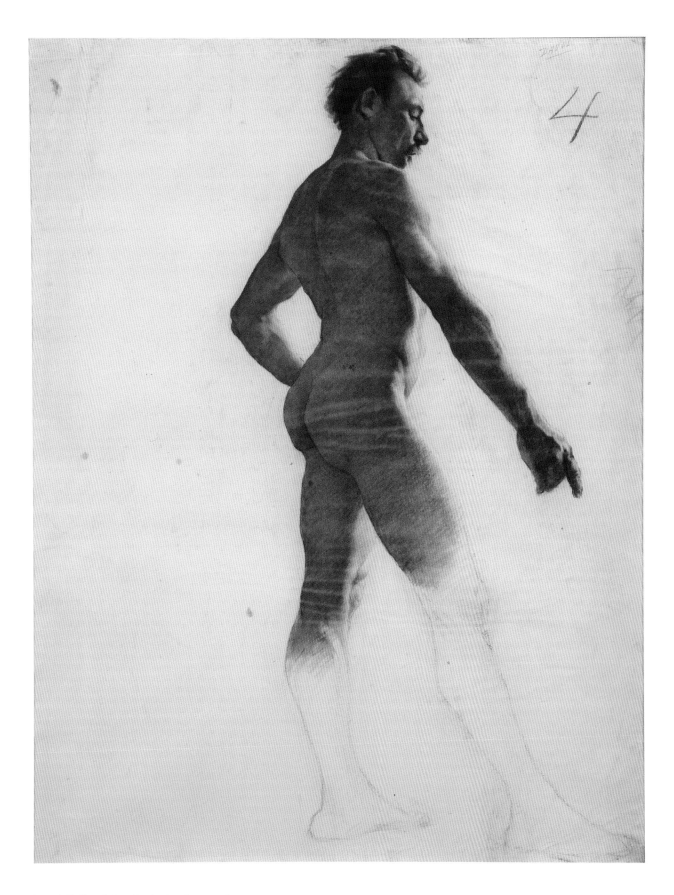

Joseph R. Davol, Academic drawing, ca. 1892,
charcoal on paper, 24 x 18½ inches.

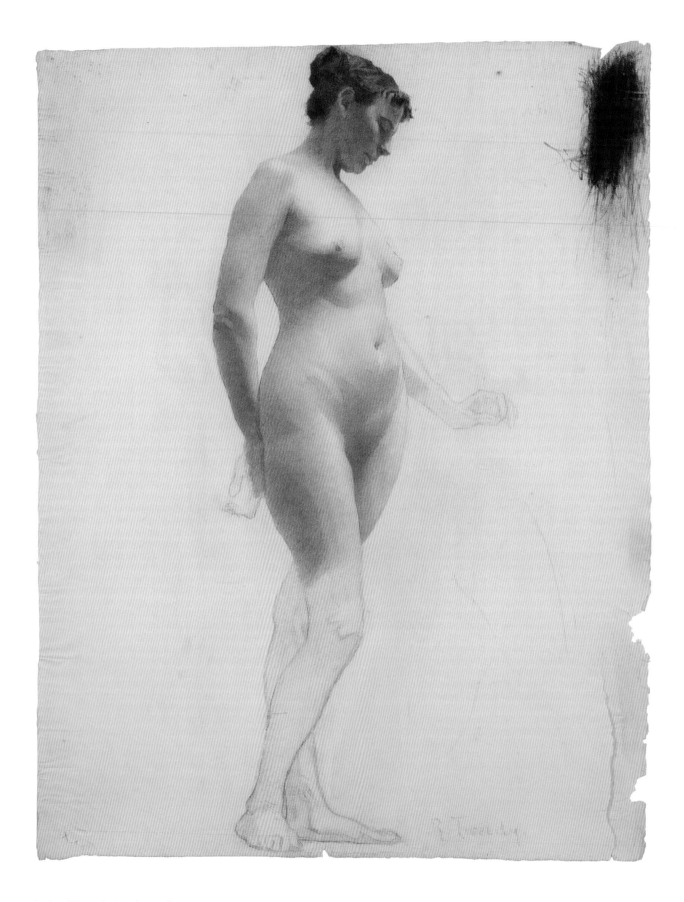

Richard Tweedy, Academic drawing, ca. 1895,
charcoal on paper, 24¼ x 19 inches.

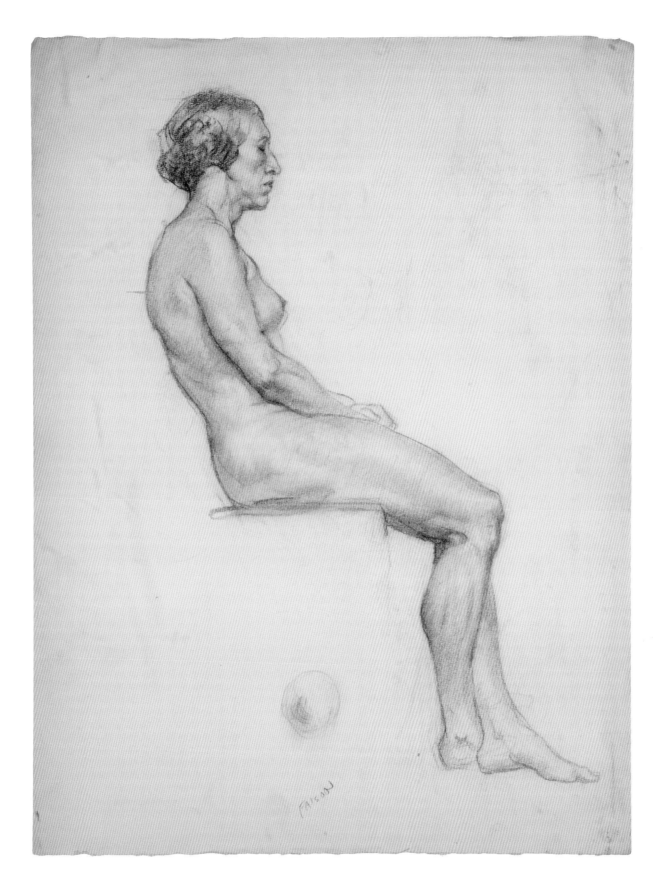

Sherwood Faison, Academic drawing, ca. 1900,
charcoal on paper, 25 x 19 inches.

Ethel Hayes, Academic
drawing, 1918, charcoal on
paper, 12½ x 18½ inches.

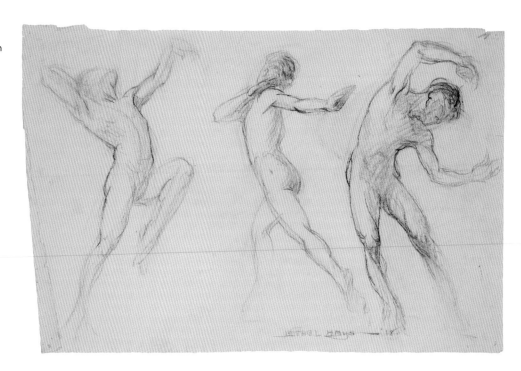

Mary Ashton Cotton,
Academic drawing, 1918,
charcoal on paper,
25¼ x 18½ inches.

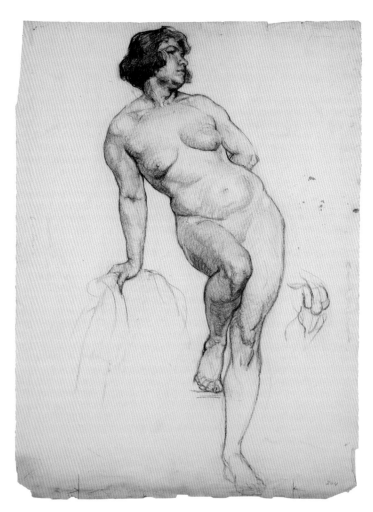

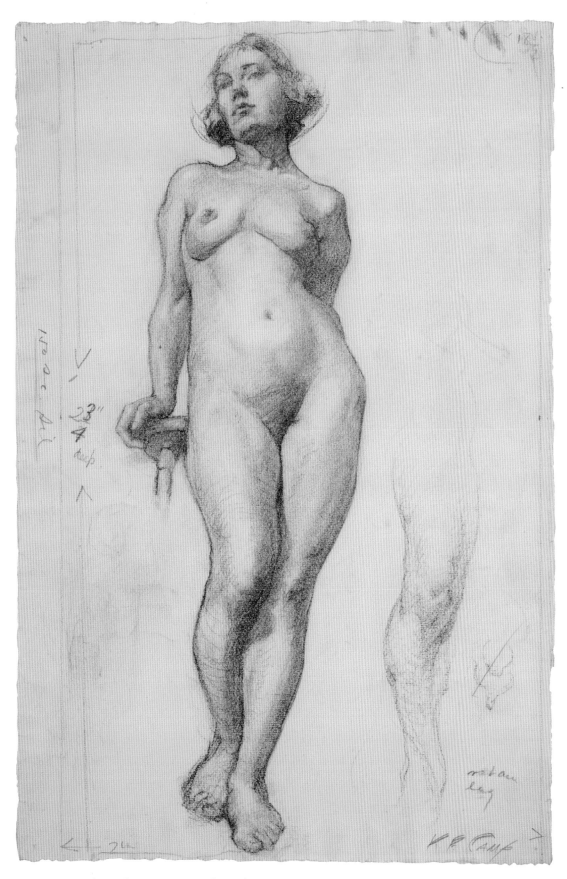

K. P. Camp, Academic drawing, ca. 1926, charcoal
on paper, 18½ x 12¼ inches.

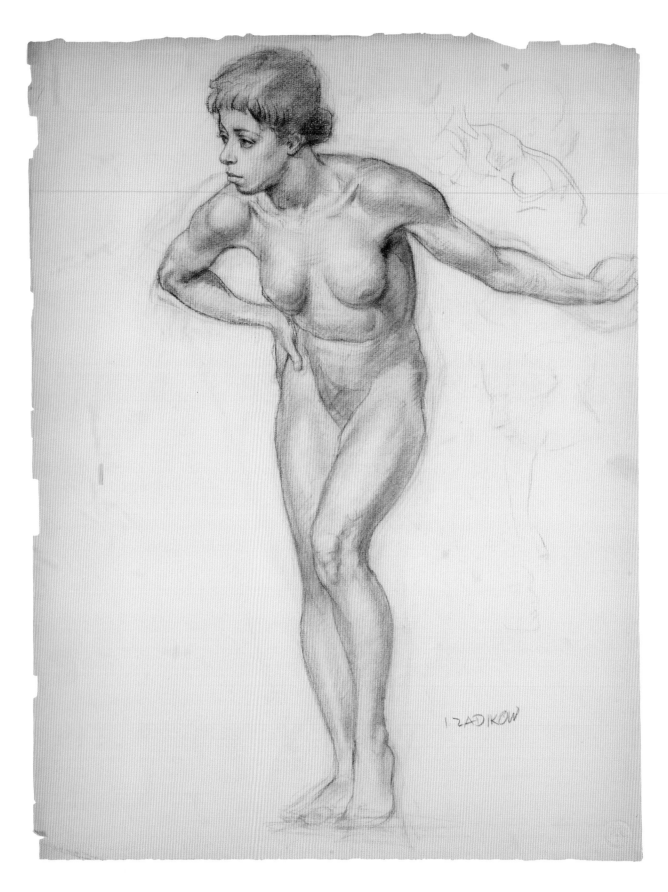

Israel Zadikow, Academic drawing, 1933, charcoal
on paper, 25 x 19 inches.

Anonymous, Academic drawing, n.d., charcoal on
paper, 24½ x 18½ inches.

B. L. K., Antique drawing, n.d., charcoal on paper,
25¼ x 18½ inches.

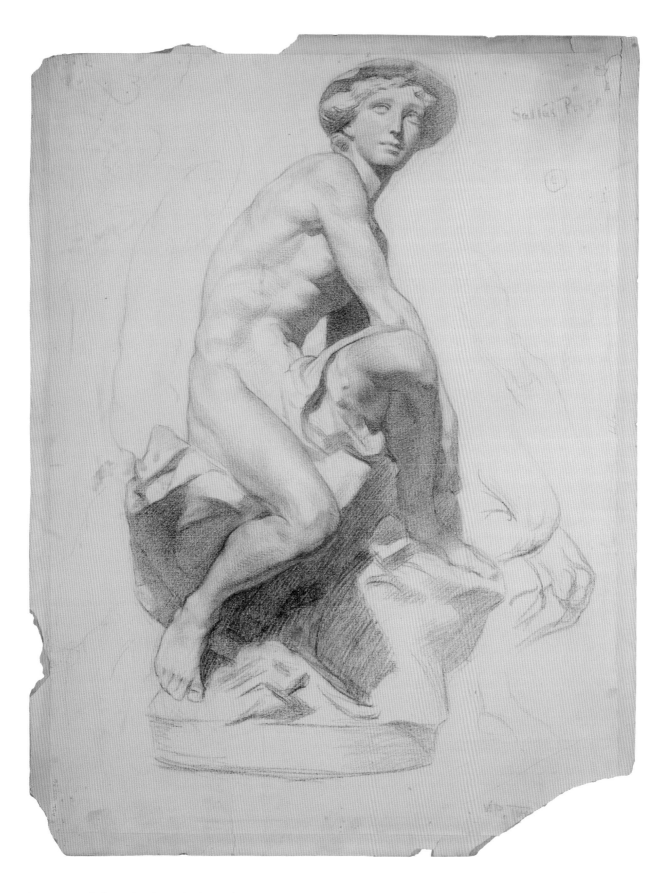

Anonymous, Antique drawing, n.d., charcoal on
paper, 24 x 18 inches. Awarded the Saltus Prize.

Anonymous, Studies of
hands, n.d., charcoal on
paper, 25 x 19 inches.

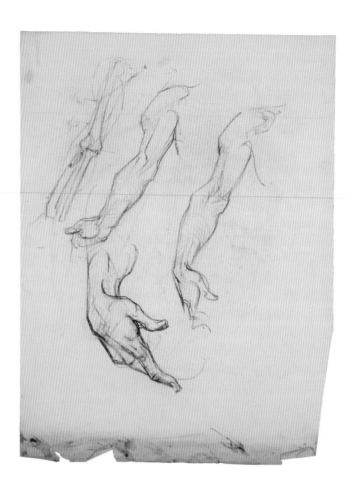

Anonymous, Studies of
hands, n.d., charcoal on
paper, 18½ x 21 inches.

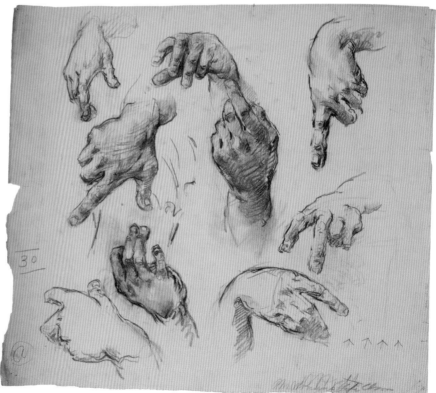

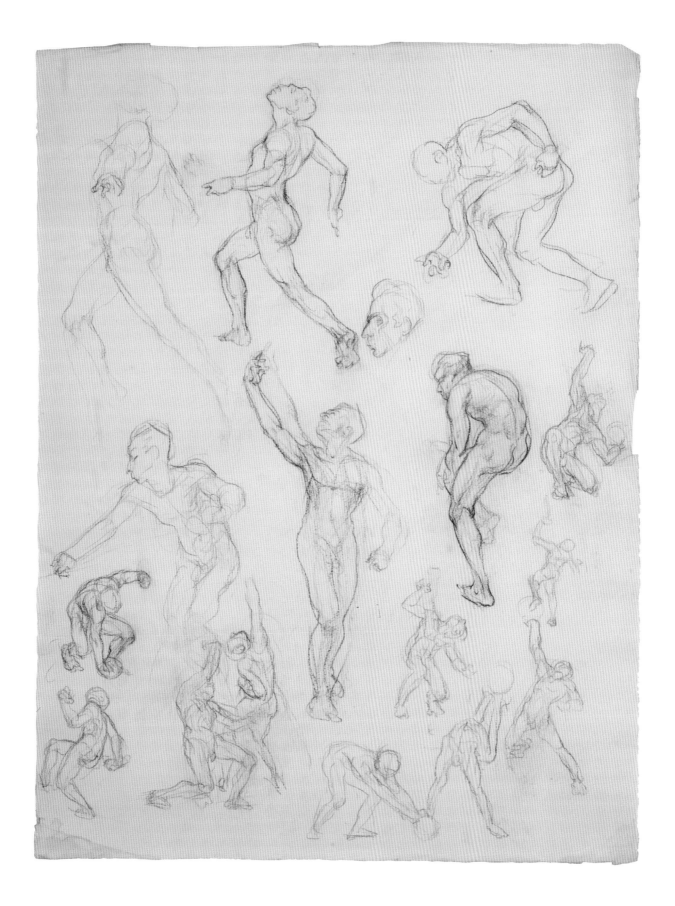

Anonymous, Figure studies, n.d., charcoal on paper,
24¼ x 18½ inches.

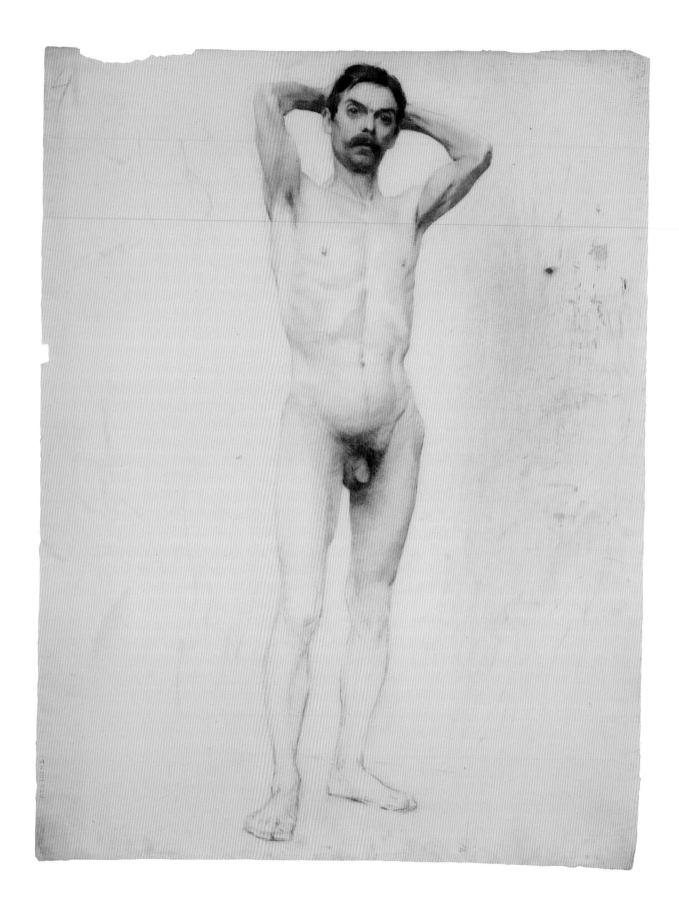

Anonymous, Academic drawing, n.d., charcoal on
paper, 24¼ x 20½ inches.

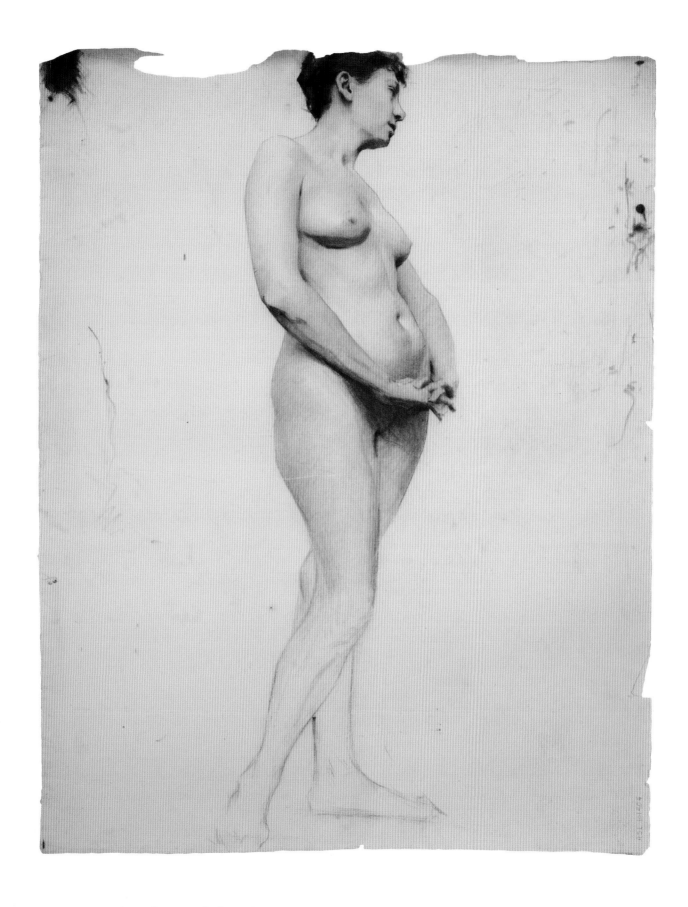

Anonymous, Academic drawing, n.d., charcoal on
paper, 23½ x 19 inches

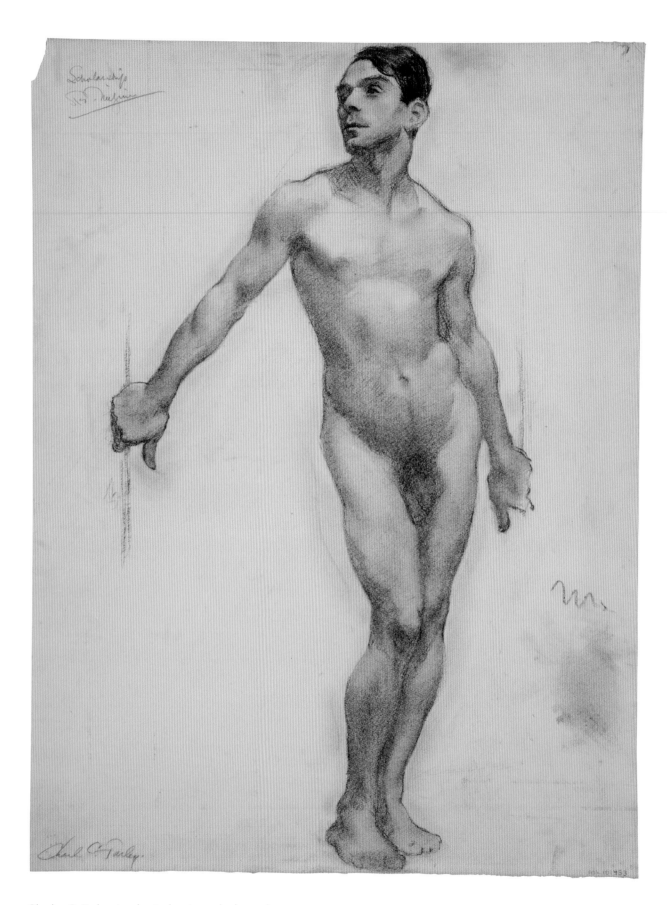

Charles C. Farley, Academic drawing, n.d., charcoal
on paper, 25 x 18½ inches.

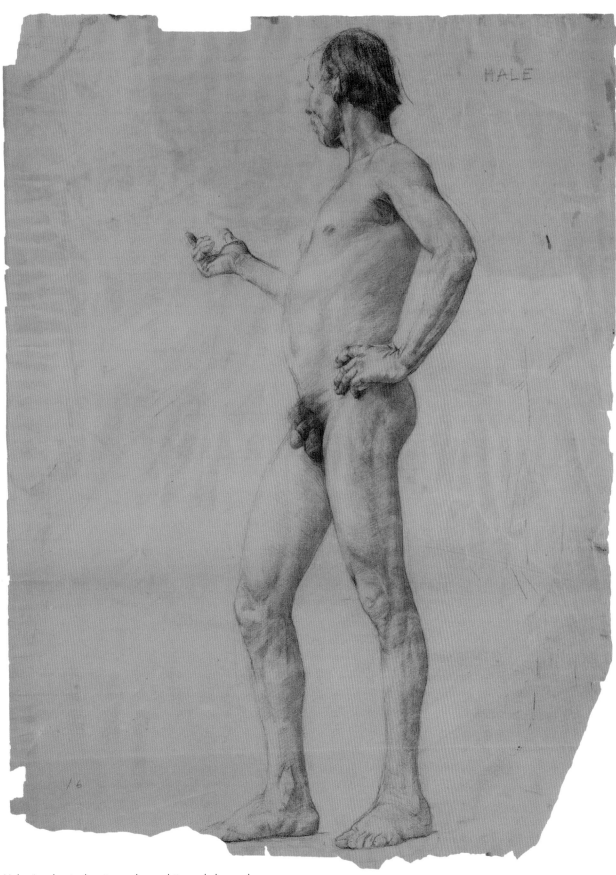

Hale, Academic drawing, n.d., graphite and charcoal
on paper, 24 x 17 inches.

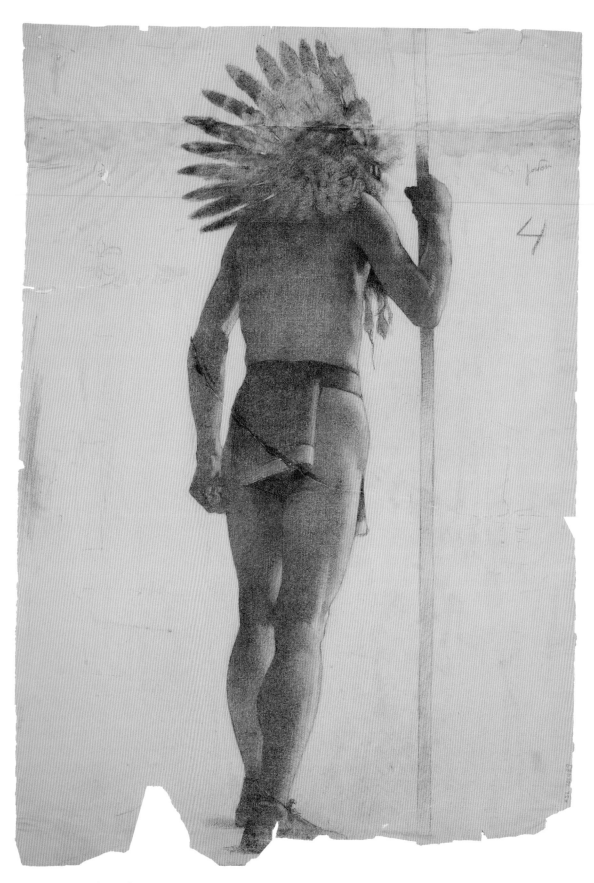

Anonymous, Academic drawing, n.d., charcoal on
paper, 28 x 18½ inches.

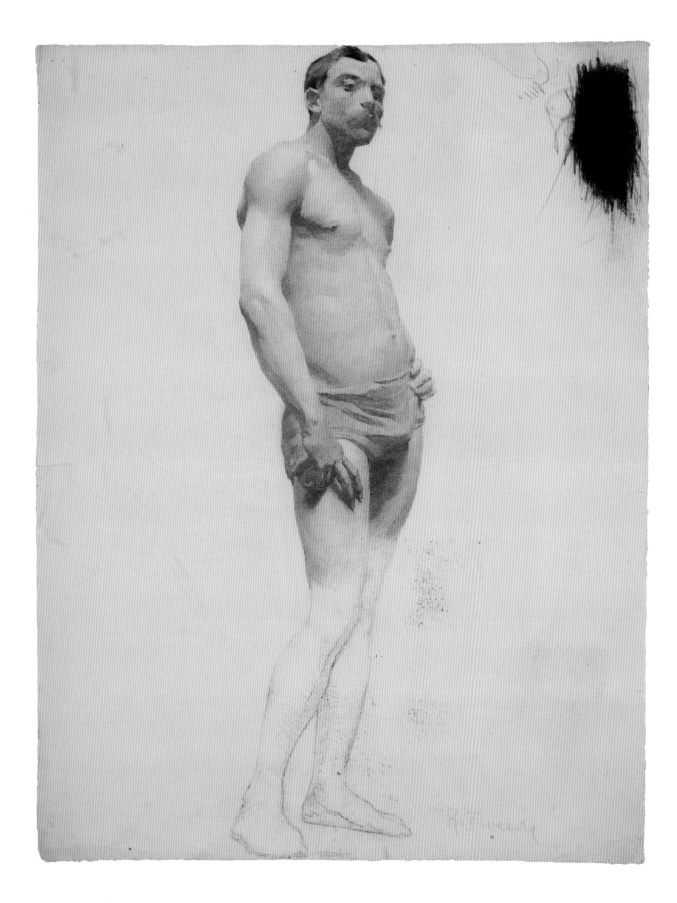

R. Tweedy, Academic drawing, n.d., charcoal on paper.

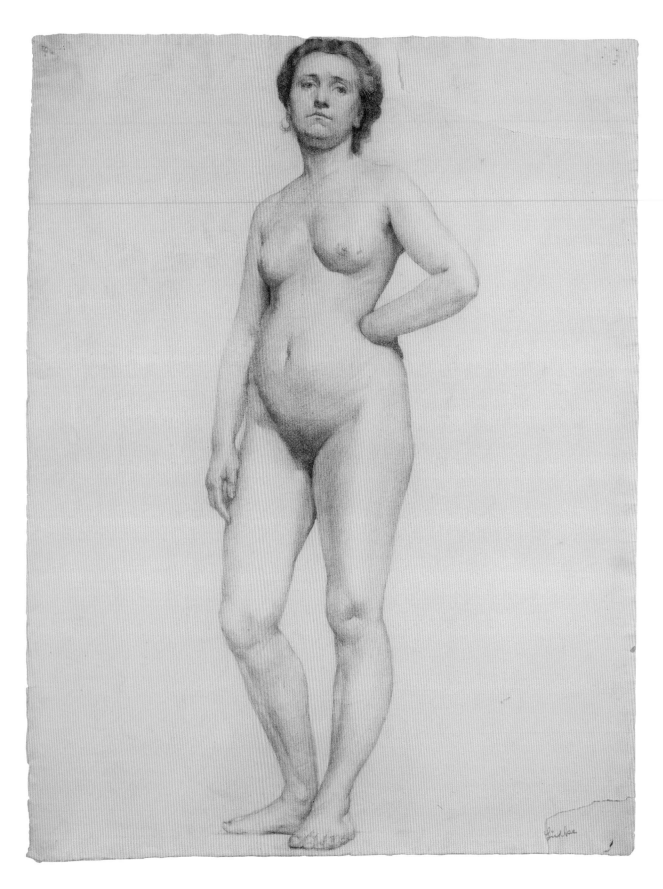

Ludke, Academic drawing, n.d., charcoal on paper,
24¼ x 19 inches.

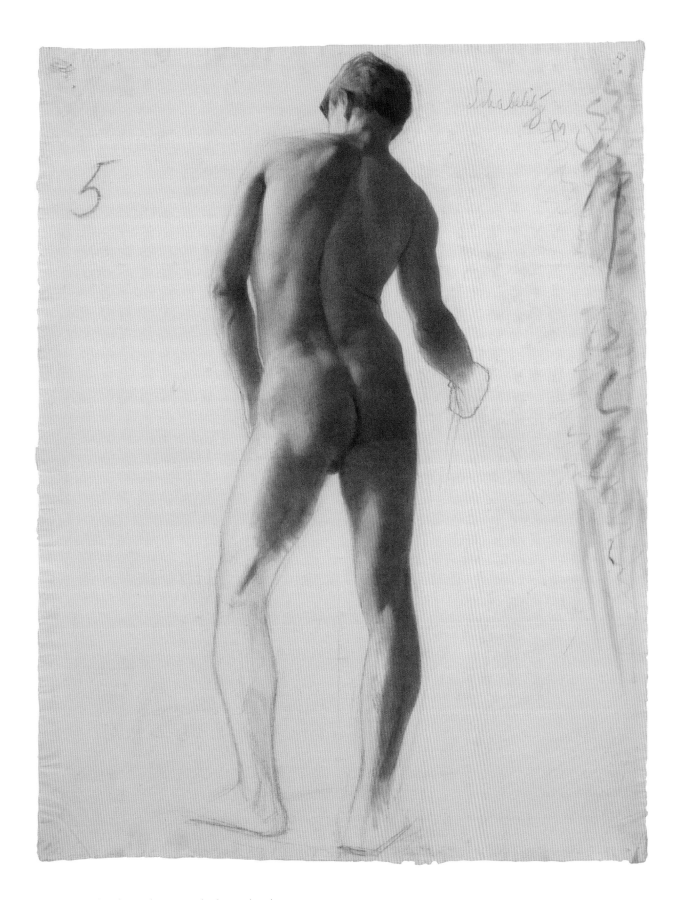

Anonymous, Academic drawing, n.d., charcoal and
graphite on paper.

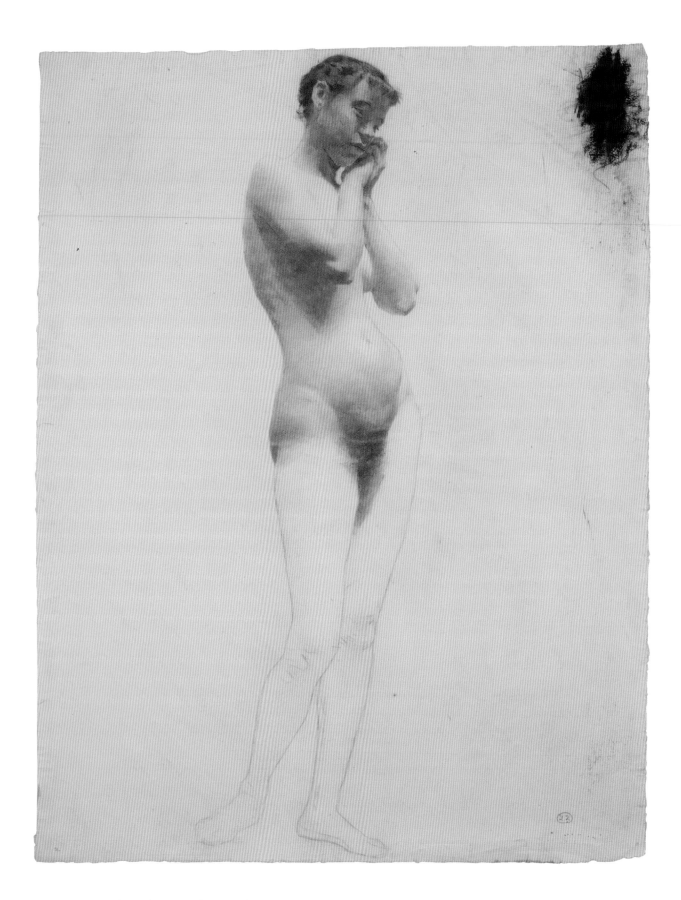

Anonymous, Academic drawing, n.d., charcoal and
graphite on paper, 24½ x 19 inches.

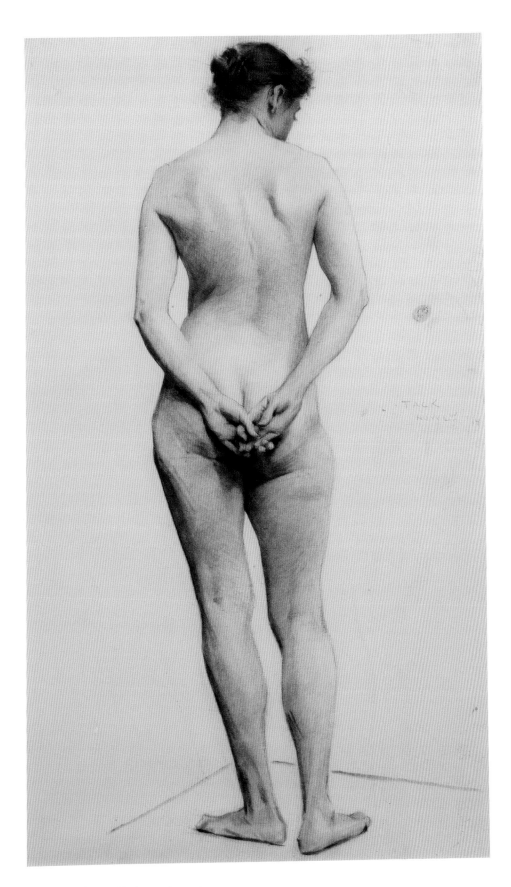

Augustus Vincent Tack, Academic drawing, Nov. 2, 1894, charcoal.

Lessons on Drawing and Contemporary Works from Instructors and Students of the Art Students League of New York

Detail, James Lancel McElhinney, *Portrait of Emily*, 2008, pastel pencils on toned paper, 24 x 18 inches.

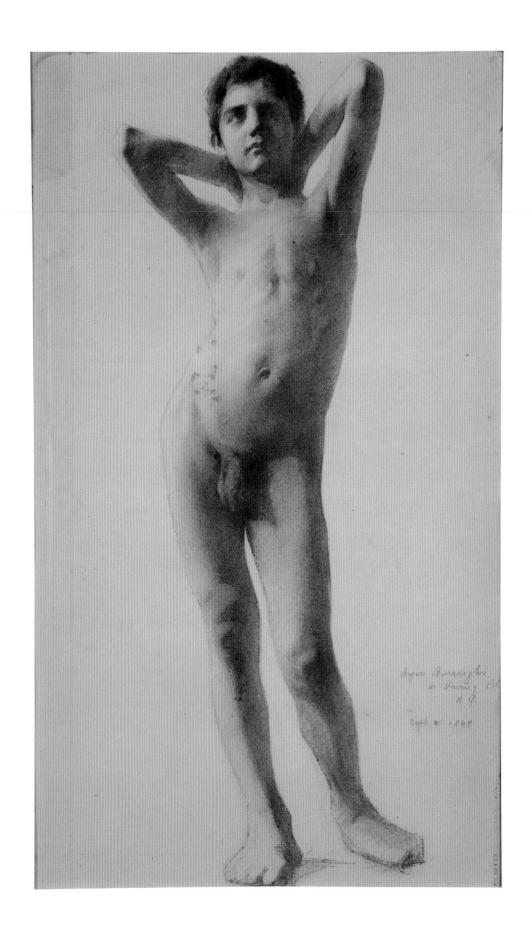

Sherry Camhy

THE HUMAN FORM HAS ALWAYS BEEN the starting point for artists—from the first charcoal handprint made in a cave to the myth of the Maid of Corinth, who invented drawing by tracing her lover's shadow on a wall, to masters such as Michelangelo, Leonardo, and others who looked to the Greek and Roman past for inspiration. Inspired by this same past, students seeking more freedom to study from live models left the National Academy of Design and formed the Art Students League of New York. Thomas Eakins braved condemnation to allow both his male and female students to study anatomy. Once upon a time artists robbed graves to study anatomy. I was able to dissect cadavers at New York University Medical School.

You will find that Picasso, Matisse, Mondrian, Pollock, the Impressionists, Cubists, and Surrealists all studied figure drawing. When painting was dead and drawing was deader, students at Cal Arts rejected traditional drawing by making marks on paper with their naked bodies. Ironically, the human body was still necessary to their rebellion. Eric Fischl had links to conceptual art but today acknowledges the need to draw the human figure. Paula Rego and Lucian Freud show us the way. We have come full circle.

I help students choose their own path by teaching them the principles of Classical drawing. This knowledge is a powerful source of creative freedom because looking to the past lets us look to the future.

The Classical drawing tradition is about more than just style. Bryson Burroughs's 1869 life drawing seen here splendidly celebrates the unadorned human body viewed without shame or moral judgment, but with respect—showing that drawing is about learning to see and interpret reality, not copy it. The language of drawing is about learning to create the illusion of three-dimensional forms on two-dimensional surfaces by investigating how lines can move from thick to thin, light to dark, hard to soft. Burroughs's drawing reveals how light defines space and volume; how knowledge of anatomy, form, value, line, and composition—embodied by Classical life drawing—is fundamental, a springboard for the art of yesterday and today.

Sometimes I draw with a brush. Sometimes I paint with a pencil. I prefer graphite and silverpoint to charcoal and use black paper as often as white. Sometimes I work with models who fit the "ideal." More often I make beautiful drawings of people who are not conventionally beautiful but who are uniquely and grandly human. I frequently draw them larger than life, exploring variations on the theme of Classical human form.

OPPOSITE PAGE
Bryson Burroughs, Academic drawing, 1869, charcoal on paper. Permanent collection, Art Students League of New York.

Sherry Camhy, *Adam*, 1997, graphite on paper, 40½ x 19½ inches. Private collection.

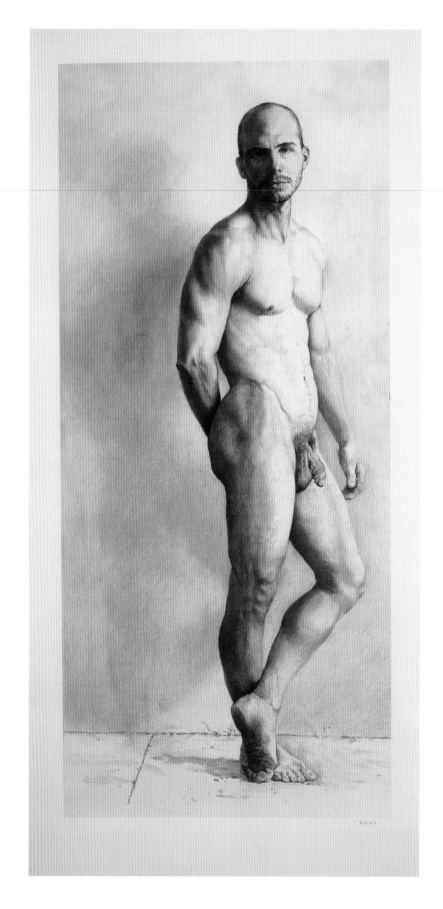

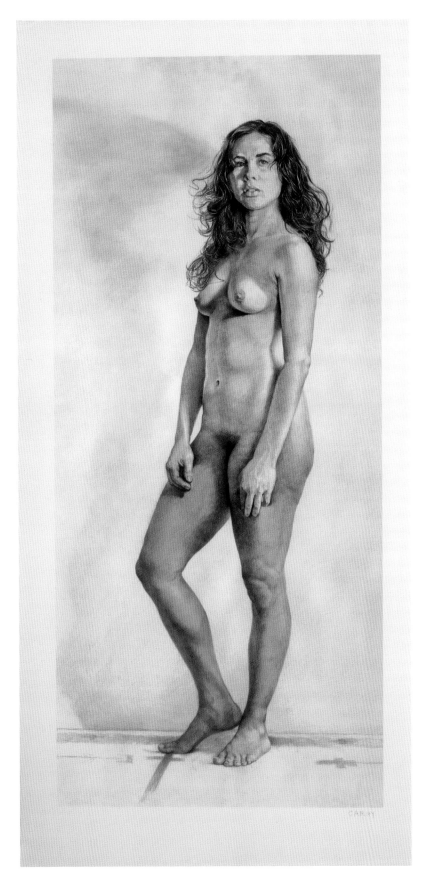

Sherry Camhy, *Chava (Eve)*, 2004, graphite on paper, 4 x 6 feet. Collection of Howard A. and Judith Tullman.

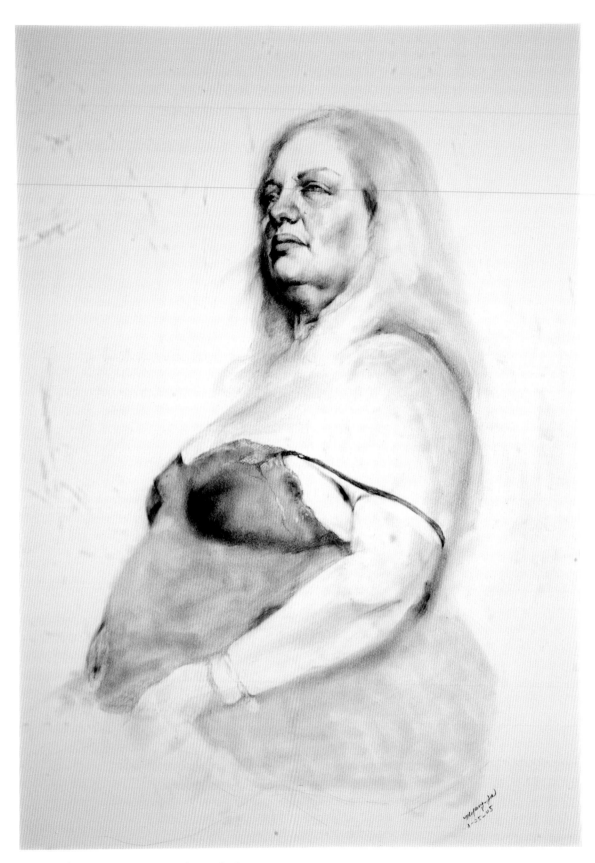

Myung-Ja Chun, *Aviva: Beauty crowds me till I die. Beauty, mercy
have on me. But if I expire today, let it be in sight of thee,* 2005,
graphite powder on paper, 19¼ x 27 inches. Student of Sherry Camhy.

Myung-Ja Chun, *An Anonymous*, 2007, silverpoint on paper, 18 x 18 inches. Student of Sherry Camhy.

Richard Romero, *Julie*, n.d., graphite on paper, 18 x 14 inches. Student of Sherry Camhy.

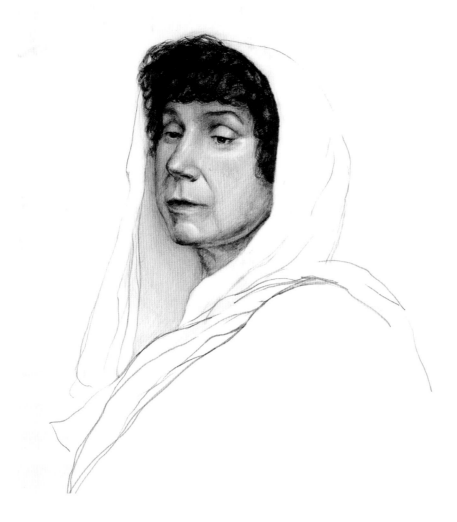

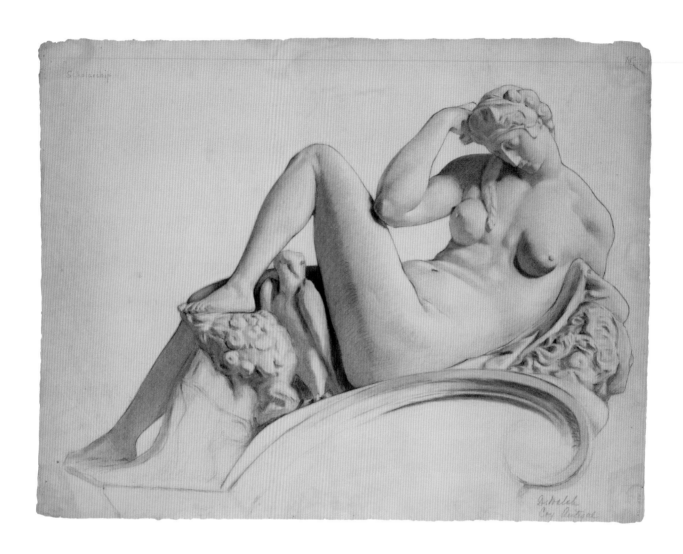

Harvey Dinnerstein

REFLECTING ON THIS DRAWING, I wonder what happened to the student after performing so splendidly in the Antique Class. The highly skilled rendering of the subject, with a rigid outline enveloping the shapes, reflects Cox's view of the Classic tradition. How did this rendering ability, derived from a study of the inanimate cast, affect the student in responding to the human qualities of a living, breathing subject? William Merritt Chase also taught painting classes at the school, with an emphasis on brushwork and fluid edges that suggest the transitory nature of the subject. This indicates to me another sensibility, contrasting Cox's vision of a Classical tradition that encompassed order, harmony, and stability. How did the student resolve these paradoxical elements?

The rigorous training available to art students in the nineteenth century is impressive, but I believe there are many other complex issues the figurative artist must engage, far beyond pedagogical exercises concerned with rendering.

When I began my studies in the 1940s, most of the art school training was focused on Modernist concerns that really did not interest me. The figurative classes that I encountered seemed to engage the most superficial aspects of the great traditions of the past that I was just beginning to study. There was either an emphasis on expressive qualities that lacked the rigorous construction of the great masters, or a focus on craft and rendering, unconnected with other philosophical concerns that I felt were an integral part of the subject. The limitation of these classes implied a separation of form and content that seemed to impoverish the work, resulting in a pale imitation of the distant past.

I finally concluded that the information I yearned for was to be found in museums—where I could study the great artists of the past and try to comprehend technical and conceptual aspects of the work. I also read extensively in old treatises, artists' journals, and art history texts, searching for anything that would provide information on the subject.

In my class at the League, I try to convey those methods that I have found most useful. I emphasize working from life, with the figure as the foundation of the visual image. This includes sight size methods and other approaches to the subject that encourage a bold selection of shapes before the smaller details fall into place. The importance of memory in perception is also advocated, with reference to renowned French art educator H. Lecoq de Boisbaudran's nineteenth-century teaching methods. The construction of figurative compositions is included, from the initial sketch, studies from the model of the individual figures, and the fully resolved composition. I also advocate keeping a sketchbook and responding to the world outside of the classroom. All of this instruction is conveyed with an awareness of the relationship between form and content, considering the individual sensibilities of the student. It is the artist's personal vision, beyond craft and technique, that will ultimately shape the authentic quality of the image.

OPPOSITE PAGE
D. Walsh, Antique drawing, n.d., charcoal on paper. Student of Kenyon Cox, scholarship. Permanent collection, Art Students League of New York.

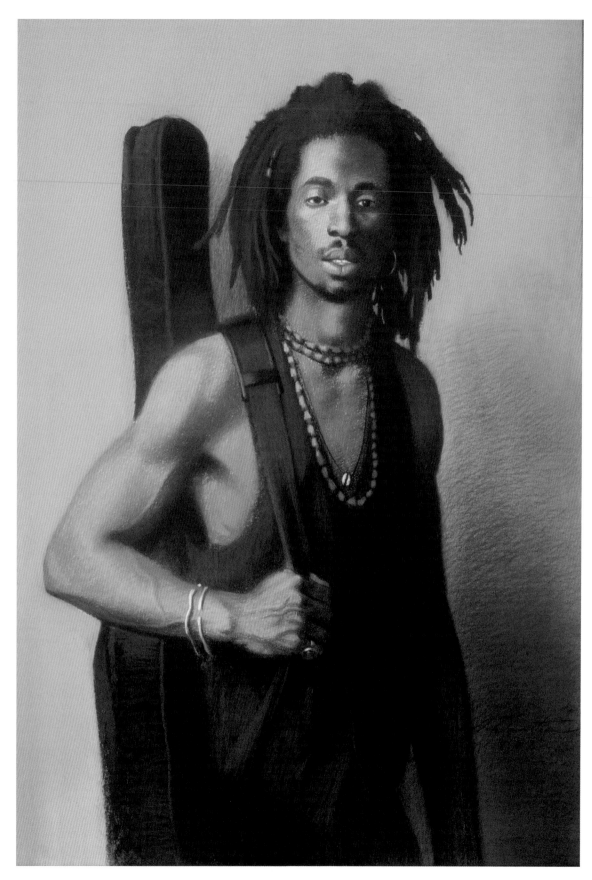

Harvey Dinnerstein, *Rene Akan*, 1991, pastel on
board, 18½ x 29 inches.

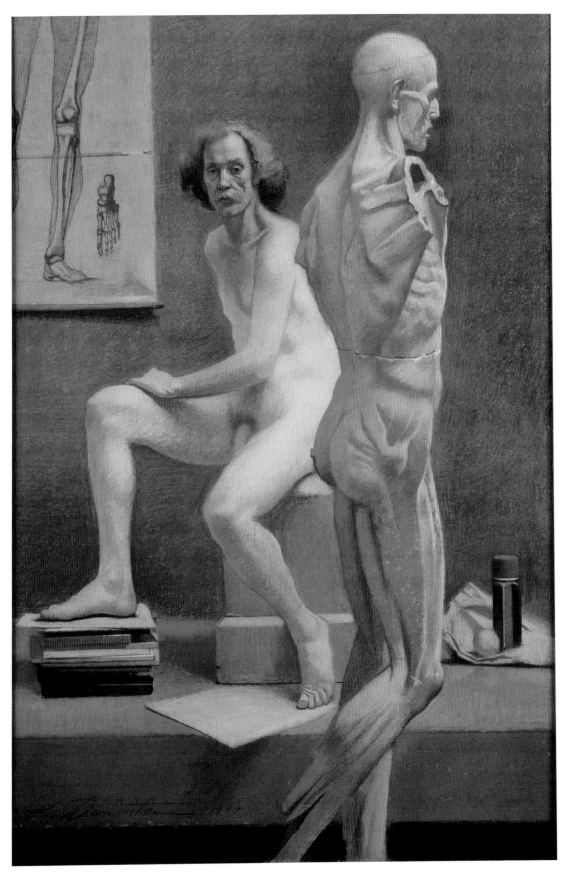

Harvey Dinnerstein, *Figure Studio*, 1978, pastel on board, 27½ x 18 inches.

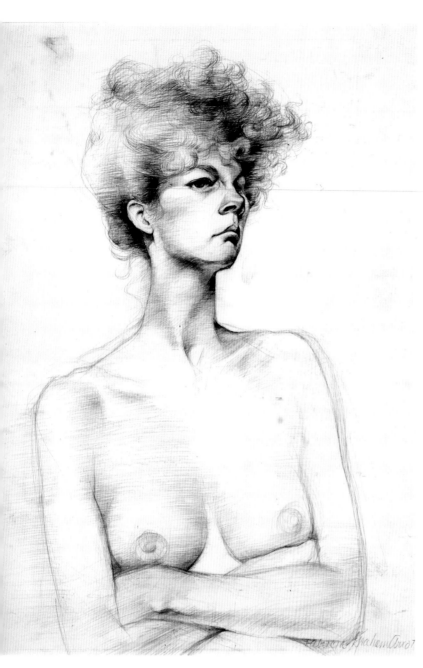

Patricia Graham Arrott,
Seated Woman in Robe,
1986, graphite on paper.
Student of Harvey
Dinnerstein.

Patricia Graham Arrott,
Female Nude Torso,
n.d., graphite on paper.
Student of Harvey
Dinnerstein.

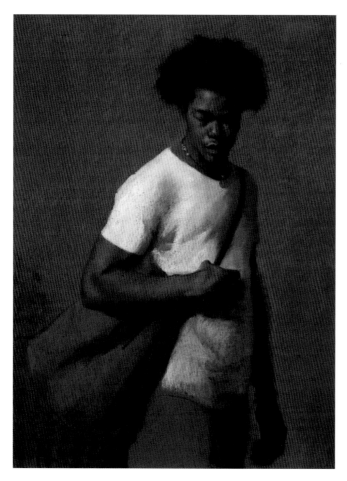

Sam Goodsell, *Untitled
(Man with Bag)*, n.d.,
pastel on paper. Student
of Harvey Dinnerstein.

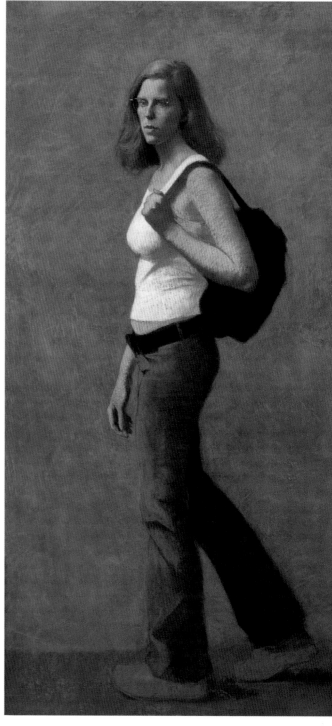

Sam Goodsell, *Untitled
(Woman with Bag)*, n.d.,
pastel on paper. Student
of Harvey Dinnerstein.

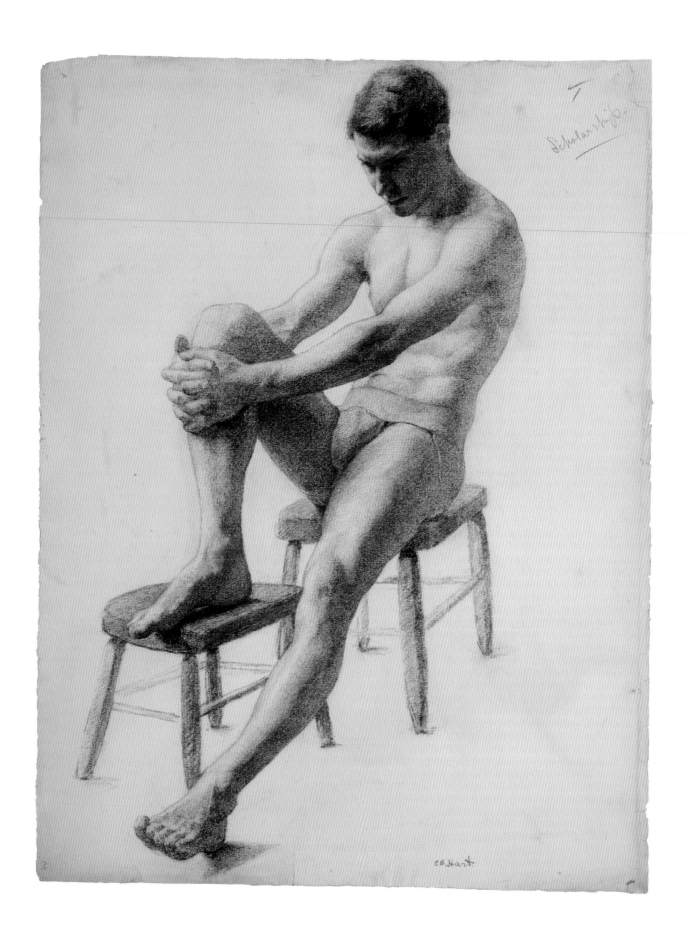

Scholarship.

E.B.Hart.

Ellen Eagle

THE FIRST THINGS I LOVED ABOUT the wider world when I was growing up were drawings and paintings. I was fascinated that lines and shapes arranged on a flat surface could summon an emotional response. Most especially, I loved paintings of people. Solid physiognomies of individuals, when warmed by the penetrating love and sympathy of the artist, convey authenticity of a gorgeous intensity. These heartfelt paintings, so beautifully observed and constructed with specificity and elegance, say "Look. Do not turn your back on this person. See how important she is." They drew me in and transported me.

I try to impart this attitude of observation to my students. I hope to help them know the joy one can feel if one brings an exploratory eye to the subject, to look quietly, with patience and humility. To know what it is to submit to the reality of an individual and not think "I have to turn this subject into something beautiful."

I stress simplicity. The goal is to observe the model's form and value relationships with a clear eye, and to distill this complex information into a simply expressed harmonious construction. If we are attentive to the way in which the light reveals and veils form and creates atmosphere around the form, our tones will be perfect, each note intensifying the beauty of the others, nothing discordant.

This lovely *académie* drawing is an example of these practices. Its strength and beauty derive from the restraint of the artist, who respects the light, gracefully massing the large planes. The artist's control of these elements and their selection beautifully underscore the gesture expressed by the sitter, a young man whose body both reaches outward and folds inward. His concentration is visible in his brow, his thumb poised in upward motion, separating from the fingers clasped tight, grasping his leg. The big toe on the floor repeats the lift. The young sitter uses his own strength to support his introspection—the power of restraint. I like this drawing more each time I look at it.

I am drawing a portrait of my model, in profile. She faces the light. The rise of her forehead, the assertion of her nose displacing this bit of air, the hair pulled back in opposition to the diagonal of the jaw, slender shoots of hair fanning out from her tightly gathered bun. Sometimes she sits up energetically; at other times she needs to rest back in her chair, her shoulders settling downward. Her lips part in private thought, then resolve shut. Her skin tones seem impossible, but they are true.

My love is to tell how perfect it all is.

OPPOSITE PAGE
E. B. Hart, Academic drawing, n.d., charcoal on paper. Permanent collection, Art Students League of New York.

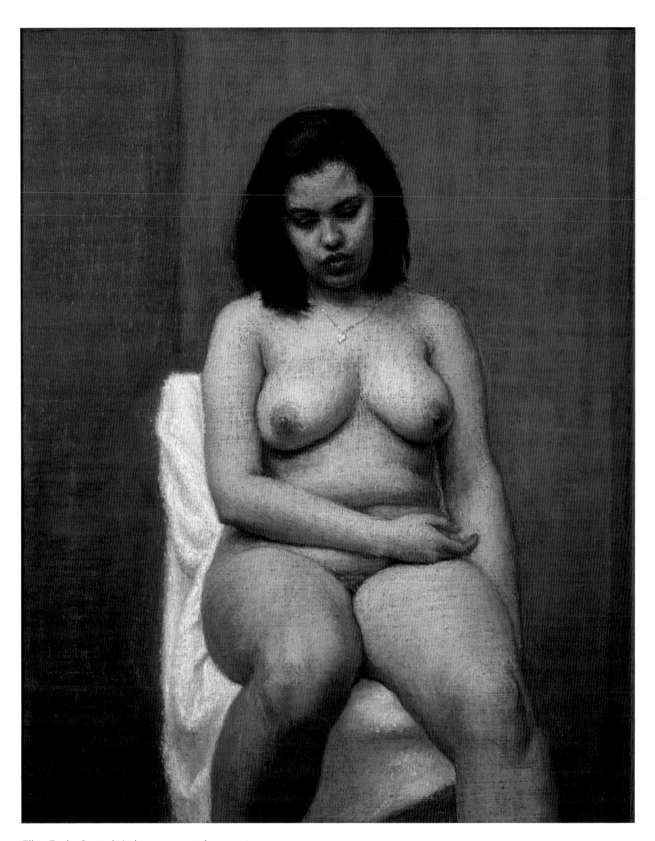

Ellen Eagle, *Seated Nude*, 2000, pastel on pumice
board, 8¾ x 7 inches. Courtesy Forum Gallery.

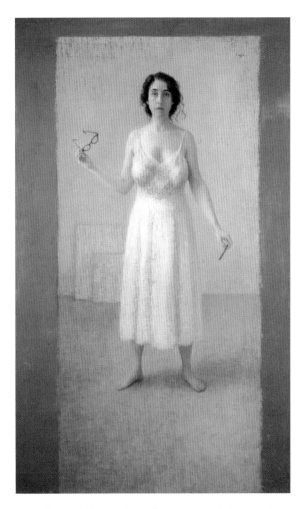

Ellen Eagle, *Self-Portrait in Blue*, 2003, pastel on pumice board; 35¾ x 16⅝ inches. Courtesy Forum Gallery.

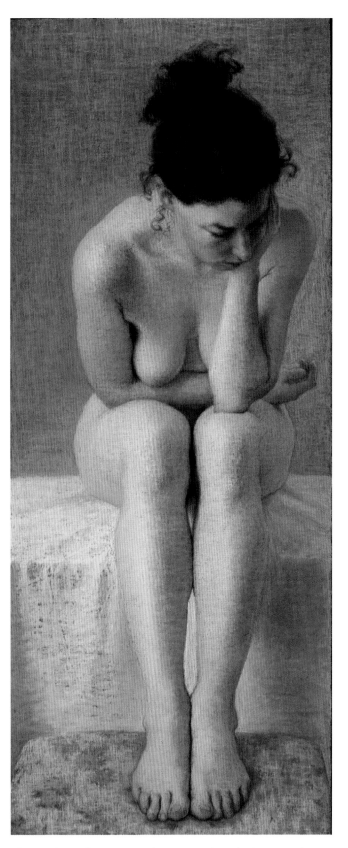

Ellen Eagle, *Nude*, 2001, pastel on pumice board, 31½ x 13 inches. Private collection.

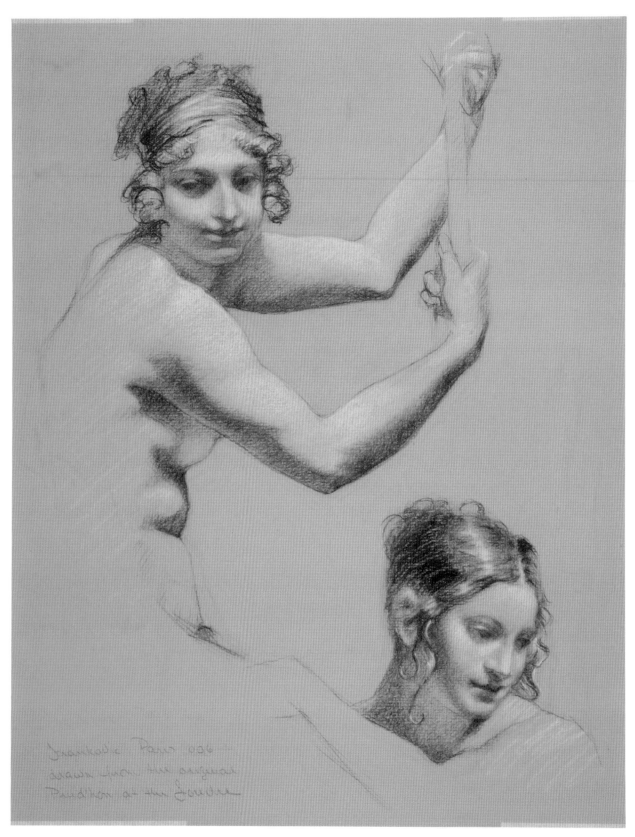

Janet Francovic, *Drawing after Prud'hon*, 2006,
black and white charcoal on paper, 14 x 11 inches.
Student of Ellen Eagle.

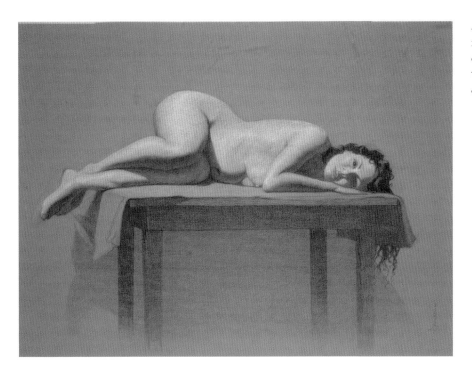

Janet Francovic, *Maria*, 2006, black and white charcoal on paper, 18 x 24 inches. Student of Ellen Eagle.

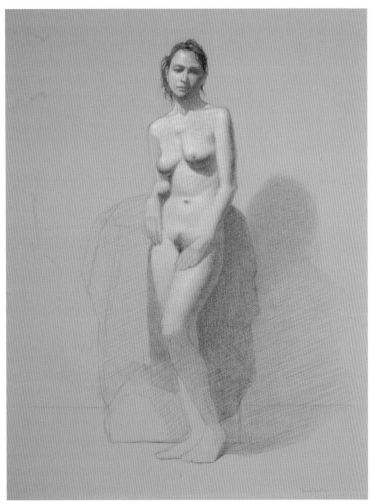

Janet Francovic, *Louisa*, 2006, black and white charcoal on paper, 24 x 18 inches. Student of Ellen Eagle.

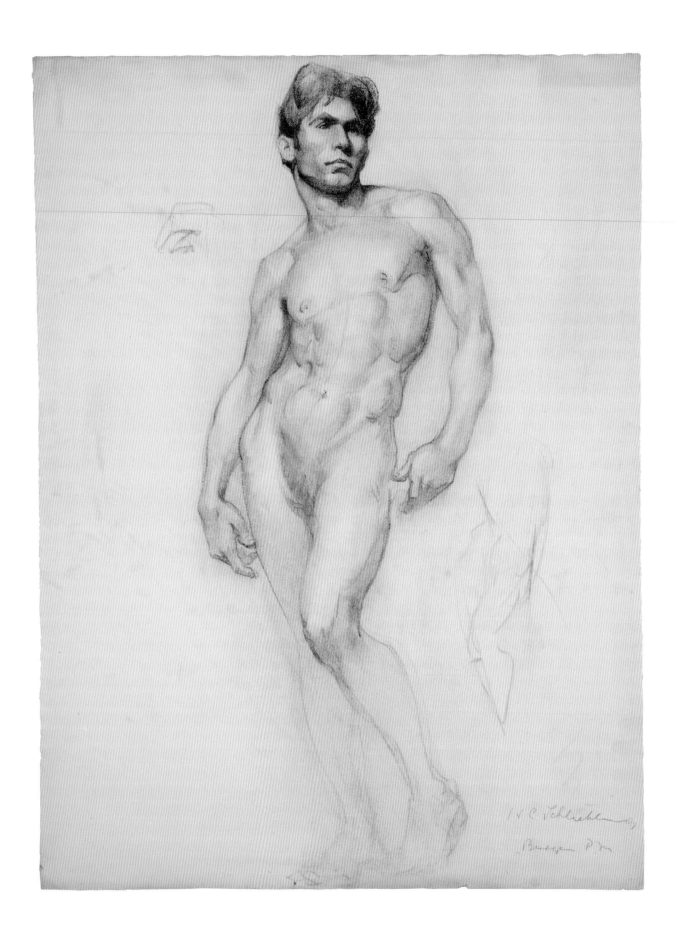

Jack Faragasso

THE ARTIST FRANK J. REILLY FOUNDED HIS eponymous school of art in 1961 in New York. When Professor Reilly died in 1967, I became director of his school, where I was already an art instructor. Because of the overwhelming prevalence of trends and artistic movements that made the teaching of Classical and academic art practically nonexistent, I saw myself as a vital link between the past of Classical teaching, and its future. I was sure it would eventually return, and so it has.

My only art training came from Mr. Reilly, who studied painting with Frank V. DuMond and drawing with George Bridgman. Both of these artists had studied with Jean-Léon Gérôme (1824–1904), who had studied with Paul Delaroche, who studied with Jean-Auguste-Dominique Ingres, who in turn had studied with Jacques-Louis David and thus represented an instructional lineage back to the founding of the French Academy in 1648.

Mr. Reilly had absorbed all that his teachers had to offer, adding his own ideas to theirs, evolving a complete and related system of painting and drawing that broke up traditional academic drawing into the basic elements of form and plane, light and shade, and then elaborating on them together. He insisted that we not draw by copying, but by constructing the figure according to his system, which also included anatomy, proportion, and line—structures informed by concepts of "action" and "growth." This, he maintained, was drawing in its most complete sense.

The male *académie* drawing illustrated here exemplifies the concept of "action"— the figure drawn from one side of the body to the other—not up one side and down the other. Our eye follows the movement of the body from the top of the left shoulder across the body to the weight descending onto the right foot. The active side of the figure should be stressed by delineating the muscular forms, making them more pronounced than the muscles on the relaxed, inactive side of the figure. A complete drawing system is contained in my book *Mastering Drawing the Human Figure from Life, Memory, Imagination*. What I teach is therefore firmly founded on the basic Classical principles to which Mr. Reilly adhered—and added to, and to which I now have also added.

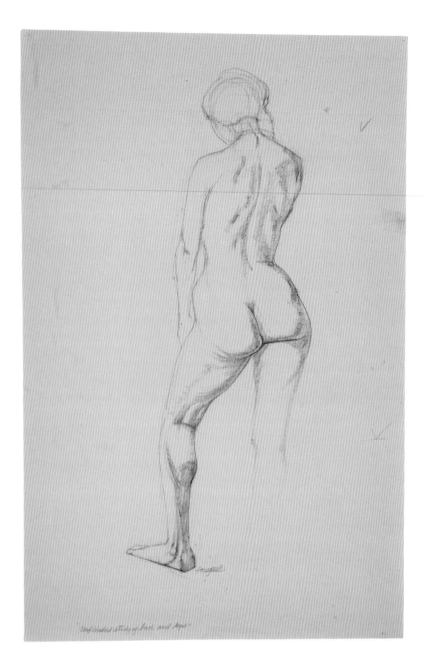

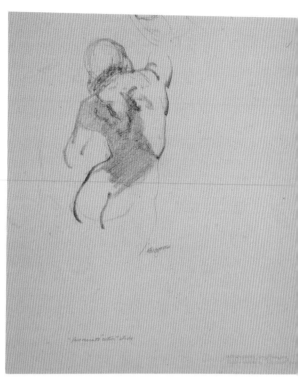

Jack Faragasso, *Five-Minute Action Study*, n.d., charcoal and sanguine on newsprint, 11¾ x 10½ inches.

Jack Faragasso, *Standing Female Nude*, n.d., charcoal on newsprint, 15 x 10 inches.

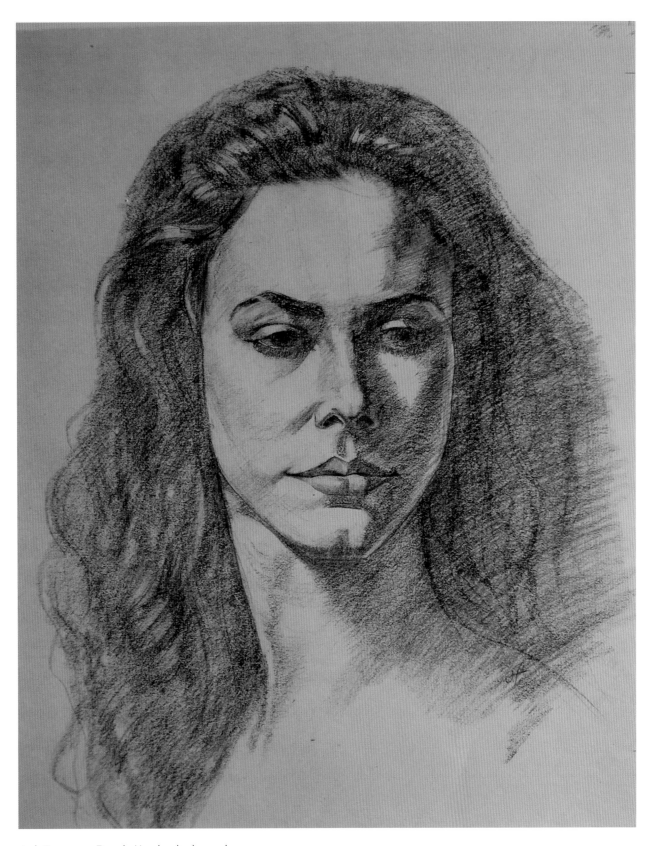

Jack Faragasso, *Female Head*, n.d., charcoal on
newsprint.

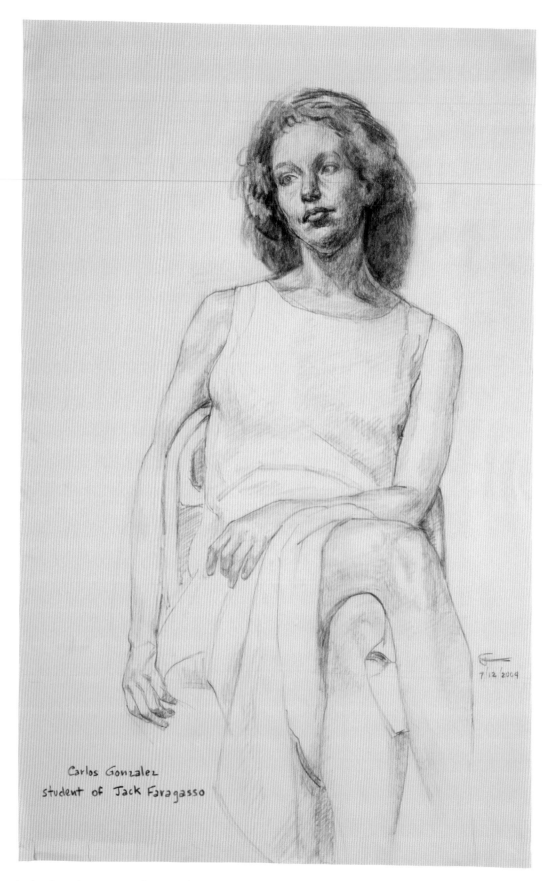

Carlos Gonzalez, *Portrait of a Seated Woman*, 2004, charcoal
on newsprint, 17½ x 12 inches. Student of Jack Faragasso.

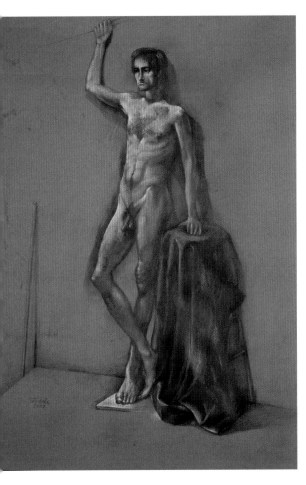

Alejandro Torre, *Standing Male Nude*,
2008, black and white chalk on paper,
24 x 18 inches. Student of Jack Faragasso.

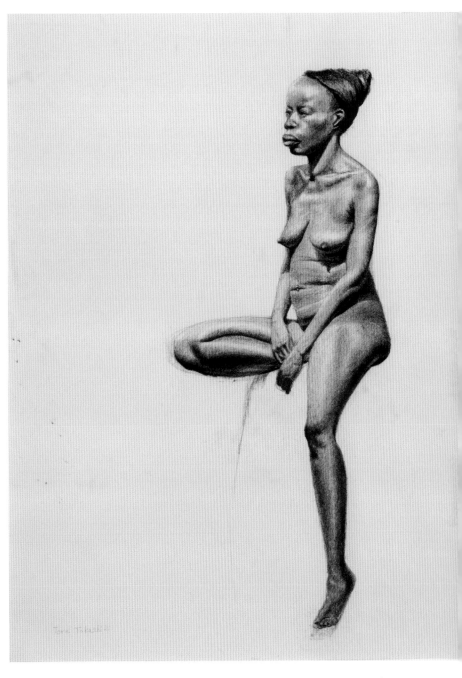

Toru Tokashiki, *Seated
Female Nude*, n.d.,
charcoal on paper, 18 x 11
inches. Student of Jack
Faragasso.

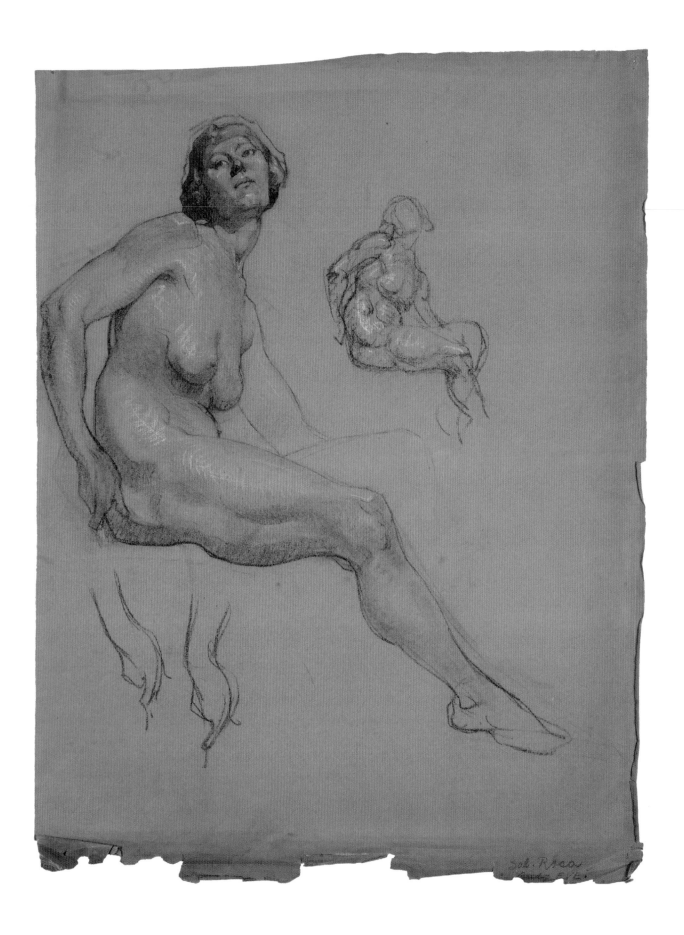

Leonid Gervits

CLASSICAL DRAWING WAS INTRODUCED TO ME in the early 1960s when I enrolled in art college in Odessa, but its significance was not apparent to me until I began studying at the Repin Institute in Leningrad Russia (1967–73). My opinion, shared by my teachers and fellow students, is that Classical drawing is the true foundation of visual art, industrial design, and architecture.

Studying at Repin gave me the opportunity to visit important collections like the Hermitage, which includes works by Peter Paul Rubens, Anthony Van Dyck, and Rembrandt—and other Russian museums' collections of Ilya Repin, Jean-Baptiste Greuze, and Karl Pavlovic Brullow. As a student, and then later as a professor, I had the thrill of holding original works by great artists in my own hands. Classical drawing is not just an auxiliary to painting, sculpture, and other disciplines: it is a beautiful, complex, and independent art form. After thirty years of making and teaching art, I am convinced that drawing is equal in importance to all other fine-art disciplines.

This drawing makes a good conventional effort to convey the figure correctly. Unfortunately for the main part of the image, the small sketch on the margin is more persuasive in terms of spatial plasticity, anatomical strength, and artistic bravery. Despite its shortcomings, the overall drawing can be considered successful as a studio sketch.

During ten years' immersion in Classical art training, each assignment I faced was calculated to be more challenging than the one before. Some of my teachers favored a *perceptual method* based on careful observation of the human figure by accurately measuring directions and proportions, while others advocated an *analytical approach* based on science, anatomy, and proportional canons described by ancient Greeks and later elaborated in Renaissance treatises. Despite obvious differences, both methods share Classical roots.

My strict academic training allows me to work fearlessly, to execute any idea, make tonal or color studies for figurative compositions, even without a live model. Feeling free every day to take my brush, I can go ahead and paint the figure in any of its twists and turns. Such training brings students to the higher ideals of art, providing them with ways of fully appreciating and participating in a tradition spanning thousands of years that celebrates harmony, refinement, and the human form as the eternal ideal of beauty. Raphael, Michelangelo, Nicolas Poussin, Antoine Watteau, Eugène Delacroix, Edgar Degas, Repin, Valentin Serov, and many other stars in the Classical firmament worshiped drawing most of all.

Beginning my teaching career in 1975, I have always based my instructional approach on Classical drawing methods. Comparing the posed model to drawings made by students working from direct observation is the most widely practiced approach to life drawing, but many beginning students lack a sense of proportion and

OPPOSITE PAGE
Sal Rosa, Academic drawing, ca. 1924, charcoal on gray paper, 24½ x 18½ inches. Student of George Bridgman. Permanent collection, Art Students League of New York.

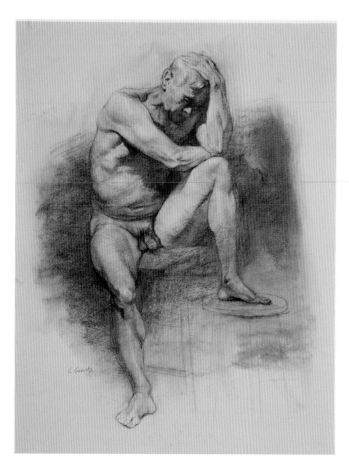

have difficulty judging what is smaller or larger (and by how much) and what is closer or farther away (and by what distance). Simply put, understanding these fundamental relationships and knowing how to translate them accurately into a drawing can only be attained by a sustained effort to copy nature.

Edgar Degas, an admirer of the indisputable genius Jean-Auguste-Dominique Ingres, is reported to have said that drawing does not describe shapes themselves, but what we think about these shapes. To paraphrase Ingres, if I were to put a sign on my studio it would be that this is the school of drawing.

ABOVE
Leonid Gervits, *Seated Male Nude*, n.d., chalk on paper, 25½ x 19½ inches.

RIGHT
Leonid Gervits, *Anatomical Studies of the Male Nude*, n.d., sanguine on gray paper, 18 x 23 inches.

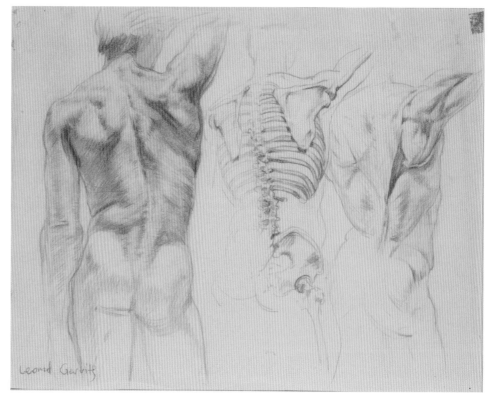

Leonid Gervits, *Belvedere Torso*, 2000, graphite on paper, 11½ x 9 inches.

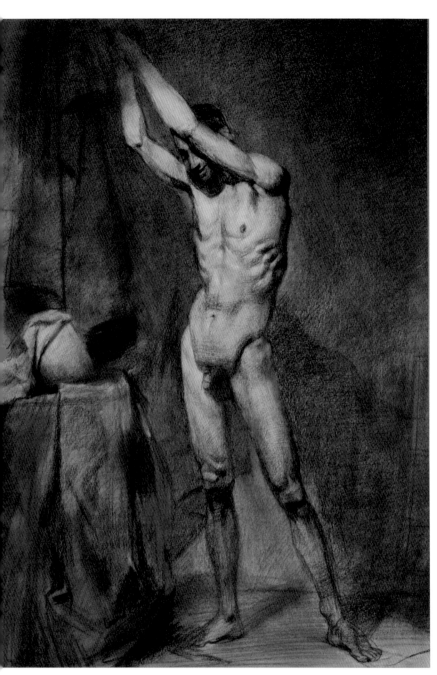

Leonid Gervits, *Standing Male Nude, Arms Raised*, n.d., charcoal on paper, 24 x 17 inches.

Takashi Uesugi, *One-Minute Pose Studies of Female Nude*, n.d., charcoal on paper. Student of Leonid Gervits.

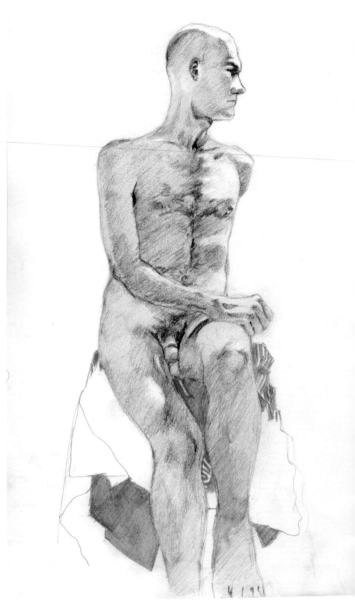

Garegin Nalbandian, *Seated Male Nude, Looking to His Left*, graphite on paper, 11 x 8½ inches. Student of Leonid Gervits.

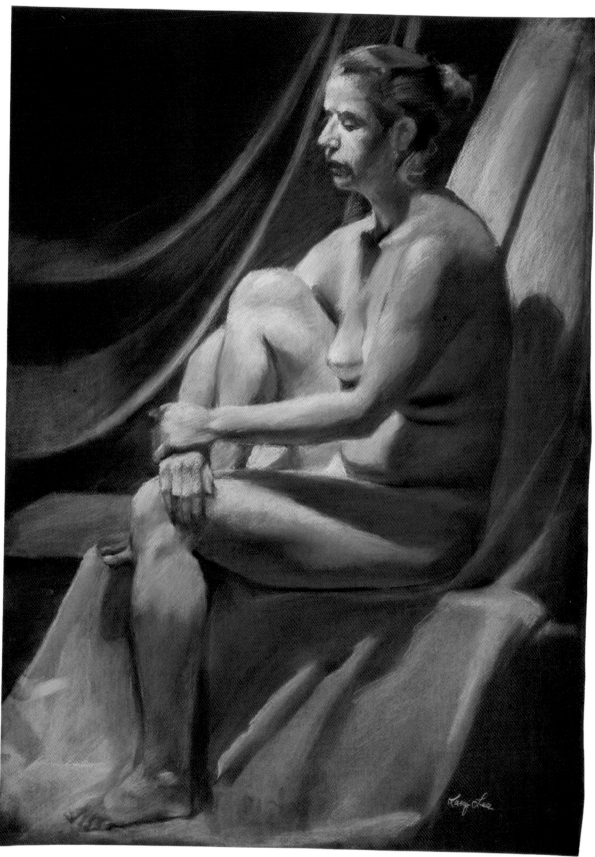

Larry Lee, *Paula*, n.d., white chalk on black paper,
27 x 20 inches. Student of Leonid Gervits.

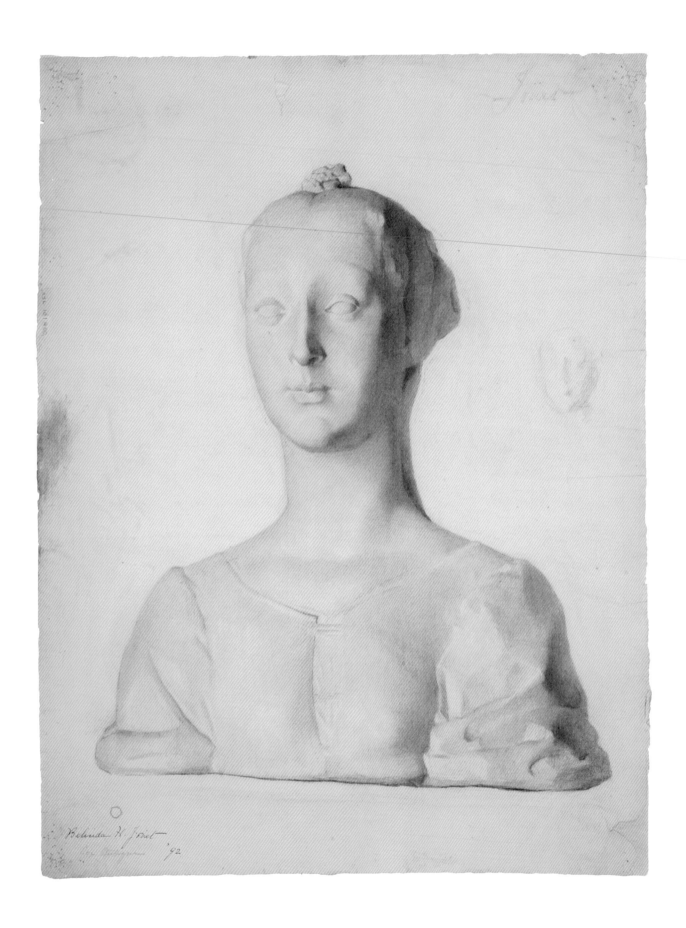

Dan Gheno

I TELL MY STUDENTS THAT AN ARTIST'S EDUCATION does not end when his or her formal training is over. For figurative artists especially, it is a life-long pursuit. Expanding one's knowledge of the human form evolves into a greater understanding of the very forms we inhabit, conditioned by psychology and environment. Whatever your artistic goals—whether you pursue abstract, expressionist, or realistic goals with the human figure—those goals require the constant exercise of eye-hand coordination. Drawing at least a little bit every day throughout your life will refine your manual ability to translate what your eye sees and your mind grasps into a graphic visual idea.

You have to start someplace in your education as an artist. Academies and schools offering traditional skills guide students through a series of steps, where they first study masterpieces by copying master drawings, usually from reproductions. Later they draw from three-dimensional plaster casts until they are finally ready to work from the living, breathing human being.

I advocate a less linear approach by encouraging my students to work from life immediately, so that, from the very beginning, they develop gut-level passion and the kind of excitement that only comes from working from a live model, and they can start to experience some of the problems of value, proportion, and line specifically associated with life drawing. Master drawings become a sort of "answer book" to see how the experts solved the same problems they might encounter in a life studio. While cast drawing is usually associated with "novices," mature artists frequently return to cast drawing to refine their use of tonality. I often tell my students to draw from marbles and plaster statuary, illuminated by a single light source whenever possible, because it will give them the greatest range of lights and darks.

The cast drawing reproduced here explores statuary that is nearly white and thus devoid of colors that might confuse the students' study of values created by light falling on form. Marble sculpture has a decided advantage over plaster casts, being, like skin, slightly translucent. Light seems to shimmer across marble surfaces, and within them. Highlights and shadow edges seem to glow as light moves across human flesh and marble, while on more opaque plaster casts these effects become flatter, matte and comparatively lifeless. Nonetheless, it is very useful for students to work from plaster casts when they are available.

I still occasionally draw from sculpture, and draw models in the studio every day, but bear in mind that because life is not confined to the model stand, neither is drawing.

It is important to carry a sketchbook with you, drawing people wherever you go, in restaurants, on the bus or subway, even from TV if the subject matter is compelling. The important thing in drawing is to practice by looking at life, not just performing academic exercises. Drawing is a visual quest, gathering information, ideas, and inspiration, perhaps for more finished artworks or perhaps to stand on their own as finished works of art.

OPPOSITE PAGE
Belinda Jouet, Antique drawing, 1892, charcoal on paper,
24¼ x 19½ inches.
Student of Kenyon Cox. Permanent collection, Art Students League of New York.

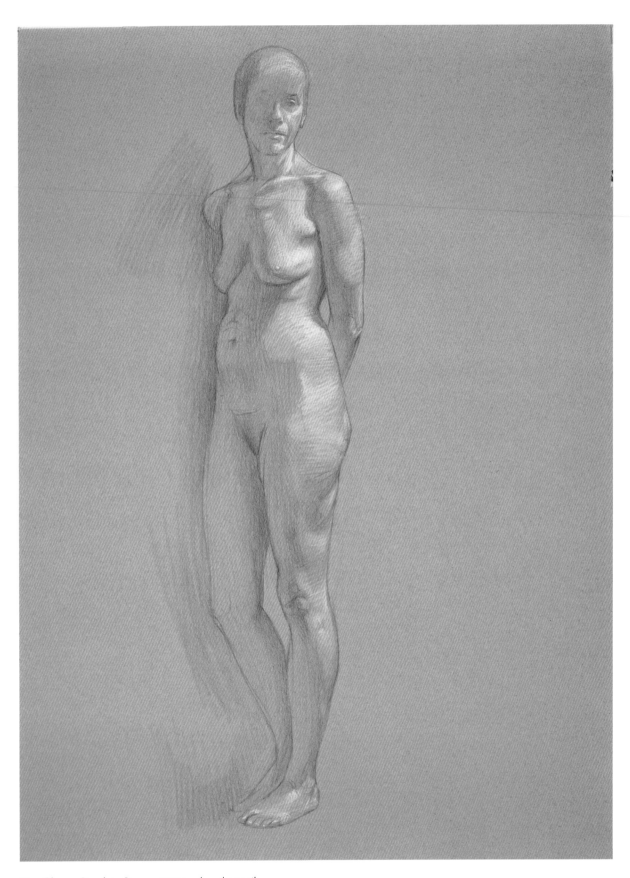

Dan Gheno, *Resolute Stance*, 2007, colored pencil
and charcoal on toned paper, 24 x 18 inches.

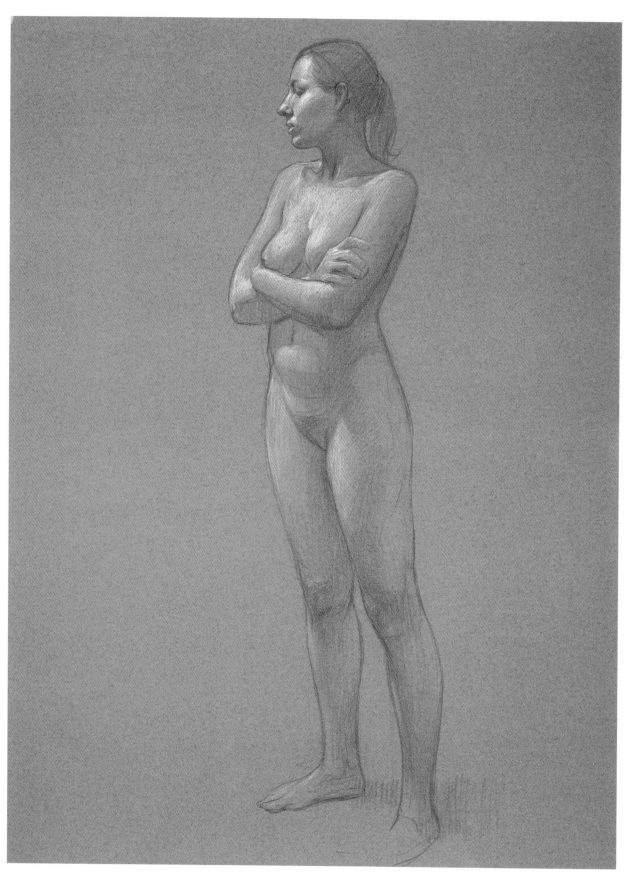

Dan Gheno, *Determined Woman*, 2007, colored
pencil and charcoal on toned paper, 24 x 18 inches.

RIGHT
Robin Smith, *Betty*, 2008,
graphite on bond paper,
9 x 12 inches. Student of
Dan Gheno.

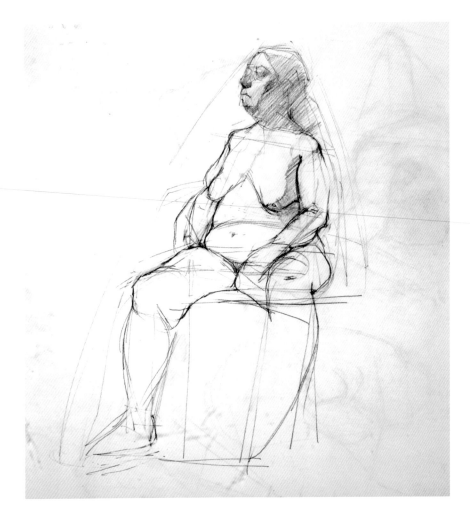

BELOW
Robin Smith, *Sleep*, 2007,
pastel and charcoal on
gray toned paper, 7 x 10
inches. Student of Dan
Gheno.

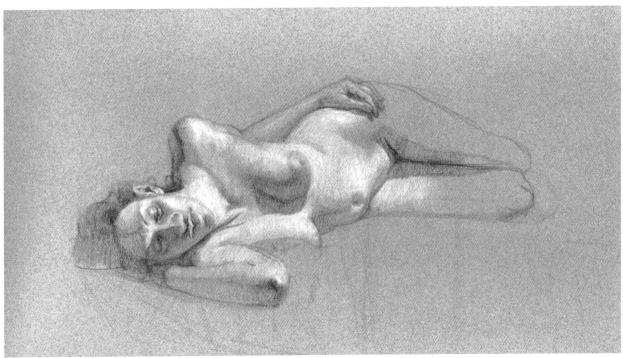

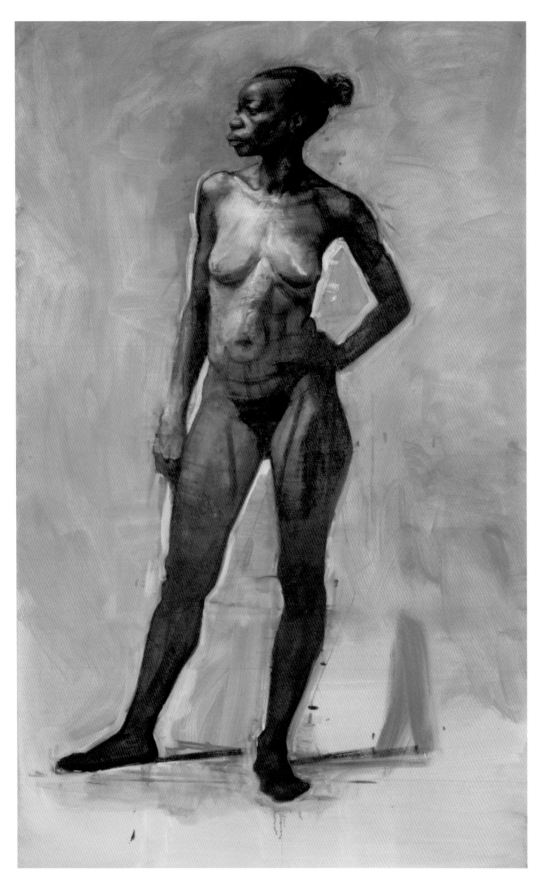

Robin Smith, *Connie*, 2007, oil on canvas, 30 x 48 inches. Student of Dan Gheno.

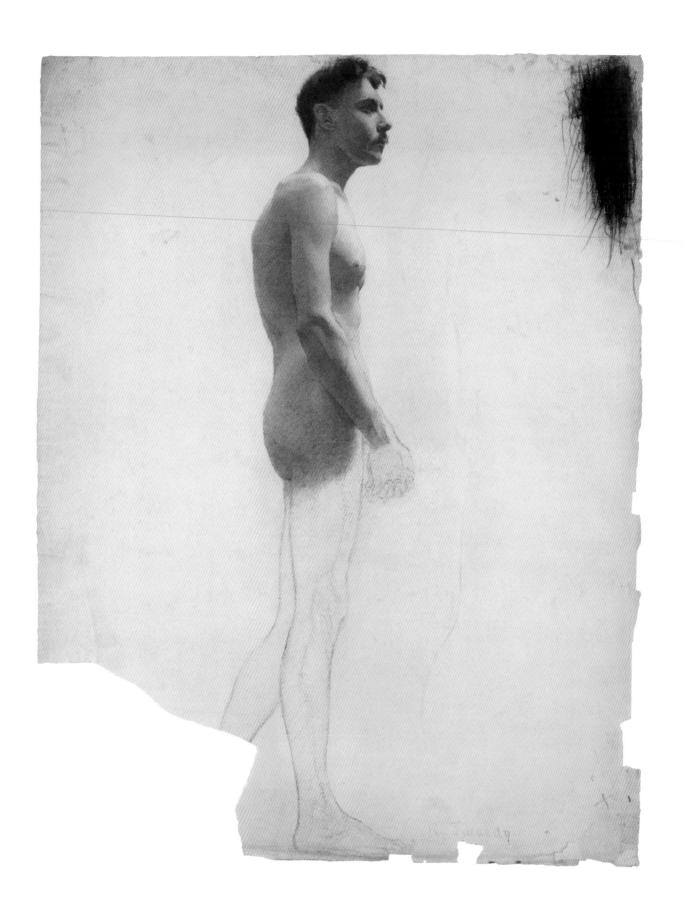

Michael Grimaldi

MY FIRST AWARENESS OF CLASSICAL DRAWING came to me as a child when I encountered a reproduction of Andrea Mantegna's *Saint Sebastian* in Anthony F. Janson's *History of Art*. Immediately held rapt by Mantegna's uncanny proficiency in rendering the human figure within an environment, capturing human emotion, and conveying his own ethos within a picture, I later came to realize that a vast pool of knowledge had gone into Mantegna's pictures and how his mastery of Classical drawing principles was paramount to his achievement.

Through disciplined practice, Classical drawing will develop the artist's sensitivity to the seen world. Exhaustive study of diverse aspects of visual experience challenges us constantly, expanding our vocabulary while honing skills to accurately translate complex visual phenomena into coherent pictorial statements. The study of classical drawing is beneficial to all art forms.

When I arrived at the Art Students League of New York, I was a student confident that the two prerequisites of becoming a good draftsman were practice and talent. My instructors quickly taught me that these attributes were negligible without first committing to studying Classical principles, anatomy, perspective, composition, optics, and color theory—in short, learning to see. Developing fundamental skills, problem-solving, self-criticism, and correction—plus cultivating a capacity for a sincere and lifelong devotion to one's work—were critical.

For works of art to become timeless, I feel that they must be created by artists with progressive mind-sets who interpret their own environment in unique and personal ways, while drawing on the wisdom of the past. Tapping into the lineage of Western art and becoming familiar with the myriad artists' vocabularies throughout history give me a constant source of inspiration and a base of knowledge to build upon. This allows me to sustain a holistic appreciation of the Classical tradition in practical, historical, and theoretical terms, as they pertain to my immediate personal experience—steadfast in my belief that a thorough understanding of Classical drawing is essential to creating works of art that both address and define contemporary art and culture.

The influence of classical drawing can be seen in Richard Tweedy's *Standing Male Nude*, executed during his studies with H. Siddons Mowbray at the League. Consistent with his other figure drawings done at this time (between 1894 and 1898, before studying painting with Joseph DeCamp in 1899 and 1900), one can see the attention Tweedy paid to the effects of perspective, proportion, gesture, and graphic shape in the early stages of the drawing. Building on this strong foundation, Tweedy clearly shows an advanced understanding of how light and shadow affect complex anatomical forms, resulting in an exquisite solid and volumetric expression of human form created by the application of advanced drawing principles—goals shared by most art students during the late nineteenth and early twentieth centuries.

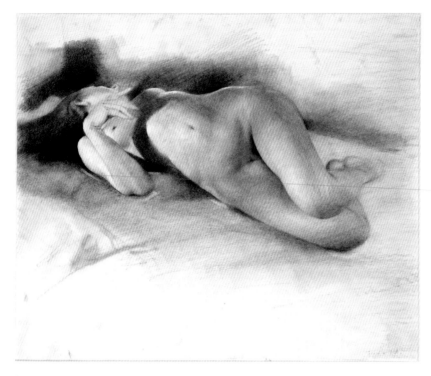

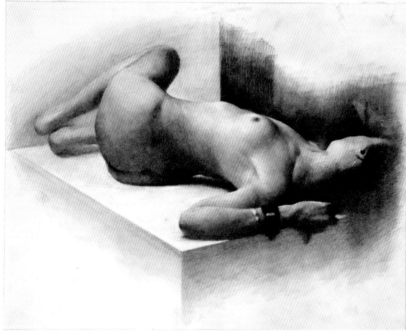

My teaching favors presenting the elements of Classical drawing independent of one another, reconstructing and combining them with the other elements to create holistically unified drawings and paintings. I show my students how to see and apply proportion, gesture, constructive anatomy, perspective, and the effects of light on form, and to integrate these elements into the construction of their drawings. I also illustrate how to investigate perceptual and theoretical aspects of the visual language that forms the basis of all Classical endeavor: striving to learn from the past and expand our knowledge from personal discoveries. Fostering the ability to meet visual experience with the same intelligence and knowledge they bring to their own work, I encourage students to seek answers to their own questions as a way of empowering them to actively participate in a progressive tradition of creating unique and lasting works of art, while challenging them, providing support and inspiration, demanding their best effort, and preparing them to continue pursuing their own artistic goals—which may be very different from my own.

TOP
Michael Grimaldi,
Doppelgänger, 2005,
graphite on paper,
14 x 18 inches.

ABOVE
Michael Grimaldi,
Untitled (Reclining Female Nude), 2005,
graphite on paper,
11 x 14 inches.

Michael Grimaldi, *Judgement of Paris*, 2007,
graphite on paper, 24 x 18 inches.

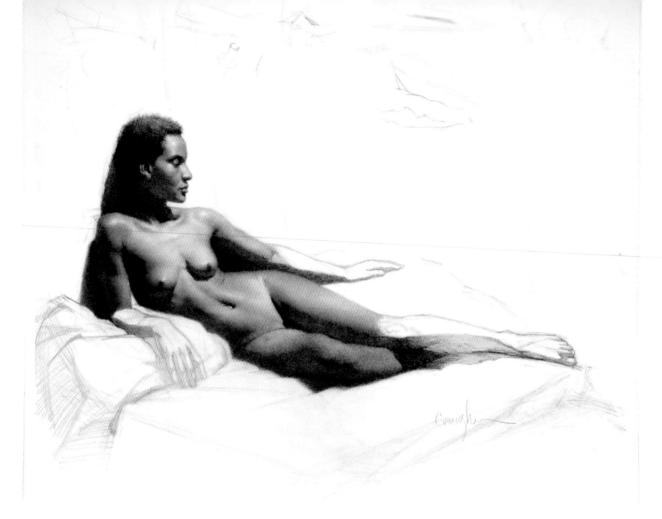

Angela Marie
Cunningham, *Female
Reclining*, 2008, pencil
on paper, 18 x 24 inches.
Student of Michael
Grimaldi.

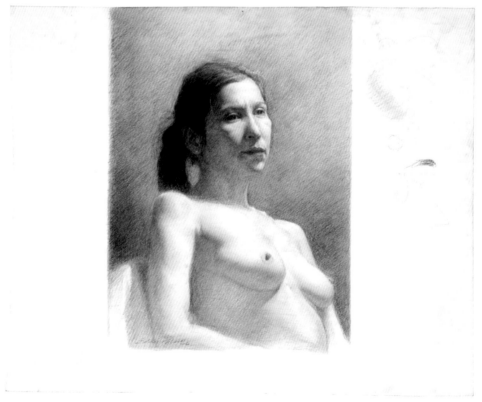

Eddie Nino, *Female Nude
Torso*, 2006, graphite on
paper. Student of Michael
Grimaldi.

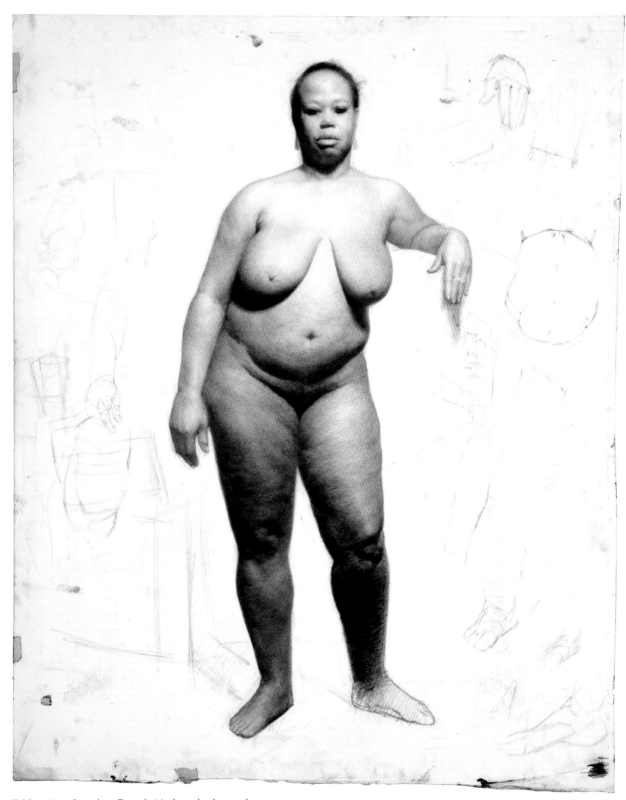

Eddie Nino, *Standing Female Nude*, n.d., charcoal
on paper. Student of Michael Grimaldi.

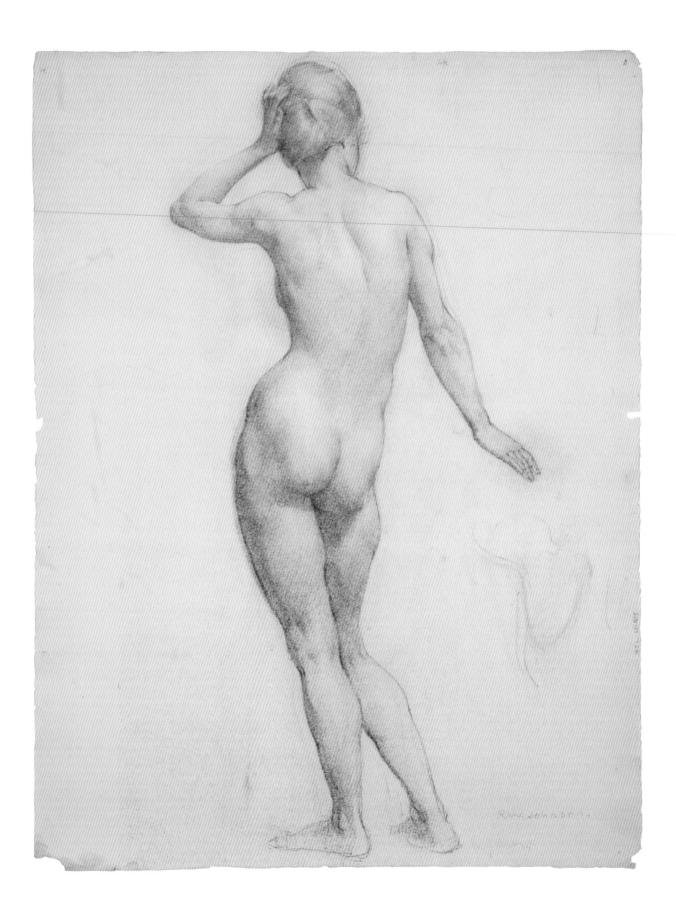

Gregg Kreutz

THE MODEL IS POSING. THE ARTIST WANTS to accurately draw what is being observed. How is that done?

A beginner will probably start by carefully trying to match the drawn line with the outer edge of the model. This outline technique may end up resembling the model, but it will necessarily be a superficial resemblance. Copying, even when it involves a lot of careful measuring, will not communicate the deeper aspects of what's going on.

Beautiful drawing is about integration, not measurement. It is about the artist, model, pose, hand, pencil, and paper all converging into a unified act. That's the real answer to how to draw: empathy. And Classical drawing—in the sense that I am using the term—is based on empathy.

In practical terms, then, how do you draw? If measurement isn't the way, how do you make a convincing drawing? The answer is seeing. You need to see what is really going on. This seeing involves not only seeing the surface details of the pose, but seeing the inner structure that is holding the pose together. The artist needs to find the rib cage under the flesh, figure out how it relates to the direction of the pelvis, visually penetrate the skin to the muscles beneath the surface and watch how they are straining—or relaxing—in the service of the gesture. This seeing doesn't depend on extensive anatomy knowledge. Anatomy—memorizing, say, lots of muscle names—can become another barrier to direct observation. Just a general sense of what is going on below the surface will be enough. After all, I'm told that in Classical Greece they didn't dissect bodies; all their sense of anatomy was from direct observation of the living model.

Of course, the artist also needs to be sensitive to his or her response to the pose. Everything cannot be depicted. There needs to be some selection, some editing, and that selection comes from figuring out what aspect of the pose has the most impact on the artist. There needs to be a sensitive selection of the quality that is most striking about the model. The skillful drawing on the opposite page, from the Art Student's League archives, is wonderfully sensitive to action and flesh and dimensionality; but to my eye, more selection would have made it even better. Everything in the drawing is spelled out to the same degree—each detail is finished so completely that you cannot tell what the artist is particularly inspired by, and that makes the drawing a little less evocative, a little less artful.

Drawing is hard. In a way, it is harder than painting. The artist's essential nature is exposed on the page, with no color or paint texture to distract the viewer. The lines tell very explicitly who the artist is. It may be that this exposed quality is why so many artists are attracted to a formula or stylization: something they can hide behind. Great drawing, though, can't flower in such constricted circumstances. Great drawing can only happen when preconceptions and inhibitions are shed and sensitivity is allowed to flourish.

OPPOSITE PAGE
R. W. Johnson, Academic drawing, n.d., charcoal on paper, Student of George Bridgman. Permanent collection, Art Students League of New York.

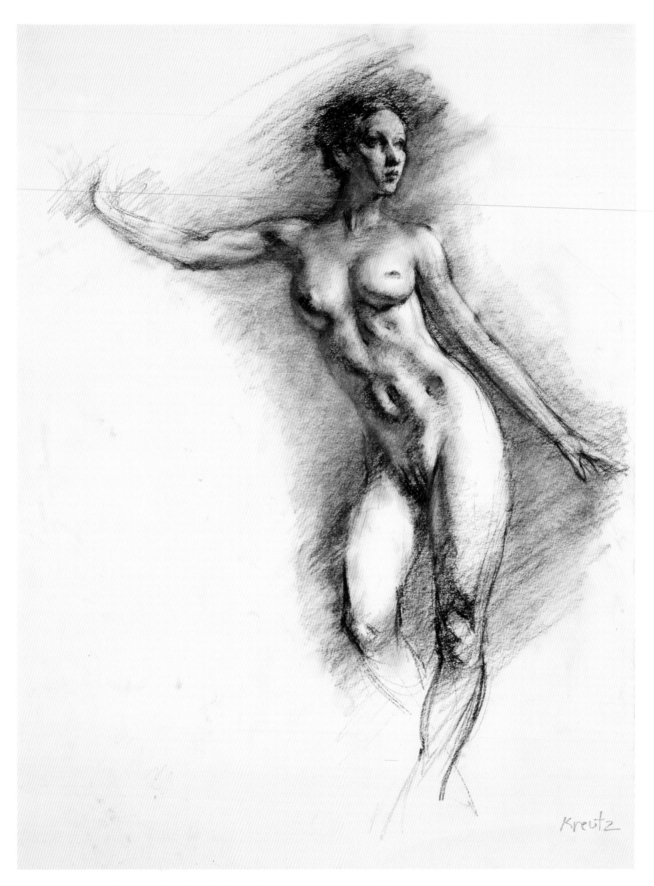

Gregg Kreutz, *Standing Female Nude*, n.d., charcoal
on paper, 22 x 16½ inches

Gregg Kreutz, *Male Head*, n.d., charcoal on paper, 10½ x 9½ inches.

Gregg Kreutz, *Man with Mustache*, n.d., charcoal on paper.

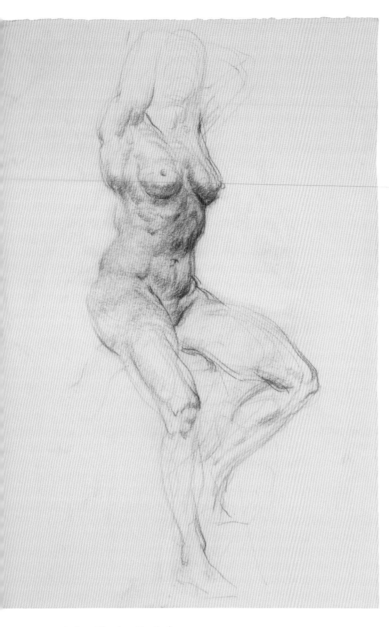

Lukas Charles, *Seated
Female Nude with
Upraised Arms*, n.d.,
sanguine on paper,
17 x 14 inches. Student
of Gregg Kreutz.

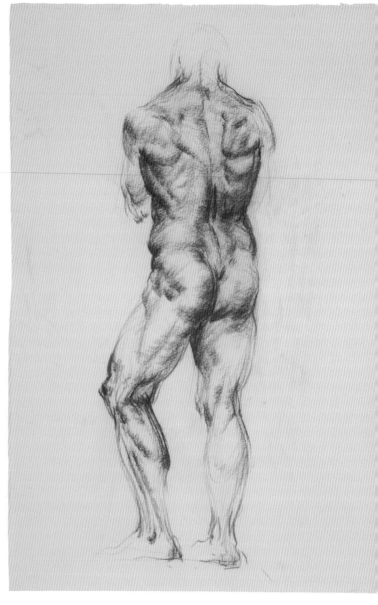

Lukas Charles, *Standing
Male Nude*, n.d., sanguine
on paper, 17 x 14 inches.
Student of Gregg Kreutz.

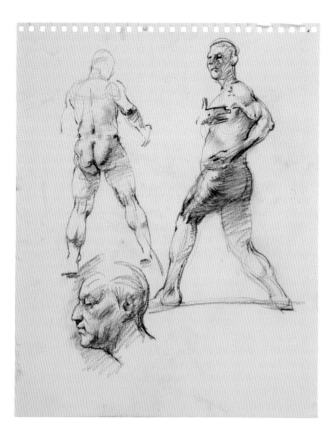

Mitchell Marco, *Short Pose Male Studies*, n.d., charcoal on paper, 17 x 14 inches. Student of Gregg Kreutz.

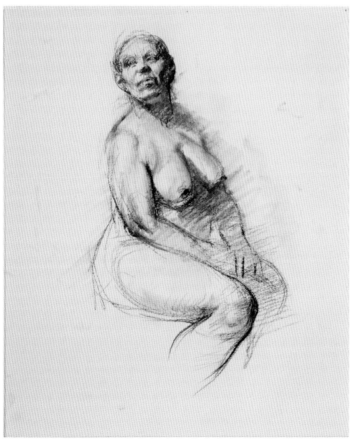

Mitchell Marco, *Seated Female Nude*, n.d., charcoal on paper, 17 x 14 inches. Student of Gregg Kreutz.

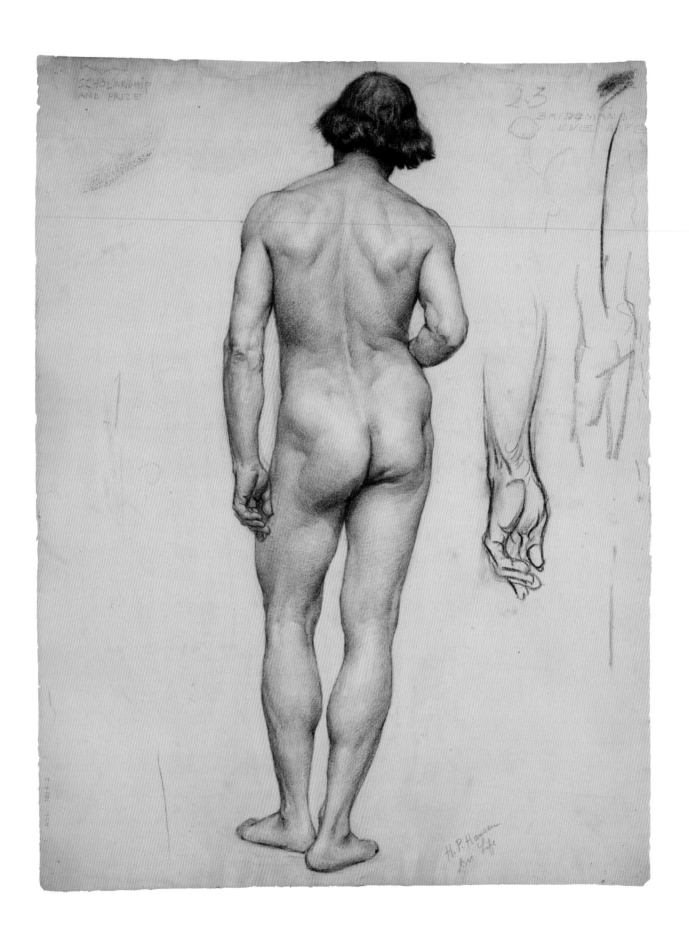

Leonid Lerman

WHEN I WAS TWELVE, I became a part of the Classical tradition without even knowing it. It was 1965, and my mother enrolled me in the school of art in Odessa, where I studied for the next four years. The school introduced me to some basic Classical principles that were reinforced when I continued my studies at a school specializing in mosaic and woodcarving, and then at a college for art and design in St. Petersburg.

Later, when I became a teacher, it became clear to me how important the Classical tradition is for studying the human form—a tradition that came from the European realism of the Old Masters and still plays a vital role in educating young artists. We draw to understand, to explore, and to manifest our admiration for the human body. There are two major approaches: drawing to learn, and drawing to express. The Classical tradition engages us in the first approach.

Academic drawing has a noble mission—to give students a system and tools to observe, analyze, and depict reality. In other words, to coordinate the labors of our eye, mind, and hand. The Classical tradition not only makes you familiar with harmony, proportion, structure, balance, movement, rhythm, character, connection, and tension— to name some of the most important tools—but it also helps set priorities.

For example, I would suggest that looking at a model could be very confusing. Usually, our eye instantly zooms in on the most attractive details. We need to reverse that, step back, and try to see the big picture first. Classical tradition teaches us to focus on composition—placing the figure on the page; movement—the flow and unity of different parts of the body; balance—the sense of weight using the plumb line; structure—the geometry of inner forms such as the rib cage, pelvis, skull, and joints; character—likeness; anatomy—muscle groups and the skeleton; and finally unification and harmony—looking at the big picture again, balancing details relating to the whole.

To illustrate this, let's look at this drawing from the Art Student League collection. We are looking at the male figure, which takes up the whole page so no space is wasted. At the same time the boundaries of the paper do not cut the figure from top or bottom, ruining the integrity of the pose. The man rests on his right leg, which is straight, giving firm support to his body. His left hip dips, and his left knee is bent and relaxed. His spinal chord is curved, offering the famous S-curve from the bottom up to his neck and head. Balancing the movement of the pelvis, the top portion of his body is bent to the right, which brings the axis of his shoulders in a dramatic contrast with the hips, offering us a perfect *contrapposto* pose.

In my own creative efforts, I do not deal with realistic figures any more. Rather, I am trying to develop a visual language, informed by the rich vocabulary that the human body has taught me. That is why I consider myself a link in a chain that is called "Classical Tradition" and why I see traditional methods as the most fruitful ones for helping young people gain knowledge and skills for further artistic growth.

OPPOSITE PAGE
Hans Peter Hansen, Academic drawing, n.d., charcoal on paper, Student of George Bridgman, scholarship. Permanent collection, Art Students League of New York.

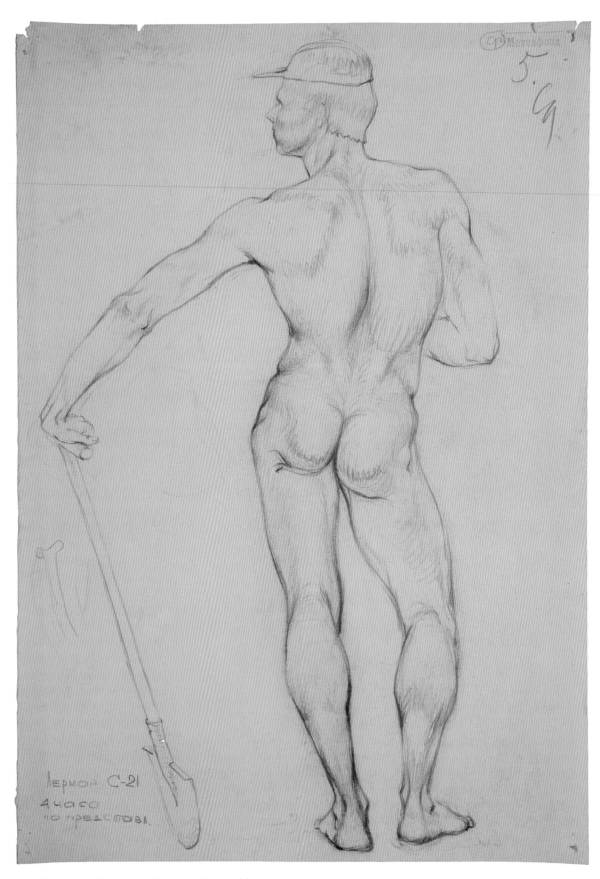

Leonid Lerman, *Nude Male Wearing a Cap, Holding Shovel*, n.d., graphite on paper, 23½ x 16½ inches.

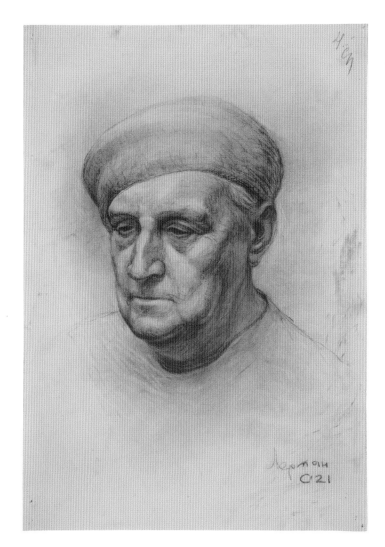

Leonid Lerman, *Old Man*,
n.d., sanguine on paper,
24 x 17 inches.

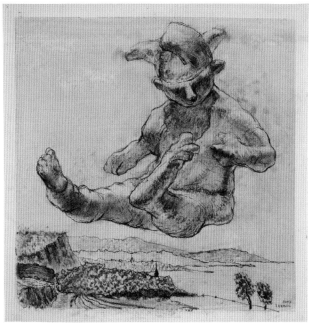

Leonid Lerman,
Allegorical Figure, 2007,
mixed media on paper.
17 x 14½ inches.

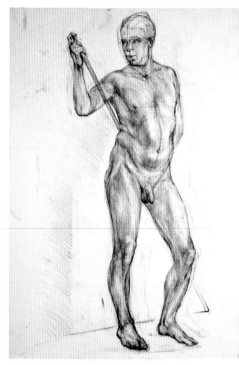

Petr Stanicky, *Standing Nude Man Holding a Pole*, n.d., graphite on paper, 24 x 18 inches. Student of Leonid Lerman.

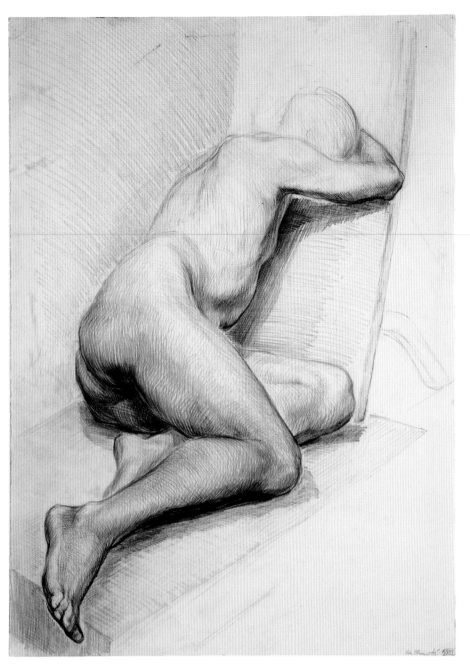

Petr Stanicky, *Reclining Nude*, 2005, graphite on paper. Student of Leonid Lerman.

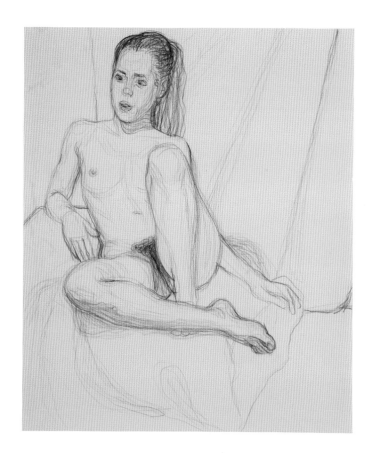

Max Phillips, *Lauren*, 1999,
colored pencil on paper,
16¾ x 14 inches. Student
of Leonid Lerman.

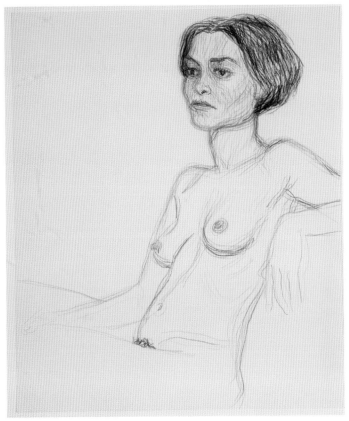

Max Phillips, *Yaquelina*,
2000, colored pencil on
paper, 16¾ x 14 inches.
Student of Leonid Lerman.

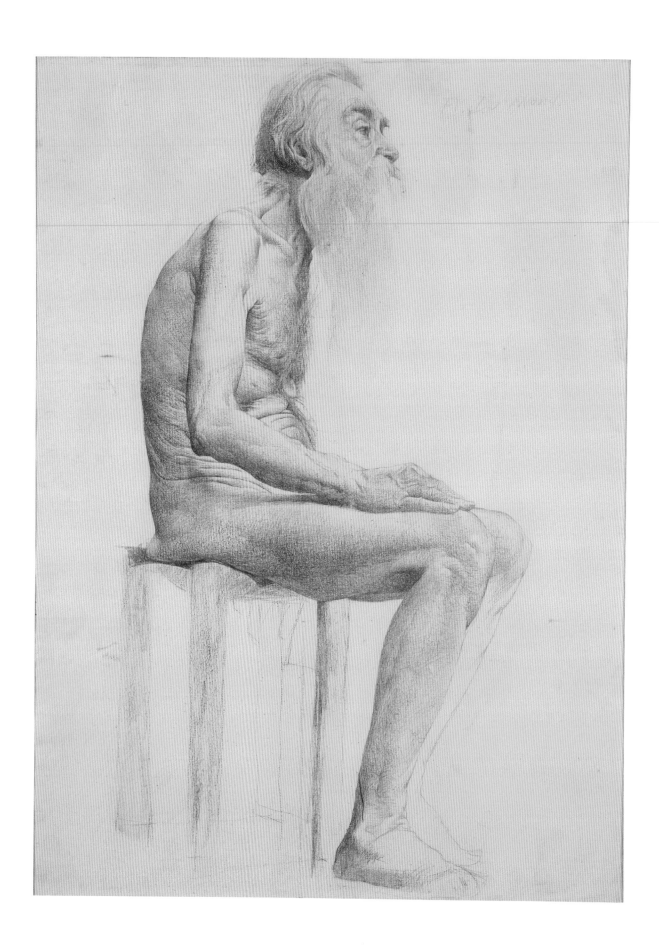

Frank Mason

ART IS BIGGER THEN ANY ONE INDIVIDUAL. The concepts that I teach and pass on to my students span countless generations. My own introduction to the Classical method came about at a very young age. At seven years old, a group of classmates and I were walking back from school in the late afternoon when our attention was drawn to a large barrel-vaulted cellar in the bowels of the Cleveland Art Museum. Forty feet below, working in a white smock with feverish energy, a sculptor was chipping away at a half-resolved great block of marble. Emerging from the top of the marble block was the form of a man's head peering out into the studio. Later I would learn that the sculptor's name was Attilio Piccirilli. The others trounced off after a few moments of curiosity, while I kept on well into twilight. Peering below, I lost track of time and my surroundings, enraptured by the timeless dance of sculptor and stone.

My youthful devotion to the world of Classical art would coincidentally land me within a stone's throw of Piccirilli's best-known New York City work, the Maine Monument (1901–13) at Columbus Circle (which he sculpted based on a design by H. Van Buren Magonigle), for I began my studies at age sixteen at the famed Art Students League. Within its inner sanctum, an entirely new world opened before me. As my mentor Frank Vincent DuMond—friend to another superb draftsman and League instructor, George Bridgman—used to tell me, "Frank, it's all in the action."

What a miraculous discovery DuMond was! He instilled in me the principles of draftsmanship that I continue to carry forth today. The living action is universal and leads us to good drawing. Before the finished line, the spirit of rhythm must awaken the form. Through a lifetime pursuit of Classical drawing, I myself arrived at something I call "liquid geometry," revealed through light on form. This approach has led me to confidently wield the wet brush with fluidity.

Frank DuMond's figure drawing of a seated old man is realized with great sensitivity. The model's posture is attentive and firm while conveying a combined sense of weariness and hope. The figure has been placed on the page with a care and authority that makes the drawing feel complete.

There is a great satisfaction in looking at master works by Rubens, Rembrandt, Velázquez, and Michelangelo. They fill me with delight and wonder. Contemplating these awesome creations is a form of soul-searching; when one is willing to receive, a whole new world emerges. The sculpted boy standing at the prow of Piccirilli's monument in Columbus Circle echoes this philosophy. Perhaps he felt my youthful presence.

It is imperative for those of us still working in the classical tradition to pass what we know on to emerging artists. They will each derive something different from this highly disciplined structure. And so the classical torch is rekindled with each new generation of inspired artists. Let us carry on the torch, and may it burn bright!

Frank Mason, *Reclining Nude*, 1971, sanguine chalk on paper, 16½ x 22 inches.

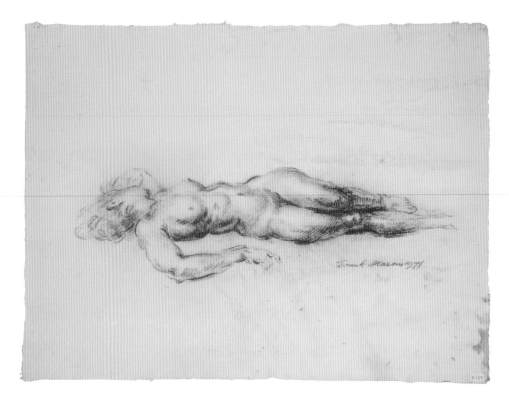

Frank Mason, *The Three Graces*, 2000, sanguine on paper, 11 x 8½ inches.

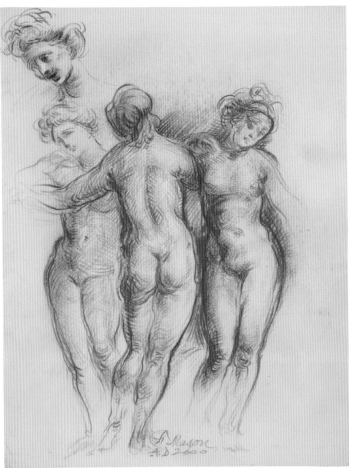

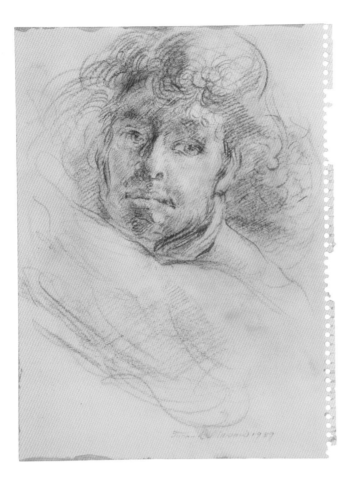

Frank Mason, *Saint Stephen*, 1989, sepia on white paper, 12 x 9 inches.

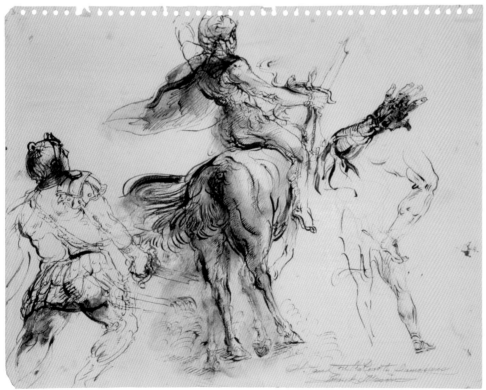

Frank Mason, *Saint Paul on the Road to Damascus*, 1992, brown ink and pencil on paper, 11 x 14 inches.

R. D. Tringali, *Untitled (Story of Mankind)*, 1999, charcoal on prepared paper, 14 x 11 inches. Student of Frank Mason.

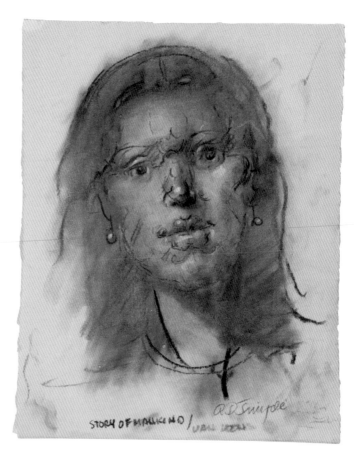

Mary Poerner, *Old Man with Hat*, n.d., white and black charcoal on gray paper. Student of Frank Mason.

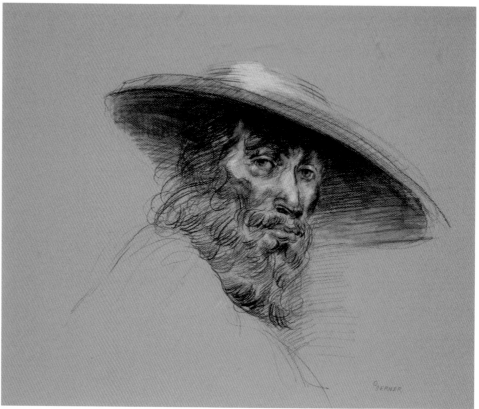

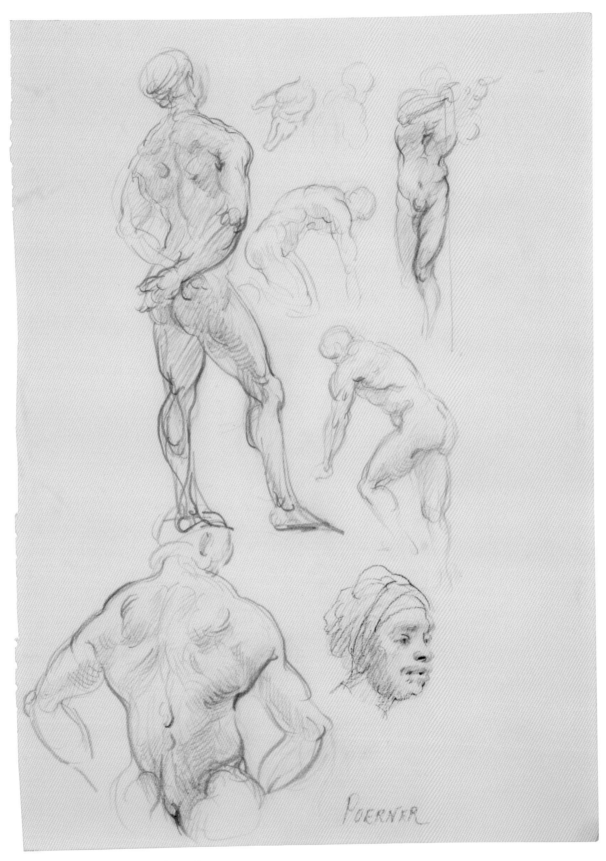

Mary Poerner, *Male Figure Studies*, n.d., sanguine
and graphite on paper. Student of Frank Mason.

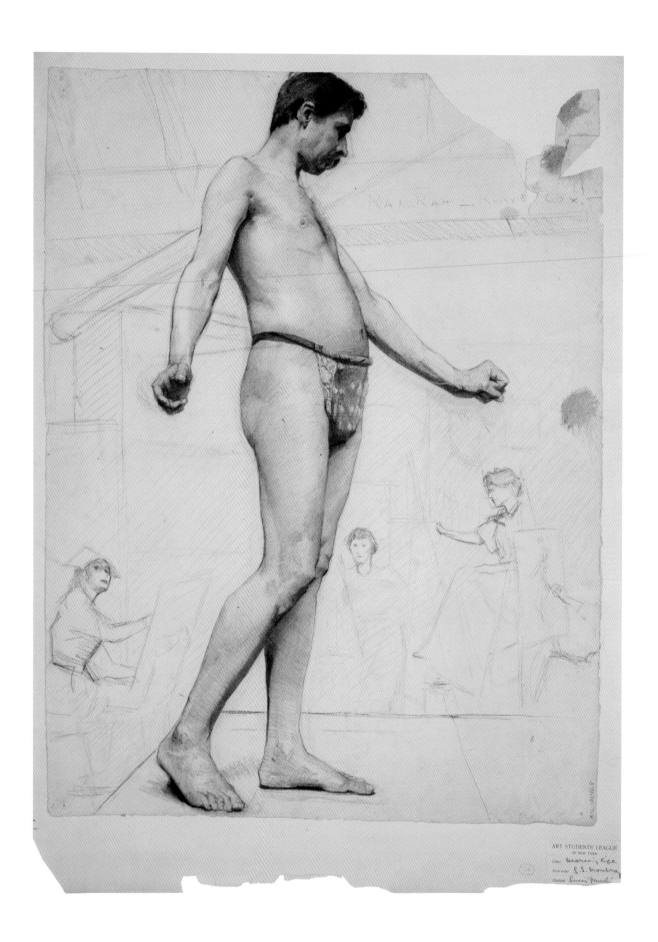

James Lancel McElhinney

MY FIRST ENCOUNTER WITH NEOCLASSICISM was in my parents' library: an edition of the *Iliad* illustrated by John Flaxman. Later, my teenage rambles following Saturday drawing classes at the Philadelphia College of Art (present-day University of the Arts) brought me to a retrospective of Degas, through whom I discovered Ingres, who declared that *"Le dessin c'est la probité de l'Art" ("Drawing is the proof of art")*. He is right.

I was filled with awe, curiosity, and ambition after seeing Augustus St. Gaudens's *Diana* on tiptoe above the grand staircase at the Philadelphia Museum of Art, as well as Nicolas Poussin's 1634 *Triumph of Amphitrite and Neptune* and Benjamin West's 1770 *Agrippina Landing at Brundisium with the Ashes of Germanicus*. My later professional training occurred during an age of rancorous rumpuses over matters of style. Representational painting was staging a comeback, but students interested in Figuration met resistance from many who remained committed to the tenets of Late Modernism. Mentors like John Moore and Richard Callner at the Tyler School of Art, Philip Grausman at Skowhegan, Bernard Chaet and William Bailey at Yale, underscored the value of historic lessons to contemporary artistic practice. My teachers reminded us that Kandinsky, Mondrian, de Kooning, and Pollock had all received some form of Academic training before they embarked on mature directions in their art.

Great debates about form continue, while none about style endure for long. I am drawn to Classicism for its assurance that beauty rises from order, as much as expressiveness yearns to resist it. Effective teaching requires order to precede expression; rules must be followed before one knows how to break them.

Working on drawings in the presence of living models forces students to address, engage, and interrogate their visual experience to learn how forms exist in space; how pictorial composition is ultimately more expressive than rendering or mark-making. Looking and seeing are parallel non sequiturs to copying and drawing. Drawing is not technique but visual language, fundamental to design—the most direct way to think about and manifest any visual idea, memory, or sensation. Because all things built or manufactured enter the world first in graphic form, understanding drawing becomes a survival skill like reading: the only way we can be sure of seeing, of understanding what we behold.

In her life drawing from Mowbray's morning (women's) life class, Lucia Fairchild depicts classmates at work behind an awkwardly posed male model. She captures hints of the model's personality by surrounding him within a wealth of visual data about the setting. Fairchild seems to understand that while anatomy is the composition of

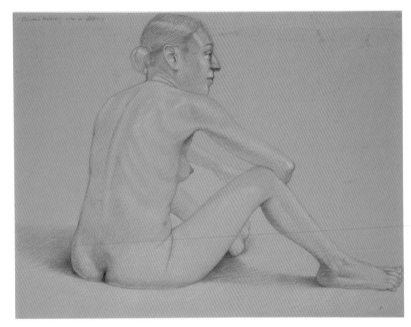

the body, composition is the anatomy of the drawing. One is unthinkable without the other.

Allowing us to encounter the perishable human frame as we reenact a timeless process, drawing from life is a bid for immortality. Academic drawing is a durable system of learning, devised to measure the world and enrich the spirit. Like science, mathematics, poetry, drama, music, and dance, it is a mode of inquiry as much as a means of expression.

James Lancel McElhinney, *Portrait of Christine M.*, 2004, pencils on toned paper, 18 x 24 inches.

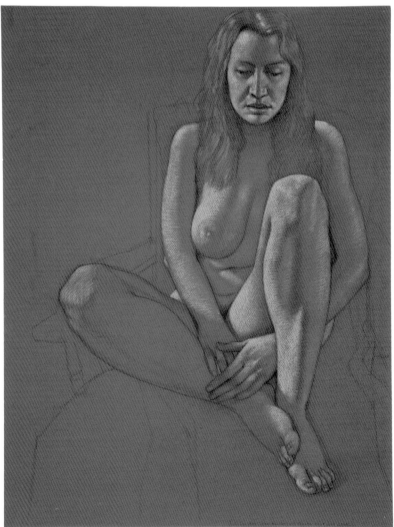

James Lancel McElhinney, *Portrait of Emily*, 2008, pastel pencils on toned paper, 24 x 18 inches.

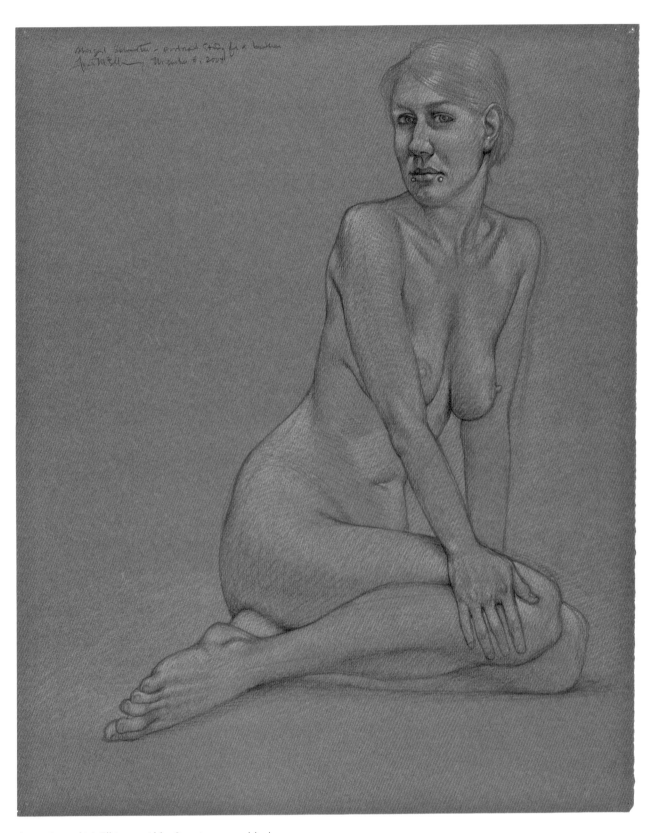

James Lancel McElhinney, *Abby Scweter*, 2004, black
and white Conté crayon on green paper, 20 x 16 inches.

Tim Buttke, *Seated Nude*,
2007, black-and-white
Conté crayon on toned
paper, 24 x 18 inches.
Student of James Lancel
McElhinney.

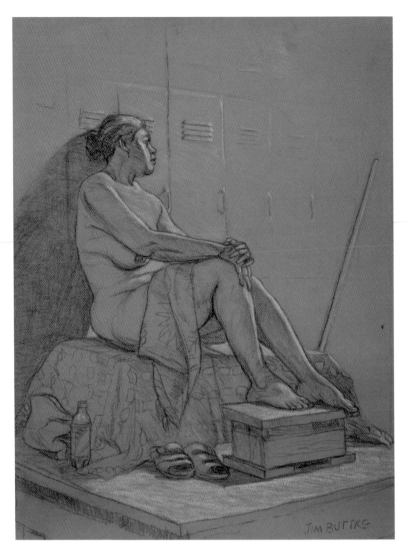

Tim Buttke, Seated Nude,
2007, black-and-white
Conté crayon on toned
paper. 18 x 24 inches.
Student of James Lancel
McElhinney.

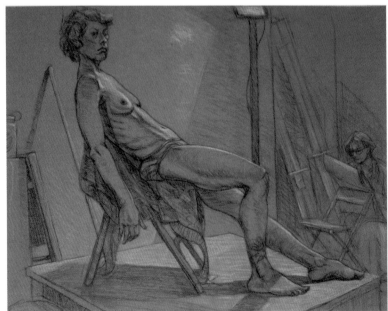

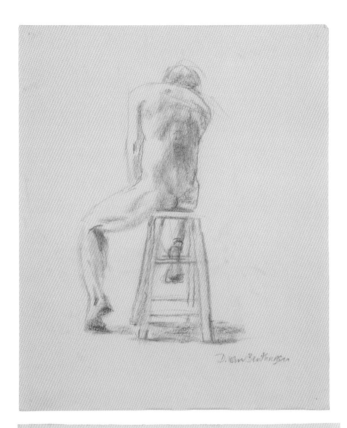

Dan van Benthuysen,
*Nude Seated on a
Stool*, 2007, sanguine
on paper, 17 x14 inches.
Student of James Lancel
McElhinney.

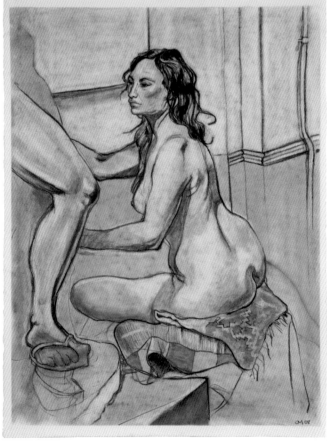

Claudia Monaco, *Letitia*,
2008, charcoal on
paper, 22 x 30 inches.
Student of James Lancel
McElhinney.

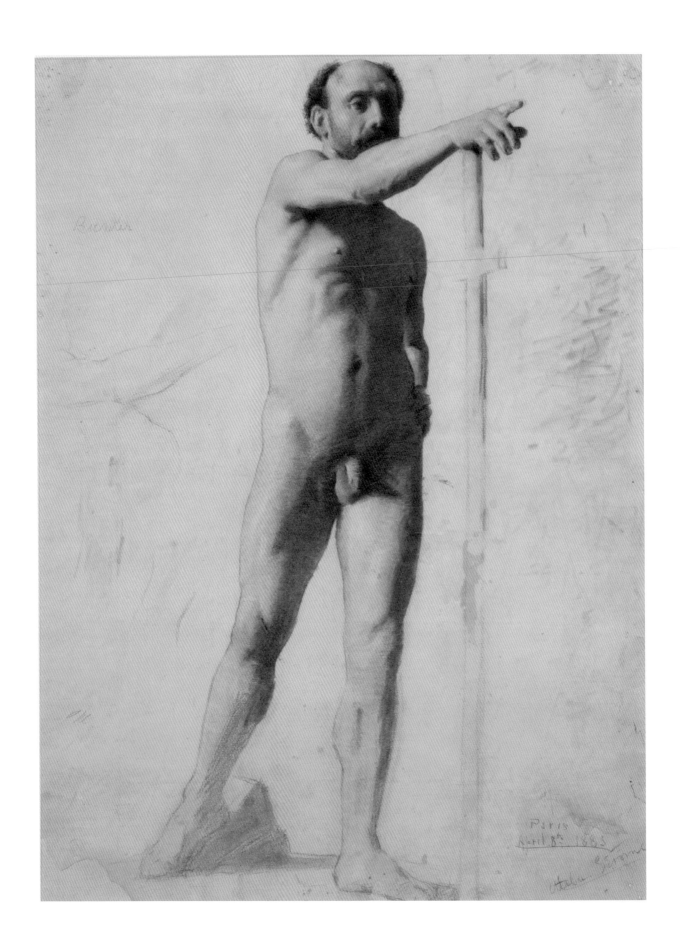

Joseph Peller

MY UNDERSTANDING OF DRAWING CAME through private study and affiliation with working figure and portrait painters. My earliest teacher, A. K. Scott, considered drawing fundamental to all forms of visual artistic expression, regardless of medium. He saw the study of the human figure—especially from life—as one of the cornerstones of Western drawing. From an early age, I was encouraged to work from the live model or "working from life in full," as my League instructor Thomas Fogarty liked to say.

All of my mentors encouraged me to study the drawings of Michelangelo, Tintoretto, Van Dyck, Raphael, Ingres, Degas, Daumier, and Augustus John. I was given the same advice that Ingres gave to Degas: "Draw lots and lots of lines, young man." Studying master drawings gave me an appreciation of the quintessential themes of antiquity—especially subjects from mythology wherein the human form in drawing explores the human condition—themes that reverberate in my subjects of the modern urban life. My teachers insisted that academic drawing was a foundation: a point of departure, not an end in itself. Decades later, my painting, printmaking, and sculpture find relevance in these early ideas. I favor linear drawing as a means of expressing my thoughts and my love of the human form. Unflinching observation is my point of departure for all figure and portrait work. Drawing fundamentals indispensably nurtured my understanding of scale, proportion, movement, and attitude.

I still insist on working from life. Computers and photography pale in comparison to the personal interaction and energy one receives from working in the presence of another human being. For me there is no substitute. Using notebooks for drawing people in situ engaged in the rituals and routines of everyday life, I generate studies that find their way into my larger painting compositions.

Teaching at the League, I stress the poetic use of line instead of tone to depict mass and volume. I encourage my students to work from life wherever possible, to keep a notebook of small studies based on sketches from the model and daily encounters with other people—practices that develop a personal vision in all aspects of their art.

My students are given the same simple tools and approaches that I received. Viewfinders and plumb lines; working site-size and life-size lets them grasp how drawing informs ways of seeing.

The League's motto *Nulla dies sine linea*—"Never a day without a line"—echoes my understanding of drawing. The historic student drawing shown here, produced many years ago, reveals many principles I admire. Emphasis on line and contour with a restrained sense of tonality achieves volume by delicately accented variations of line. Moreover, there is an elegant feeling of balance that is so crucial in depicting the standing figure. Displaying classical proportion with a relaxed, graceful movement, the figure has presence—what academic draftsmen would call "attitude"—in the character of the model and the pose. These are the hallmarks of fine draftsmanship.

OPPOSITE PAGE
Dennis Miller Bunker, Academic drawing, 1883, graphite on paper, 27 x 22 inches. Permanent collection, Art Students League of New York.

Joseph Peller, *Fausto*,
n.d., charcoal on paper.

Joseph Peller, *In Her
Chair*, n.d., charcoal
on board.

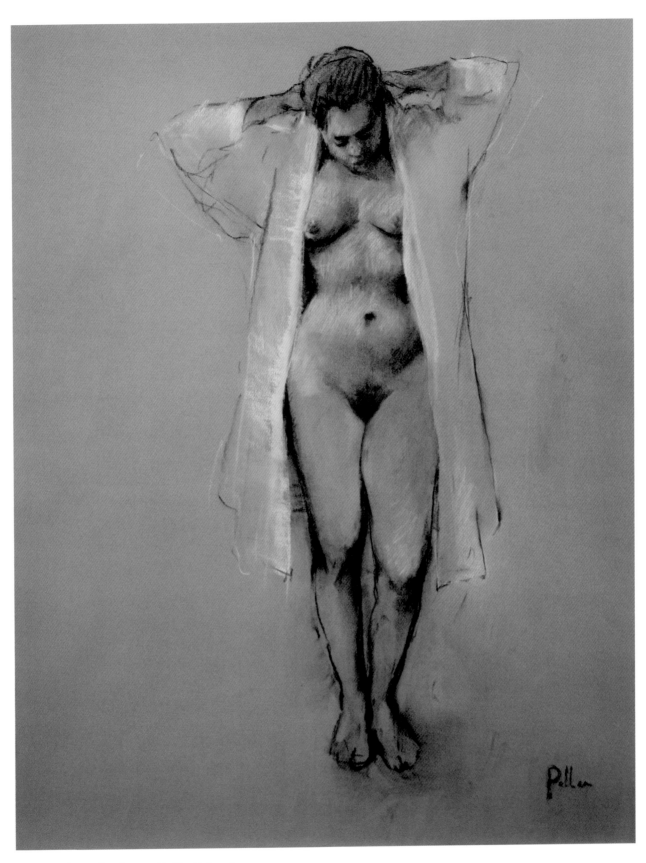

Joseph Peller, *Wilma Putting Up Her Hair*, n.d.,
pastel and charcoal on paper.

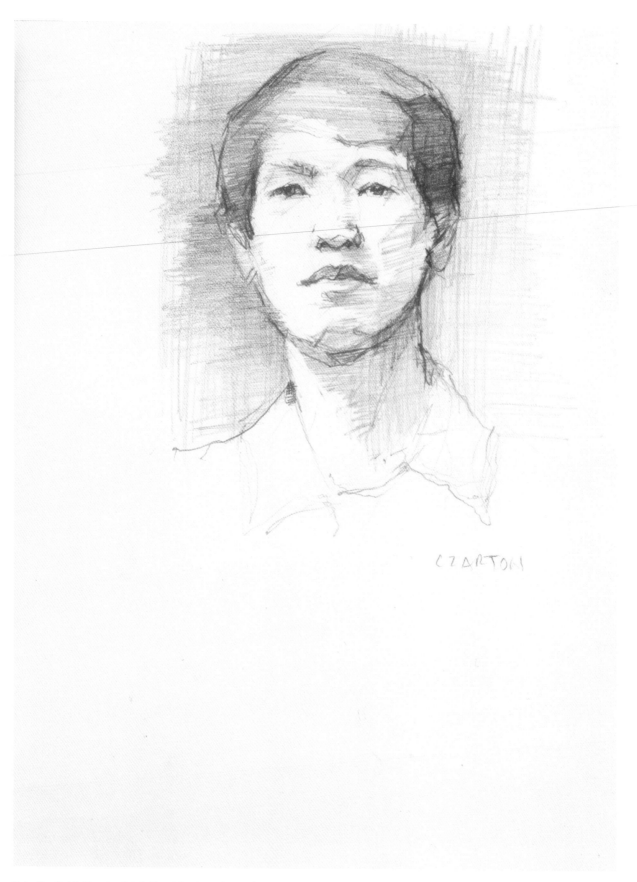

Rein Singfield, *Czarton* [sic], *Head Study*, n.d., graphite
on paper, 8¼ x 5¼ inches. Student of Joseph Peller.

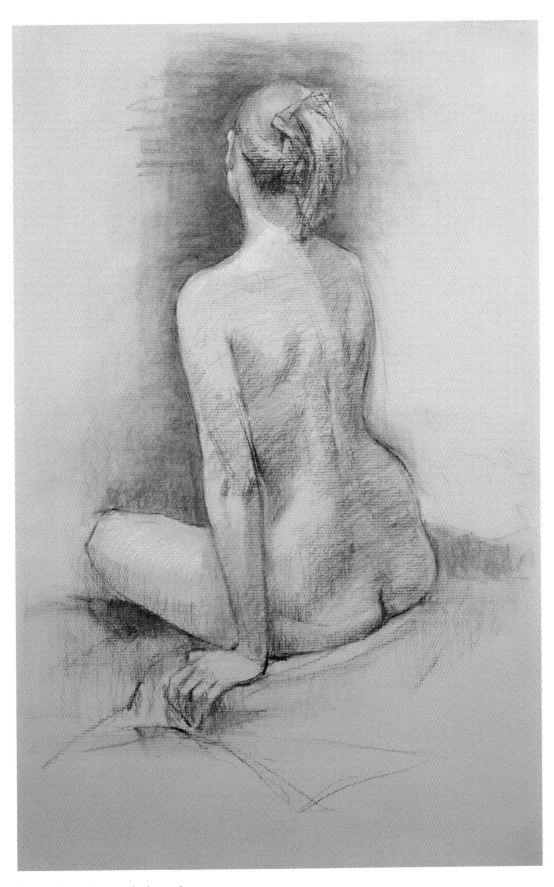

Yoshimi Tome, *Maria*, n.d., charcoal on paper,
13⅜ x 12½ inches. Student of Joseph Peller.

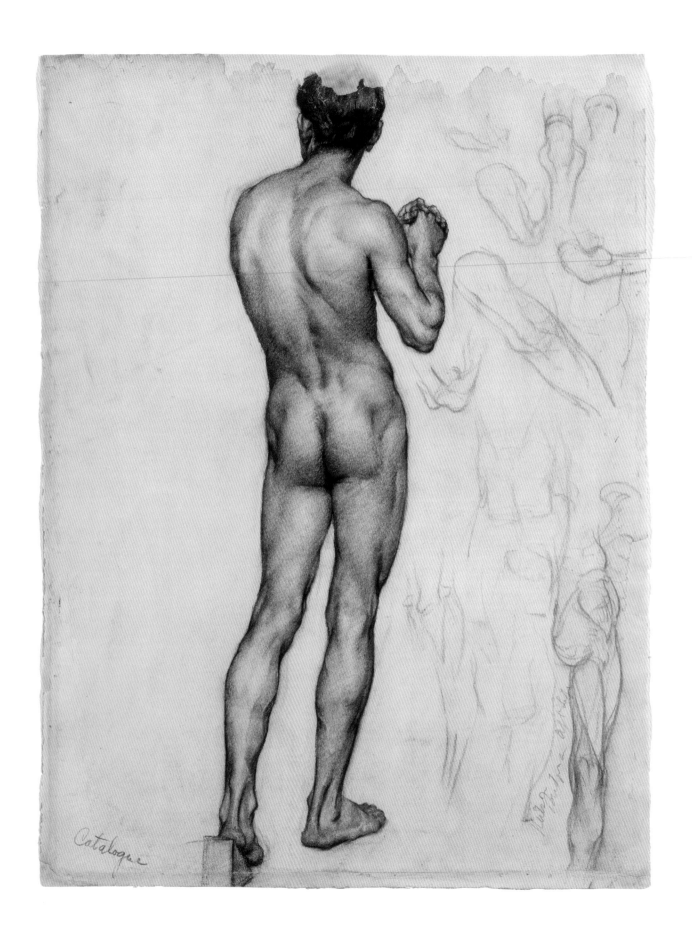

Catalogue

Frank Porcu

WHAT ONE DRAWS WHEN IN FRONT of the nude model is very much up for discussion. Recently the *académie* drawing—or figure study—has been promoted from its historical status as a preparatory drawing to being considered as a finished work of art in itself. Today, due to the absence of grand picture-making in the Classical tradition, we have lost a true understanding of where this practice of making the *académie* drawing fits into the process of making art.

In the studio, choosing our goals behind the drawing board is not as intuitive as it once was. Too often nowadays, the goal is to merely record what we see with a burnt stick. Historically, the process of drawing from the nude was governed by the need to use finished drawings as references. A clinical breakdown of visual information occurred, along with an understanding that because what we see is limited, how we record it via drawing must include much more. Great drawings are constructed through exhaustive analysis of the live model, the antique, and anatomy. Artists need an arsenal of intellectual tools to be able to draw well. *Académie* drawings in the League's collection reveal a veritable toolbox for the construction of a drawing hidden within them. By studying these drawings, we can read the minds and philosophies of the past's detectives by reading the clues left in their drawings. Today's database of solutions to visual problems is widely available to us. Handed down from generation to generation, it continues to grow.

I chose a drawing to discuss from one of Bridgman's students. At first we see an illusion of pure visual information; but looking again, we uncover a constructed world built on rules. More importantly, it is a world that illustrates the marvels of the human form better than one could by optical copying or photography. This drawing was deliberately altered to tell a story. One possible narrative is the shoulder region, which features characters named scapula, humerus, elbow, and triceps. Knowledge of anatomical construction and function is used to spotlight the leading actors in this marvelous play.

Drawing records visual phenomena filtered through the mind and reasoning of those who study nature. The nude affords a virtual shopping spree of information. Our job is to decide what to take and what to leave behind. Once gathered, this information can be used as reference to aid in our production of true art.

Our responsibility to the past is teaching that the process of making an *académie* drawing is more than reproducing a recognizable image. It is a record of all that the nude has to offer as raw material, in addition to the many other forms of research necessary to the formation of artworks. The *académie* drawing is a quest for the proper sequencing of tools; a rehearsal and a boot camp to prepare artists to ask the right questions, leading them eventually to unearth past solutions and invent new ones.

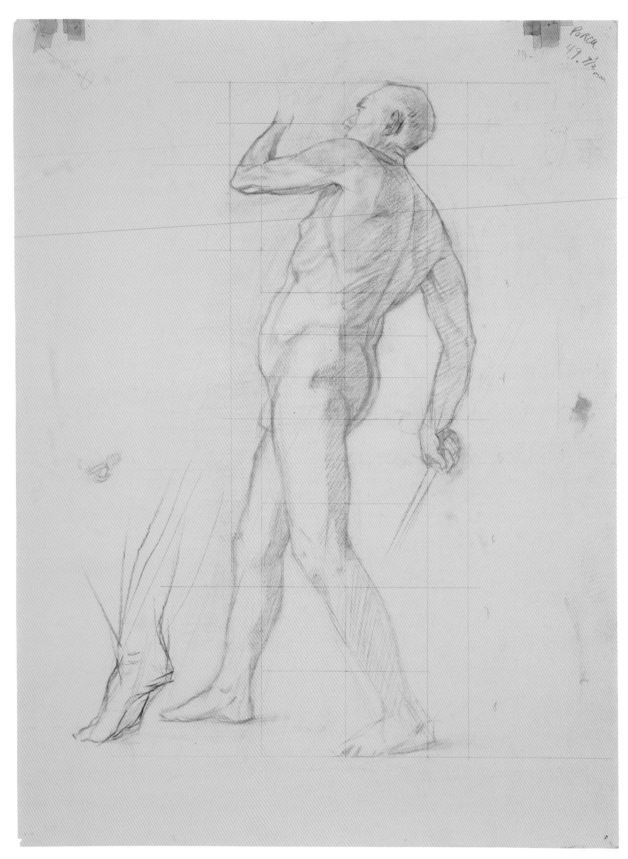

Frank Porcu, *Turning Male Nude*, n.d., charcoal on
paper, 24 x 18 inches.

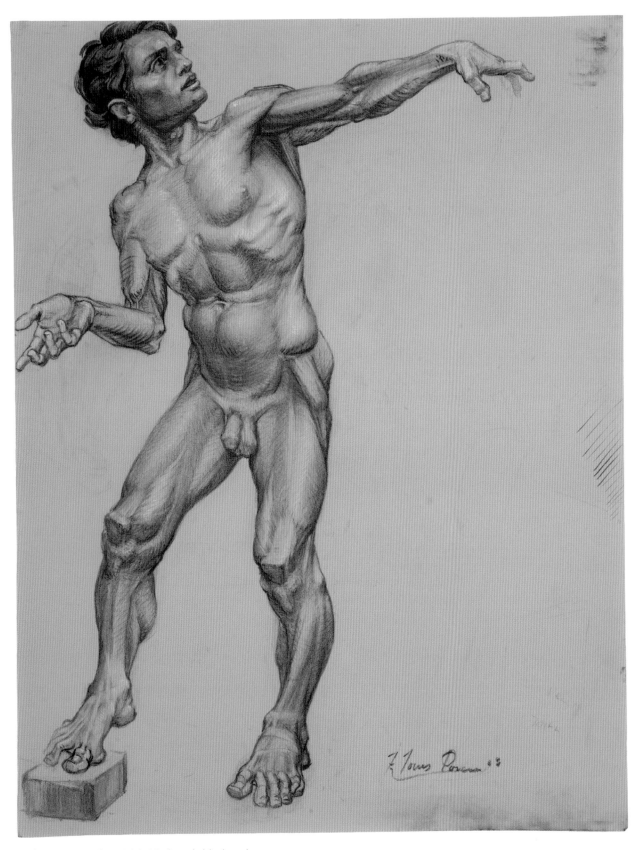

Frank Porcu, *Reaching Male Nude*, n.d., black and
white charcoal on paper, 24 x 18 inches.

Student of Frank Porcu,
Female Nude Standing,
n.d., charcoal on paper,
24 x 18 inches.

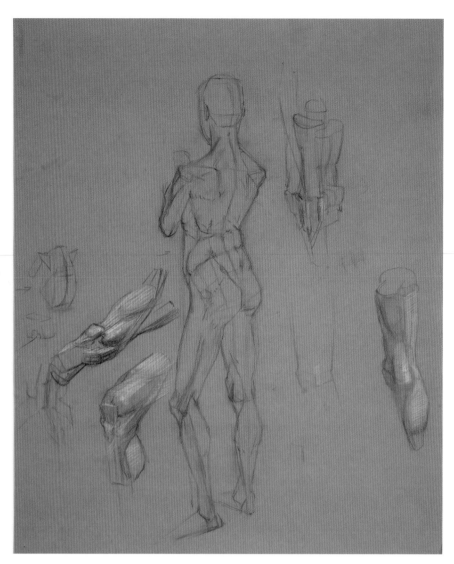

Student of Frank Porcu,
Anatomy Studies, n.d.,
charcoal on paper,
24 x 18 inches.

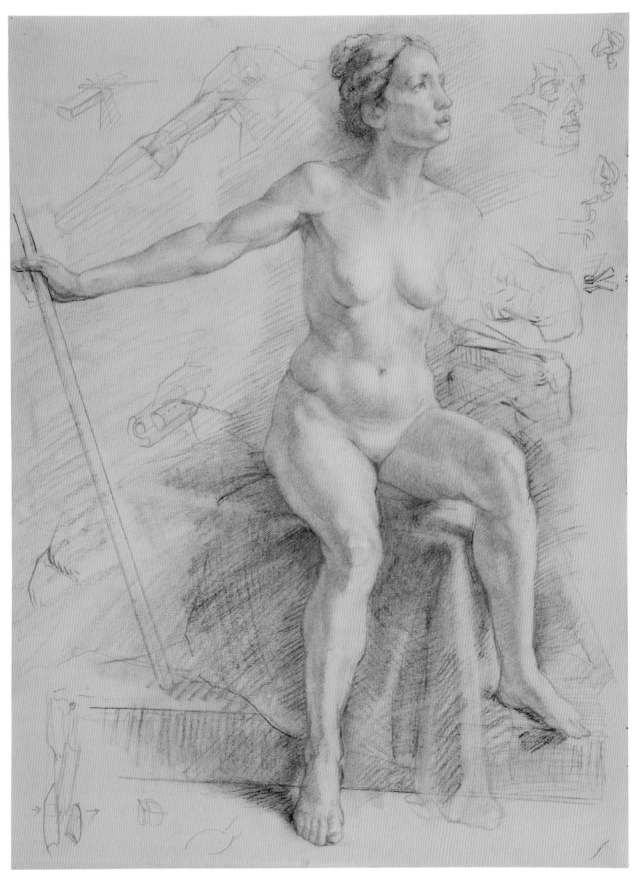

McGrath, *Seated Female with Pole*, n.d., sanguine
and pencil on paper. Student of Frank Porcu.

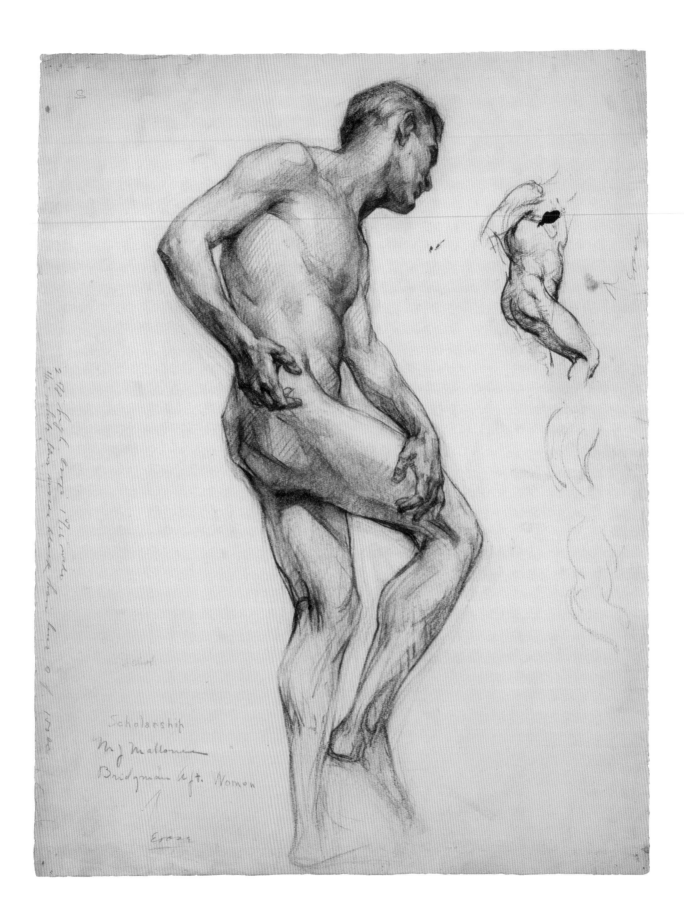

Scholarship

M J Mallomin

Bridgman Aft. Nomen

Eçass

Nelson Shanks

COMPARING THE CONCEPTS BEHIND the words "Classical" and "classic" in the context of drawing reveals a spectrum of differences. The cliché is that a Classical drawing is tighter, more polished, and finished. The word Classical suggests an idealism resembling that of a Greek statue. Classicism differs from Realism or solitary study from nature, because it constitutes a specific aesthetic based on canons of form, proportion and beauty.

The "window shade" technique—a method by which outlines are drawn and the subject is shaded and toned from top to bottom—sublimates the rhythms of light and shadow to the outline and hence relegates the artist to clichéd classical poses and subjects. The pseudo-classical "outline" resulting from this drawing technique limits and minimizes the potential for expressing how color changes happen when light passes over shifting surface planes. Finished drawings done in this way can be full of excitement and aesthetic impact, but must not be considered the ultimate drawing technique.

In fact, students solely trained in this way miss the essential elements of seeing. The Bridgman-style drawing here by Josephine Mallonee exhibits many characteristics of structure in planar drawing. While the small sketch on the right of her sketch is too rounded and the form becomes balloon-like, on the whole, Mallonee is seeing facets in the structure that show greater understanding of form than in the so-called "window shade" technique that finishes a drawing progressively by shading from the top down. This is not to say that finished drawings cannot succeed. For example, Lea Wight's and Dan Thompson's more finished drawings on the following pages exhibit inner movement and have developed a subtle, but nonetheless solid, sense of form.

OPPOSITE PAGE
Josephine Mallonee, Academic drawing, ca. 1912-13, charcoal on paper, 24¼ x 18¼ inches. Student of George Bridgman. Permanent collection, Art Students League of New York.

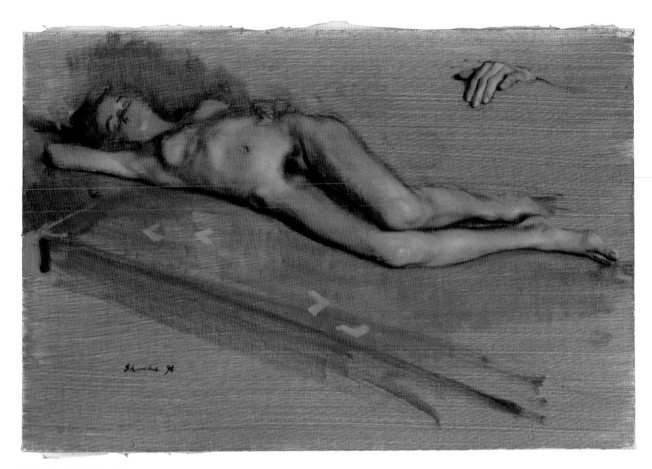

Nelson Shanks, *Reclining Female Nude*, n.d., oil on linen.

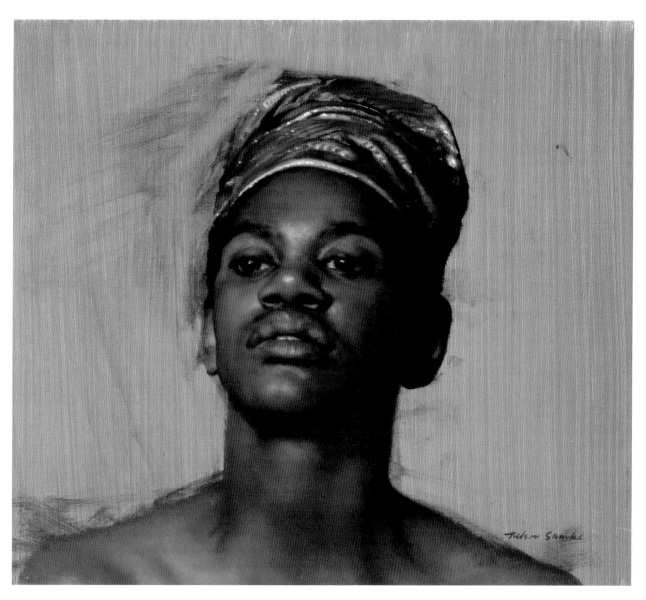

Nelson Shanks, *Young Male Wearing Turban*, n.d., oil on linen.

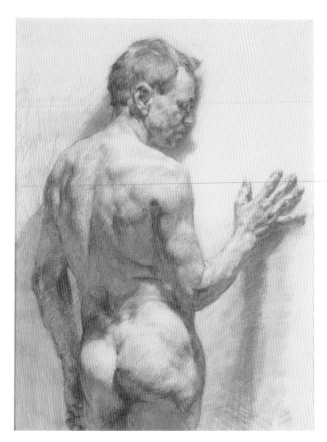

Lea Colie Wight, *Tree—
Figure Study*, n.d.,
Conté crayon on paper,
23 x 18 inches. Student of
Nelson Shanks.

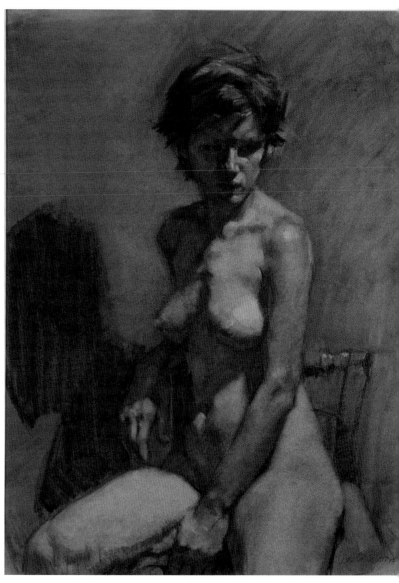

Lea Colie Wight, *Irma*,
n.d., charcoal on paper.
24 x 18 inches. Student
of Nelson Shanks.

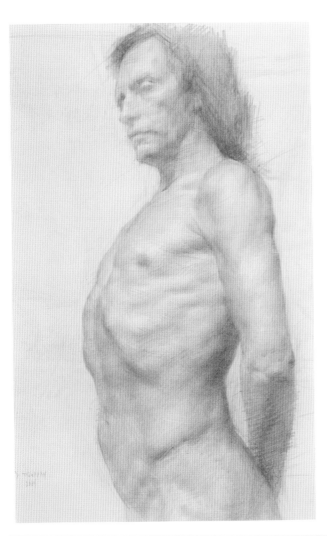

Dan Thomson, *Standing Male Nude*, 2004, graphite on paper, 28 x 12 inches. Student of Nelson Shanks.

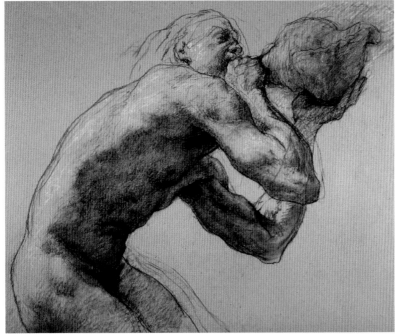

Jon de Martin, *Triton*, n.d., sanguine and white chalk on paper. Student of Nelson Shanks.

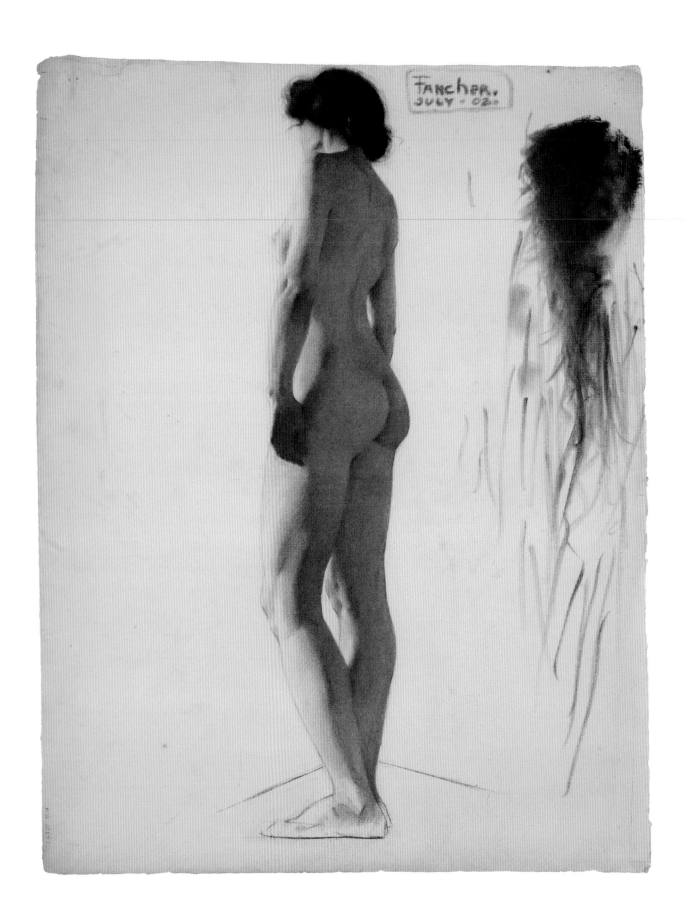

Sharon Sprung

I BEGAN MY STUDY OF DRAWING AT THE Art Students League with Robert Beverly Hale when I was nineteen. Although he seemed ancient and frail to me at the time, when he began to lecture a change came over him, and he became an energized and charismatic teacher. My experience with him formed the basis of my drawing instruction. He stressed anatomy and the importance of gesture and lighting: the guidance of draftsmanship through those artists that came before.

The League collection drawing I have chosen epitomizes many of the lessons learned from Hale and many of the elements I feel are most important in creating a skilled and moving portrayal. The first moment charcoal touches paper is fundamental. Gesture and movement drawing is essential to breathing life into a creation. The historic drawing here has a sense of ease in a moment that is human, concise, and wholly descriptive.

All painting and drawing starts with that moment, the most important armature in a work of art that breathes with life. This depiction captures a simple and elegant sense of light and shade, a beautiful balance of values that steer my eye into continuous action and maintains my interest. The movement and lighting work together in harmony, poise, and equilibrium, creating a feeling of pleasure and a sense of truth in the image. The student who made this drawing has integrated the structure of gesture, anatomy, rendering, of light and dark, and line to capture and express this moment and the model with grace and potency. I begin all my painting with a gesture drawing, and sometimes I search for months in paint to redefine the feeling of truth I captured in a few moments with pencil.

In my teaching, I draw upon Classical drawing techniques as well as more contemporary methods: quite frankly, anything that moves the piece further toward a truth and a life. There is one area where I depart from Classical tradition, and I believe it reflects my contemporary existence: I am deeply connected to the individual and the particular, rather than to a certain ideal of beauty or strength. I find that the individual speaks of universality rather than the preconceived.

OPPOSITE PAGE
Fancher, Academic drawing, 1902, charcoal on paper. Permanent collection, Art Students League of New York.

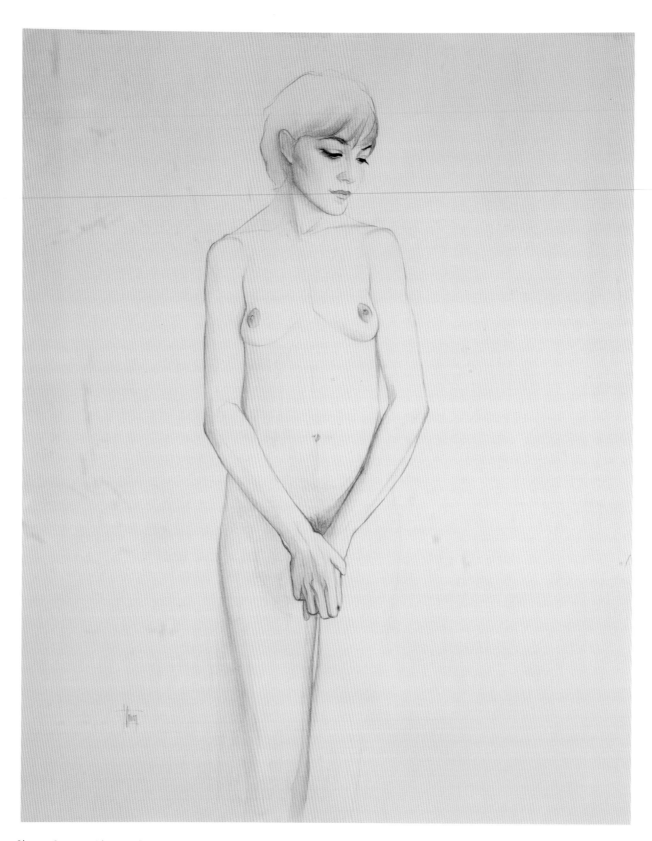

Sharon Sprung, *Gloria*, n.d., pastel pencil on paper,
29 x 23 inches.

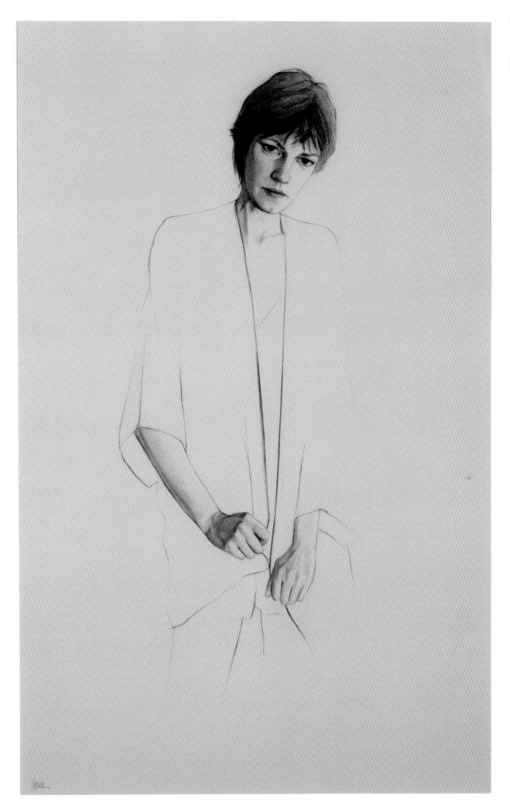

John T. Cox, *Untitled,*
2007, pencil on paper,
18 x 23½ inches. Student
of Sharon Sprung.

John T. Cox, *Untitled Figure,* n.d., pencil on paper, 24½ x 19 inches. Student of Sharon Sprung.

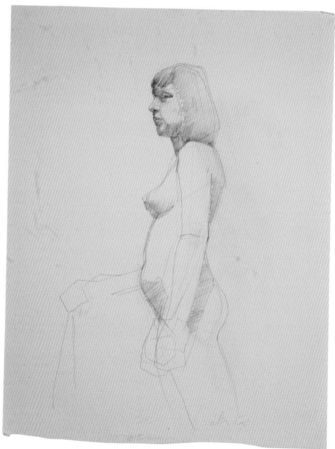

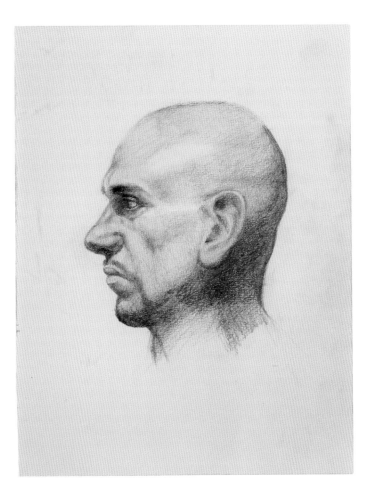

Hyun Sun Shim, *Alan*, n.d., graphite on paper, 17 x 14 inches. Student of Sharon Sprung.

Hyun Sun Shim, *Two Girls*, n.d., graphite on paper, 17 x 14 inches. Student of Sharon Sprung.

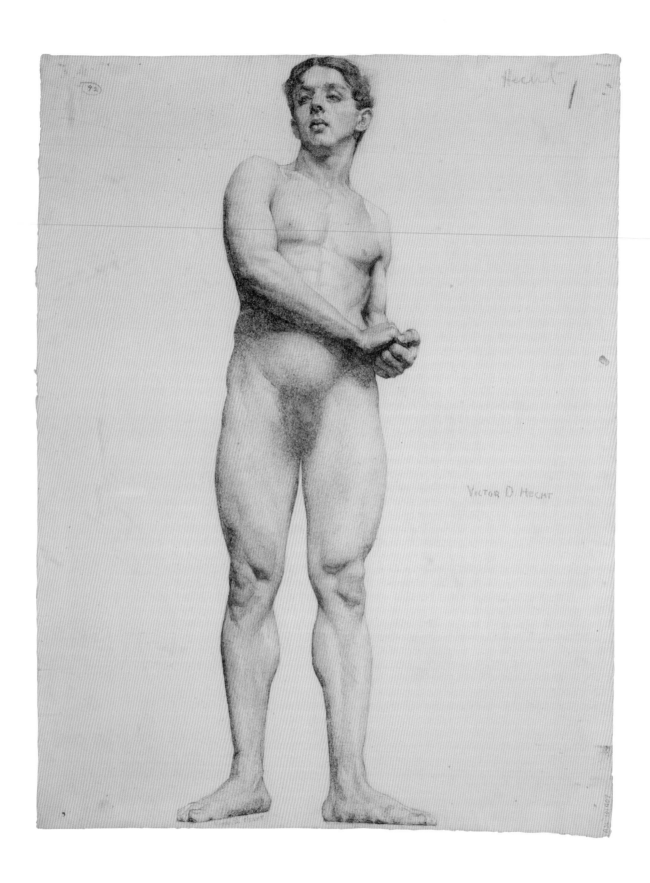

Victor D. Hecht

Costa Vavagiakis

THE DRAWING I HAVE SELECTED FROM the League archives is a good example of nineteenth-century student work by Victor Hecht (1873–1931), who was probably in his late teens or early twenties when he completed it. Hecht was born in Paris and studied with Jules-Joseph Lefebvre and Tony Robert-Fleury at the Académie Julian. Upon coming to the United States, he continued his schooling at the Art Students League of New York. Looking at this drawing, I see the influence of several prominent artists who taught at the League during this period: Frank Vincent DuMond, Kenyon Cox, and George Bridgman.

In this drawing I admire the solid construction and the understanding of perspective. Hecht was looking *up* at the figure, which means he was probably seated at the back of the room, several yards away from the standing model. He was almost certainly working in one of the League's larger drawing studios, perhaps even Studio 1–2 where I teach today. From his vantage point, Hecht saw the underside of the block of the head (beneath the chin) and the underside of the block-like forearm. The torso, from the pelvis upward, has been twisted beautifully, and Hecht fully understood how to depict this rotation. He also recorded the orientation of the ribcage and the angle of the head powerfully. Bridgman may have shown Hecht how to think of the ribcage and the head as two blocks.

Hecht's understanding of anatomy and his use of line and tone were additional evidence of his superb training. At the League today, my colleagues and I strive to give students an equivalent high level of training. My own training as an art student was much less systematic. As a young artist, I wanted to draw naturalistically, but my thinking was not particularly developed. It was only as I matured that I grew to understand the conceptual complexity of the great early draftsmen—Leonardo, Michelangelo, and Raphael. Of all the aspects of the Classical tradition that inform my own teaching, the study of the masterworks of the past is the most essential. For instance, Leonardo taught me that drawing is a kind of thinking, as is playing a musical instrument. By using a continuous gesture to depict the movement of forms in space, he showed me that drawing is a way of exploring life. And in order to get at life, he demonstrated that intuition is always at the heart of the process. These essential principles have formed the core of my teaching methodology.

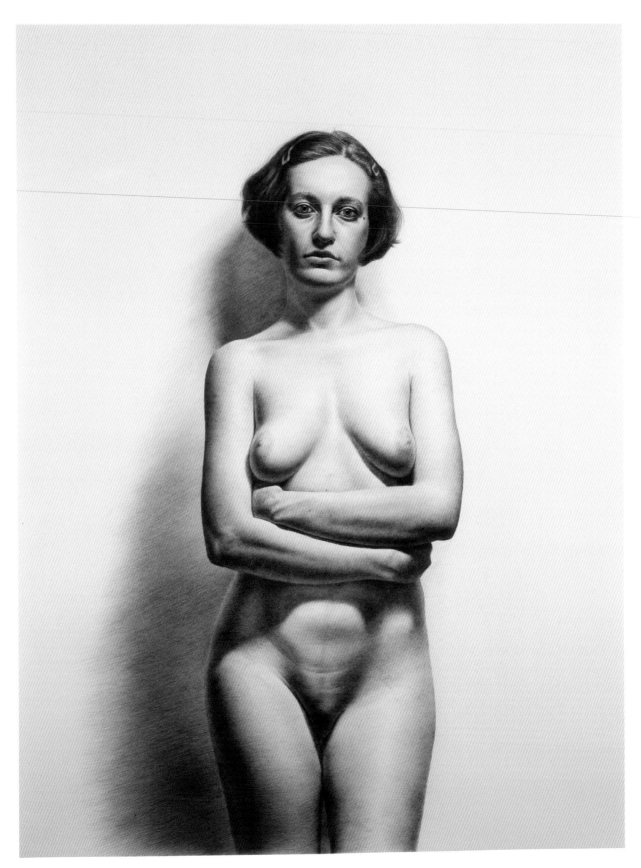

Costa Vavagiakis, *Gioia VI*, 2000, graphite on
paper, 52 x 41 inches. Collection of Noah Simmons.

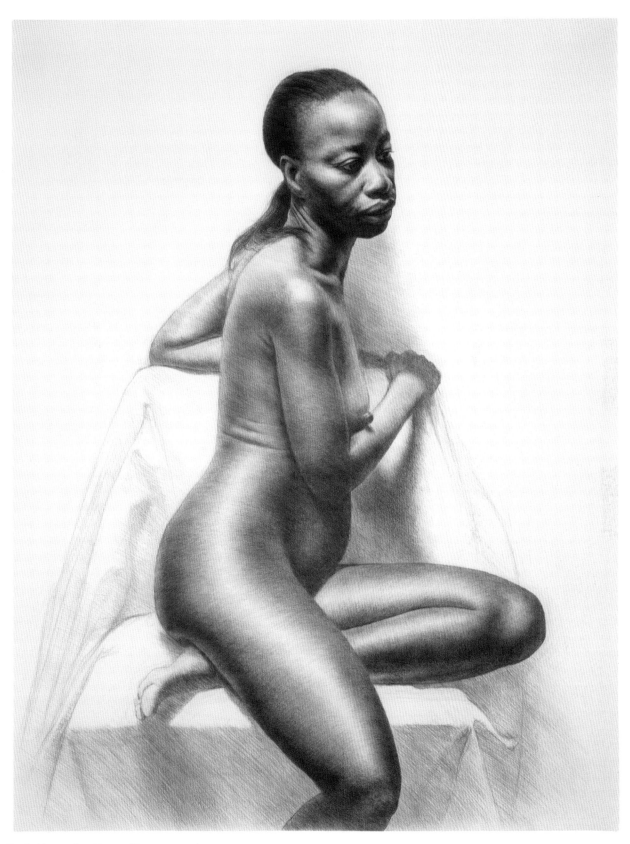

Costa Vavagiakis, *Connie XI*, 2003, graphite on
paper, 25½ x 19½ inches.

Rubenstein Diego
Amilivia, *Male Head*,
n.d., charcoal on paper.
Student of Costa
Vavagiakis.

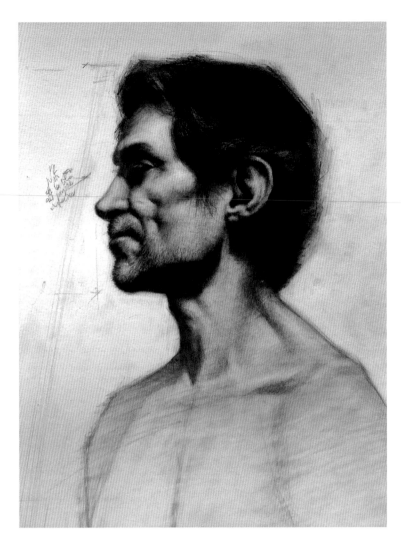

Benat Lopez Iglesias,
Karen, n.d., charcoal on
paper. Student of Costa
Vavagiakis.

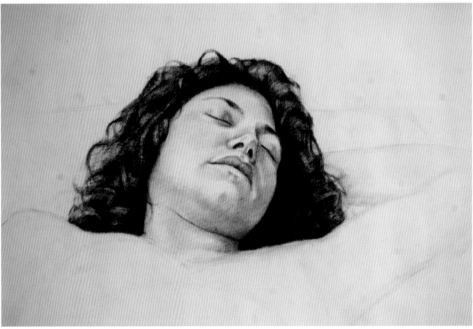

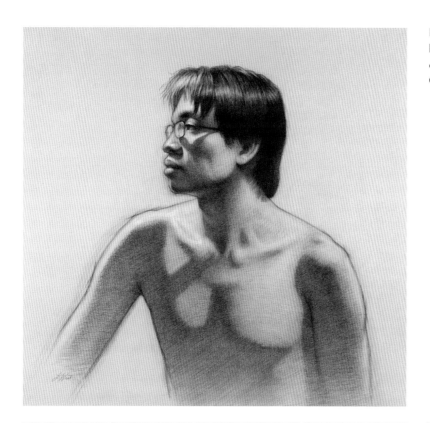

Linda West, *Czerton*, n.d.,
black-and-white charcoal
on paper. Student of
Costa Vavagiakis.

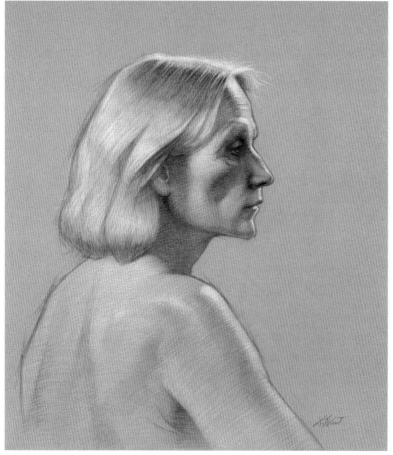

Linda West, *Nina*, n.d.,
black-and-white charcoal
on paper. Student of
Costa Vavagiakis.

Bibliography

Ackerman, Gerald M. *Charles Bargue with the Collaboration of Jean-Léon Gérôme: Drawing Course.* France: ACR Edition, 2003.

Adler, Kathleen, Erica E. Hirshler, and H. Barbara Weinberg. *Americans in Paris 1860–1900.* New Haven and London: Yale University Press, 2006.

Allen, Elizabeth K. *Open-Air Sketching: Nineteenth Century American Landscape Drawings in the Albany Institute of History and Art.* Albany, N.Y.: Albany Institute of History and Art, 1998.

Anderson, Albert A. Jr., William L. Joyce, and Sandra K. Stelts. *Teaching America to Draw: Instructional Manuals and Ephemera 1794–1925.* An Exhibition at the Grolier Club, May 17 to July 29, 2006, and the Special Collections Library, Pennsylvania State University Libraries, September 20, 2006 to January 7, 2007. University Park: The Pennsylvania State University Libraries, 2006.

Anonymous. *A Drawing Book of Landscapes.* Philadelphia: Johnson & Warner, 1810.

Aristides, Juliette. *Classical Drawing Atelier: A Contemporary Guide to Traditional Studio Practice.* New York: Watson-Guptill, 2006.

Bermingham, Ann. *Learning to Draw: Studies in the Cultural History of a Polite and Useful Art.* New Haven and London: Yale University Press for Paul Mellon Centre for the Studies of British Art, 2000.

Bridgman, George Brandt, and Howard Simon (eds.). *Bridgman's Complete Guide to Drawing from Life.* New York: Sterling, 1952.

Callow, James T., and William Gerdts (eds.). *Robert Weir: Artist and Teacher of West Point.* Exhibition catalogue. West Point: Cadet Fine Arts Forum of the United States Corps of Cadets, 1976.

Camhy, Sherry Wallerstein. *Art of the Pencil.* New York: Watson-Guptill, 1997.

Camhy, Sherry. *"Silverpoint: Old Medium, New Artists." Fine Art Connoisseur,* Vol. 4, Issue 4, August 2007.

———. *"Sparkling Magic Wand." Linea: Journal of the Art Students League of New York,* Spring 2007.

Chaet, Bernard. *The Art of Drawing. New York: Holt,* Rinehart and Winston, 1970.

Chapman, John Gadsby. *The American Drawing-Book: A Manual for the Amateur and Basis of Study for the Professional Artist, Especially Adapted to The Use of Public and Private Schools as Well as Home Instruction.* New York: J. S. Redfield, 1847.

Cuthbert, John A., and Jessie Poesch. *David Hunter Strother: One of the Best Draughtsmen the Country Possesses.* Morgantown: West Virginia University Press, 1997.

Davenport, Guy, and Stephen Frankel (eds.). *The Drawings of Paul Cadmus.* New York: Rizzoli, 1989.

Davis, Elliott Bostwick. *Training the Eye and the Hand: Fitz Hugh [sic] Lane and Nineteenth-Century Drawing Books.* Gloucester, Mass.: Cape Anne Historical Society, 1993. [Author note: This catalogue of a 1993–94 exhibition examines the impact of instructional books like Lucas's and Chapman's on drawing practices used by New England maritime artist Fitz Henry Lane (previously misidentified as Fitz Hugh Lane).]

Faragasso, Jack. *Mastering Drawing the Human Figure from Life, Memory, Imagination.* Woodstock, N.Y.: Stargarden Press, 2004.

Felker, Tracie. *Master Drawings of the Hudson River School.* Exhibition catalogue. New York: Metropolitan Museum of Art and Gallery Association of New York State, 1993.

Fink, Lois Marie, and Joshua Taylor. *Academy: The Academic Tradition in American Art. An Exhibition Organized on the Occasion of the 150th Anniversary of the National Academy of Design: 1825–1975.* Washington, D.C.: Smithsonian Institution Press, U.S. Government Printing Office number 6054, 1975.

Fort, Megan Holloway. "Archibald and Alexander Robinson and their Schools, The Columbian Academy of Art and the Academy of Painting and Drawing, New York, 1791–1835." PhD diss., CUNY Graduate Center, May 8, 2006.

Foster, Kathleen A., with an essay by Amy B. Werbel. *A Drawing Manual by Thomas Eakins.* New Haven and London: Yale University Press, 2005, in association with the Philadelphia Museum of Art.

Glanz, Dawn. *How the West Was Drawn: American Arts and the Settling of the Frontier.* Ann Arbor, Mich.: UMI Research Press, 1982.

Groseclose, Barbara. *Nineteenth-Century American Art.* Oxford and New York: Oxford University Press, 2000.

Hale, Robert Beverly. *Anatomy Lessons from the Great Masters.* New York: Watson-Guptill, 1977.

Haverkamp-Begemann, Egbert. *Creative Copies: Interpretive Drawings from Michelangelo to Picasso.* London: Philip Wilson, 1988; Sotheby's in association with the Drawing Center, New York.

Ingres Centennial Exhibition, 1867–1967: Drawings, Watercolors, and Oil Sketches from American Collections. Exhibition catalogue. Cambridge, Mass.: Fogg Art Museum, Harvard University, 1967.

Karolik Collection. *M. and M. Karolik Collection of American Watercolors and Drawings 1800–1875.* 2 vols. Boston: Boston Museum of Fine Arts, 1962.

Koob, Pamela N. *Drawing Lessons: Early Academic Drawings from the Art Students League of New York.* New York: Art Students League of New York, 2009.

Korzenik, Diana, with a foreword by Rudolf Arnheim. *Drawn to Art: A Nineteenth Century American Dream.* Hanover, N.H.: University Press of New England, 1985.

Kreutz, Gregg. *Problem Solving for Oil Painters: Recognizing What's Gone Wrong and How to Make It Right.* New York: Watson-Guptill, 1997.

Landgren, Marchal E. *Years of Art: The Story of the Art Students League of New York.* Introduction by Walter Pach. New York: Robert McBride, 1940. Copyright by the Art Students League of New York, 1940.

Lucas, Fielding Jr. *The Art of Drawing, Colouring and Painting Landscpes, in Watercolours.* Baltimore: Fielding Lucas Jr., 1815.

Lucas, Fielding Jr., and John Latrobe. *Progressive Drawing Book.* Baltimore: Fielding Lucas Jr., 1825.

Marzio, Peter C. *The Art Crusade: An Analysis of American Drawing Manuals 1820–1860.* Washington, D.C.: Smithsonian Institution Press, U.S. Government Printing Office, 1976.

McElhinney, James Lancel. "From Peale to Pixar." *American Arts Quarterly.* Newington Cropsey Cultural Studies Center, New York. Vol. 23, no. 4, Fall 2006.

———. "The Rebirth of Drawing." *American Arts Quarterly.* Newington Cropsey Cultural Studies Center, New York. Vol. 21, no. 2, 2004.

Mitchell, Mark. "The Artist-Makers: Professional Art Training in Mid-Nineteenth Century New York." PhD diss., Department of Art and Archaeology, Princeton University, 2000.

Olson, Roberta J. M. "John Singer Sargent and James Carroll Beckwith, Two Americans in Paris. A Trove of Their Unpublished Drawings," *Master Drawings,* Master Drawings Association, New York, Vol. 43, No. 4, 2005.

Peale, Rembrandt. *Graphics: A Manual Of Drawing And Writing, for the Use of Schools and Families.* New York: B. & S. Collins, 1835.

Pestle, Martin, and William Vaughan. *The Artist's Model: From Etty to Spencer.* London: Merrell Holberton, 1999.

Phagan, Patricia. *Hudson River School Drawings from Dia Art Foundation*. Exhibition catalogue, April 12 to June 15, 2003. Poughkeepsie, N.Y.: Frances Lehman Loeb Art Center, Vassar College, 2007.

The Progressive Drawing Book; containing a series of easy and comprehensive lessons for drawing . . . without the aid of a master. Also a complete treatise on perspective. With nearly 300 engravings. London, 1853. New York Public Library Collection.

Prown, Jules. "An Anatomy Book by John Singleton Copley." *Art Quarterly 26,* Spring 1963.

Robertson, Archibald. *Elements of the Graphic Arts*. New York: David Longworth, 1802.

Ruskin, John. *The Elements of Drawing*. New York: Dover, 1971.

Shelley, Marjorie. "The Craft of American Drawing: Early Eighteenth to Late Nineteenth Century," in Avery, Kevin J. *American Drawings and Watercolors in the Metropolitan Museum of Art*, Vol. 1. New Haven and London: Yale University Press, 2002, in association with the Metropolitan Museum of Art, New York.

Stebbins, Theodore E. Jr. *American Drawings and Watercolors*. New York: Harper & Row, 1976, in association with the Drawing Society, New York.

Steiner, Raymond J. *The Art Students League of New York: A History*. Saugerties, N.Y.: CSS Publications, 1999.

Steinhart, Peter. *The Undressed Art: Why We Draw*. New York: Vintage, 2005.

Reel, David M. "The Drawing Curriculum at the U.S. Military Academy during the Nineteenth Century," *West Point, Points West*. Western Passages, No. 1. Denver: Institute of Western American Art, Denver Art Museum, 2002.

U.S. War Department, Secretary John C. Calhoun. *General Regulations for the Army, 1821*. Philadelphia: M. Carey and Sons, 1821.

Viola, Elisa, and Gloria Vallese (eds.). *The Accademia di Venezia: The masters, the collections, the premises*. Venice: Marsilio Editori, S.p.A., 2005.

Ward, David C. *Charles Willson Peale: Art and Selfhood in the Early Republic*. Berkeley and Los Angeles: University of California Press, 2004, in cooperation with the National Portrait Gallery, Smithsonian Institution, Washington, D.C.

Index

Note: Page numbers in *italics* include illustrations and photographs/captions.

Picture Credits

All artworks are either from the collection of the Art Students League of New York or individual artists, as credited next to each image, except for the following images:

Courtesy the Arkansas Art Center / Will Barnet: vi

Courtesy Forum Gallery: 114, 115l

Collection of Tenley Jones-Franklin: x

Courtesy Google Books: 13: The American drawing-book by John Gadsby Chapman, 1847

Courtesy the Library of Congress Prints and Photographs Division: viii: LC-USZ62-72256; 2: LC-DIG-ppmsca-00061; 6: LC-USZ62-65374

Courtesy National Institutes of Health, U.S. National Library of Medicine: 5, 17

Private Collection: 102, 115r

Collection of Nancy and George Sheghtman, courtesy Gallery Henoch, New York: 187

Shutterstock: 11: © Shutterstock/Nikita Rogul

Collection of Noah Simmons: 192

Collection of Howard A. and Judith Tullman: 103

Courtesy Wikimedia Commons: 1: Dionysos pediment Parthenon BM / © Marie-Lan Nguyen / Wikimedia Commons; 4: Vite-Vasari; 8: Annual Reception at the National Academy of Design, New York

A Note on the Type

Classical Life Drawing Studio is composed largely in the classic font known as Bembo, which was originally designed by Francesco Griffo in 1495. Griffo worked in Venice for the renowned printer and publisher Aldus Manutius. The type was created for an essay published by Manutius entitled *De Aetna*, written by Cardinal Pietro Bembo—for whom the font was named. Today's Bembo is a revival of the original type cut by Griffo; it was created by the Monotype Corporation in 1929 under the direction of Stanley Morison. Over five hundred years later, Bembo remains an avatar of classic, elegant type design and is considered one of the primary roots of "Old Style" serif fonts. Additional fonts used are Neutra Text, designed by Richard Neutra and Christian Schwartz in 2002; Goudy, designed by Frederic W. Goudy in 1915; and Gill Sans, designed by Eric Gill in 1928–32.

Color separations by Embassy Graphics.
Printed and bound by 1010 Printing International Ltd., in China.
Interior designed by Rachel Maloney.

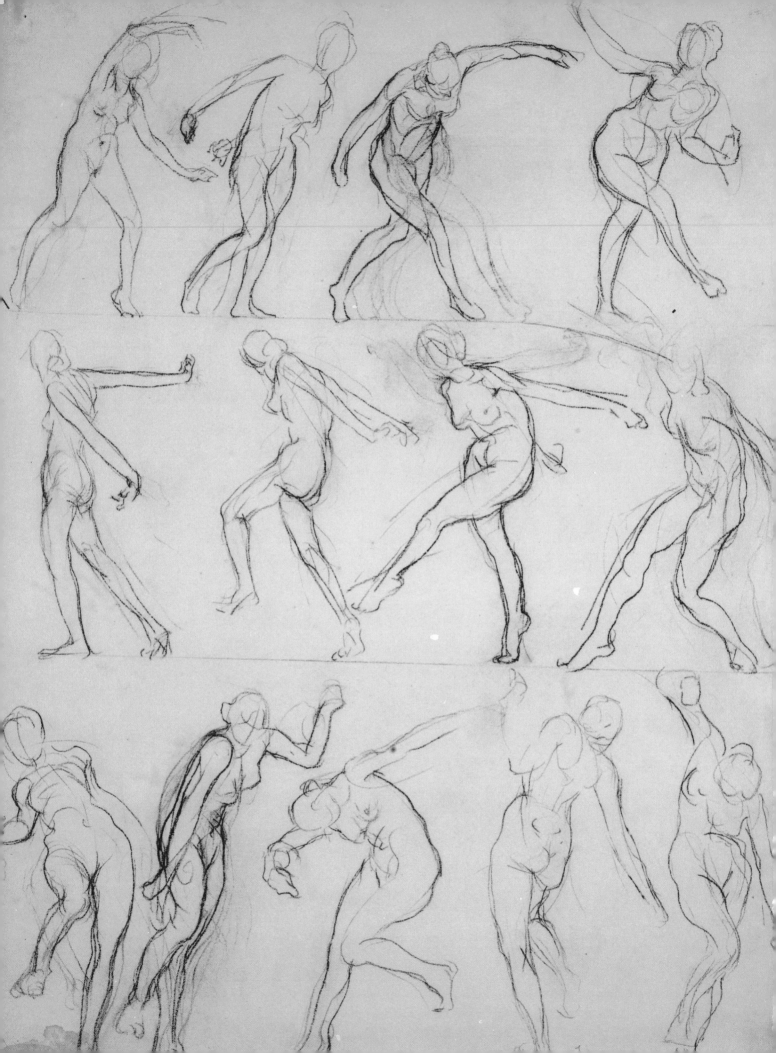